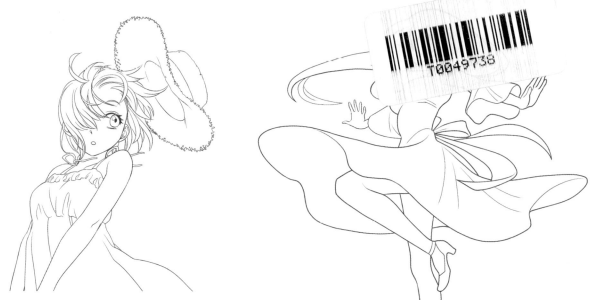

Learn to Draw Exciting
ANIME & MANGA
Characters

Lessons from 100 Professional Japanese Illustrators

Sideranch

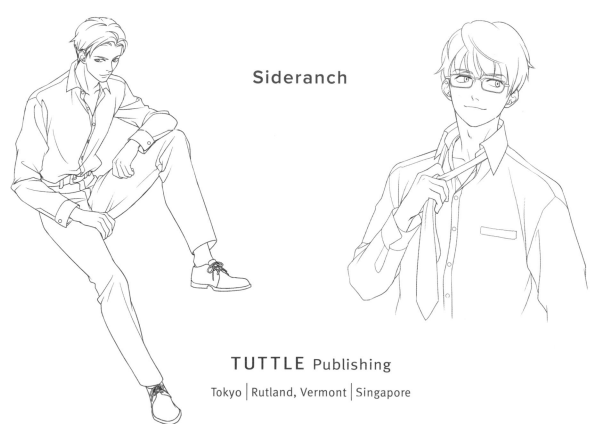

TUTTLE Publishing

Tokyo │ Rutland, Vermont │ Singapore

CONTENTS

CHAPTER 1
Character Shapes and Forms

Clothing and Other Items

CHAPTER **3**
Digital Line Drawing and Painting

CHAPTER **4**

Poses and Composition

Why We Wrote This Book

You're clearly ready to expand your skills as an anime or manga artist. Or both! Well, you've come to the right place.

Each page of the book contains a lesson derived from the ideas and techniques of the more than 100 artists we consulted. From basic knowledge and tips that are easy to apply, to standard tactics and helpful techniques, this book contains everything you need to know to elevate your artistic abilities.

Chapter 1: Character Shapes and Forms offers pointers to keep in mind when drawing human figures, such as balancing the face and body and how to draw parts of the body to match the character's personality.

Chapter 2: Clothing and Other Items presents tips for drawing Items, such as how to draw creases in clothes and other details you need to know to draw clothing.

Chapter 3: Digital Line Drawing and Painting contains a wealth of information on creating works with paint tools. We focus on two primary platforms: CLIP STUDIO PAINT and Photoshop to provide an explanation of how to use the tools' basic functions.

Chapter 4: Poses and Composition presents know-how on, you guessed it, poses and composition.

Each artist who participated in this project has a different style, so not all the techniques presented will be helpful to everyone. Even if a certain approach is the best method for some, it may not suit all. Take the tips that best suit your taste and style and go from there. You'll soon find your way to a signature style and distinctively dynamic drawings!

—Sideranch

How to Use This Book In this book, we present one lesson on each page.

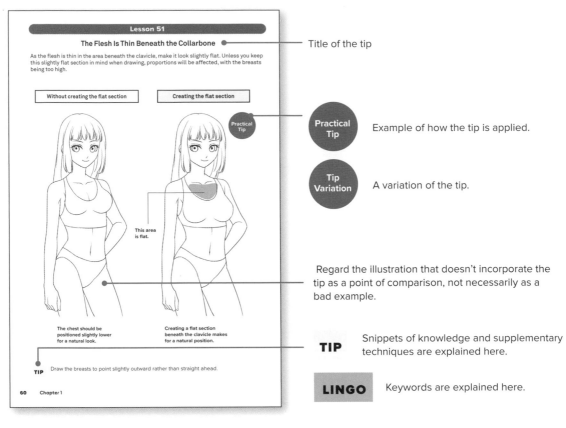

Lesson 51

The Flesh Is Thin Beneath the Collarbone ●—————— Title of the tip

As the flesh is thin in the area beneath the clavicle, make it look slightly flat. Unless you keep this slightly flat section in mind when drawing, proportions will be affected, with the breasts being too high.

| Without creating the flat section | Creating the flat section |

Practical Tip —————— **Practical Tip** Example of how the tip is applied.

Tip Variation A variation of the tip.

This area is flat.

The chest should be positioned slightly lower for a natural look.

Creating a flat section beneath the clavicle makes for a natural position.

Regard the illustration that doesn't incorporate the tip as a point of comparison, not necessarily as a bad example.

TIP Snippets of knowledge and supplementary techniques are explained here.

TIP Draw the breasts to point slightly outward rather than straight ahead.

LINGO Keywords are explained here.

60 Chapter 1

Lesson 88

Tilt the Canvas to Make It Easier to Draw Lines That Are on a Difficult Angle

It may be difficult to move your wrist or arm, depending on the angle of the canvas. If you're having trouble creating lines, rotate or reverse the image that you are working on so that it is on an angle that is easier to work with.

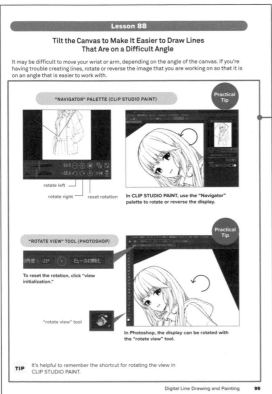

"NAVIGATOR" PALETTE (CLIP STUDIO PAINT)

Practical Tip

rotate left
rotate right reset rotation

In CLIP STUDIO PAINT, use the "Navigator" palette to rotate or reverse the display.

"ROTATE VIEW" TOOL (PHOTOSHOP)

Practical Tip

To reset the rotation, click "view initialization."

"rotate view" tool

In Photoshop, the display can be rotated with the "rotate view" tool.

TIP It's helpful to remember the shortcut for rotating the view in CLIP STUDIO PAINT.

In the explanation of digital tools, the use of CLIP STUDIO PAINT and Photoshop are described together. However, a few functions are explained for CLIP STUDIO PAINT only. The names of similar functions are based on those used in CLIP STUDIO PAINT.

Example
Composite mode (CLIP STUDIO)
▼
PAINT Drawing mode (Photoshop)

In this book, operating keys refer to Windows systems. For MacOS users, please use the corresponding keys in the table below.

Windows	macOS
Alt key	Option key
Ctrl key	Command key

Digital Line Drawing and Painting 99

Chapter 1

Character Shapes and Forms

An attractive face, balanced physique,
naturally flowing hair . . . this chapter has the
lessons you need for drawing human figures.

Block in a Cross for the Eyes to Make Drawing the Face Easier

Blocking-in lines that divide the center of the face serve as guides for where to position facial features. The vertical blocking-in line passes through the midline of the figure, so works as a benchmark for creating symmetry and balance. Marking in the width of the eyes above and below the horizontal blocking-in line makes drawing easier.

> **Blocking in for a cross and the width of the eyes**

Practical Tip

S Ci

To prevent a flat look, draw smooth lines to follow the circle.

For a front-on angle, even a cross formed from straight lines creates natural blocking-in.

LINGO　**Midline** The vertical line that passes straight through the center of the body. The vertical line of the cross used for blocking in sits on top of the midline.

Use a Circle + Chin to Block in the Outline of the Face

One technique for drawing the outline of the face is to draw a circle and add a chin. Using a circle for the skull and adding an inverse trapezoid shape for the chin allows you to create a silhouette with an attractive outline.

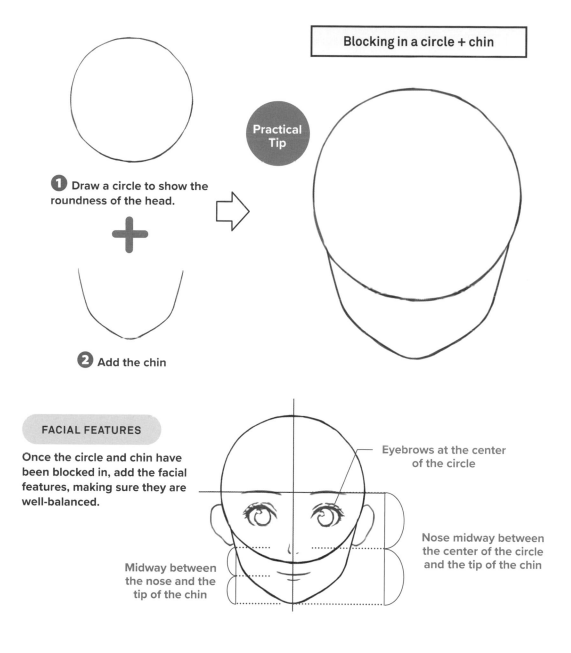

Practical Tip

Blocking in a circle + chin

1 Draw a circle to show the roundness of the head.

2 Add the chin

FACIAL FEATURES

Once the circle and chin have been blocked in, add the facial features, making sure they are well-balanced.

Eyebrows at the center of the circle

Nose midway between the center of the circle and the tip of the chin

Midway between the nose and the tip of the chin

TIP The facial arrangement above is just one example of basic balance. The positioning of facial features differs depending on the artist, and this often leads to new creative directions.

The Face is About the Same Size as an Open Hand

It is basic practice to make a character's open hand about the same size as the face. Of course the size of the face and hands differs with each individual, but keeping this benchmark size in mind allows you to draw hands of different sizes as a way to distinguish characters.

Hand drawn to a small size	About the same size as the face

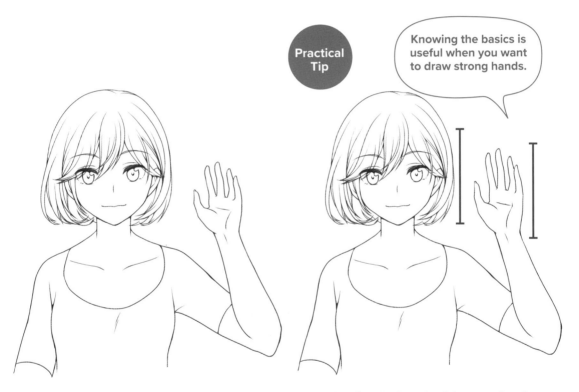

Practical Tip

Knowing the basics is useful when you want to draw strong hands.

When drawing women, some illustrators intentionally make the hands smaller.

Making the length of the open hand the same as from the forehead to the chin creates a natural-looking size.

TIP With chibi or similar distorted styles that make characters' heads exaggeratedly large, hands may be drawn smaller.

Using a Triangle Creates Balanced Facial Features

Balance between facial features can be measured with dotted lines between both eyes and from the eyes to the mouth. If the triangle formed is equilateral, it makes it easier to produce a well-balanced face. For a more realistic adult face or a character with a longer face, the triangle formed will be more isosceles.

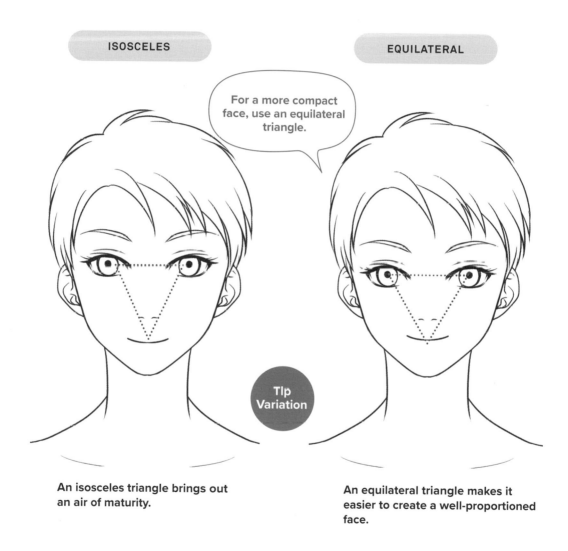

ISOSCELES

EQUILATERAL

For a more compact face, use an equilateral triangle.

Tip Variation

An isosceles triangle brings out an air of maturity.

An equilateral triangle makes it easier to create a well-proportioned face.

TIP Draw the nose in the area below the center of the triangle.

If the Eyes, Nose and Mouth Are Close Together, It Creates a Childlike Impression

It's possible to express differences in age through the distance between the eyes, nose and mouth. The closer they are, the better the balance and the more childlike impression they will make. Conversely, more widely distanced features create a more adult impression.

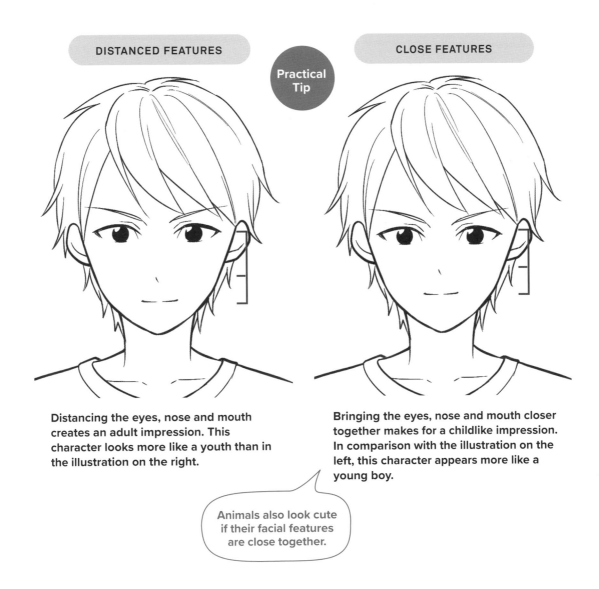

DISTANCED FEATURES

Practical Tip

CLOSE FEATURES

Distancing the eyes, nose and mouth creates an adult impression. This character looks more like a youth than in the illustration on the right.

Bringing the eyes, nose and mouth closer together makes for a childlike impression. In comparison with the illustration on the left, this character appears more like a young boy.

Animals also look cute if their facial features are close together.

TIP Chibi-style characters have eyes very close to their mouths. These designs are created by exaggerating the cuteness of a child.

Divide the Face into Three Equal Parts for a Balanced Look

A well-balanced and well-proportioned face has a 1:1:1 ratio of hairline to eyebrows, eyebrows to nose, and nose to chin. For realistic drawings, this ratio can be used even if the eyes are slightly distorted.

Practical Tip

Attractive balance

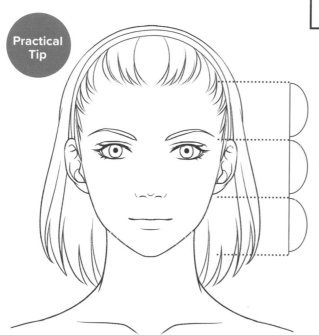

An illustration drawn with a 1:1:1 ratio of hairline to eyebrows, eyebrows to nose, and nose to chin. The ratio is a matter of taste, so find what suits you best.

HEAVILY DISTORTED BALANCE

For a heavily distorted illustration style, a larger eyebrow-to-nose ratio seems to strike the right balance.

Large

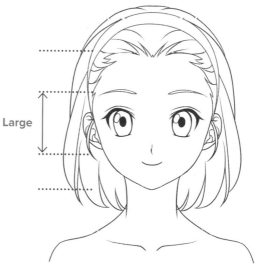

For Youthful Characters, Make the Nose Small and Chin Narrow

Younger characters tend to have small noses and chins. In particular, the nose is often simplified or omitted altogether. In some cases, the nose and chin of men are drawn clearly, while those of women and young characters are made small and less distinctive.

| Clear nose and chin | Small nose and chin |

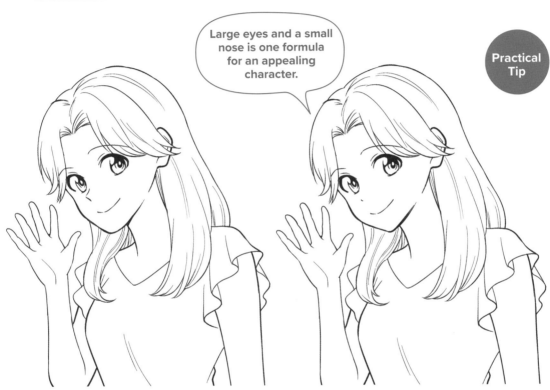

Large eyes and a small nose is one formula for an appealing character.

Practical Tip

A clearly drawn nose and chin makes for a more realistic style of illustration.

An example where the nose and chin are drawn small. Many female manga and anime characters have chins drawn so narrow as to be pointed.

TIP In terms of ways for abbreviating noses, there are various approaches such as only drawing the bridge, only drawing the nostrils and only drawing a shadow.

Be Conscious of the E-Line to Create a Strong Profile

A striking or appealing profile typically has the lips positioned just inside the straight line that joins the nose and chin. This is called the E-line. If you feel that you're not quite getting profiles right, try adding in the E-line as a guide to check your proportions.

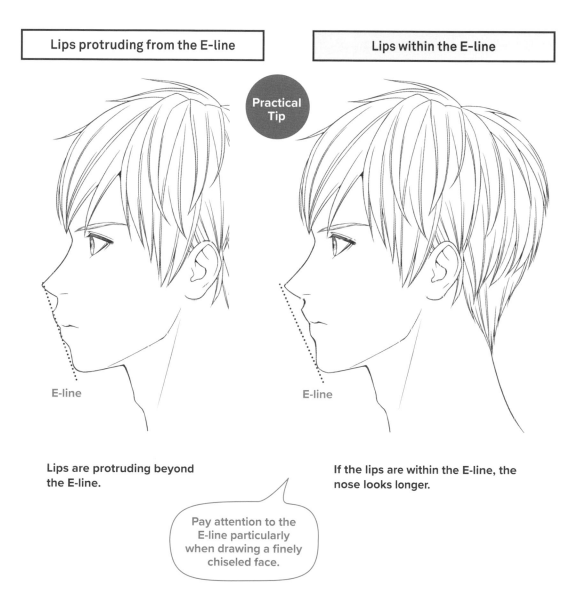

Lips protruding from the E-line

Lips within the E-line

Practical Tip

E-line

E-line

Lips are protruding beyond the E-line.

If the lips are within the E-line, the nose looks longer.

Pay attention to the E-line particularly when drawing a finely chiseled face.

Slightly Angle the Face in Profile to Create a Sense of Dimension

Angling a face in profile slightly towards the viewer brings out density in the part of the face furthest away that can only just be glimpsed, creating an illustration with a sense of dimension. However, it is not suited for deforme styles of illustration where dimension in the bridge of the nose and so on is not accentuated.

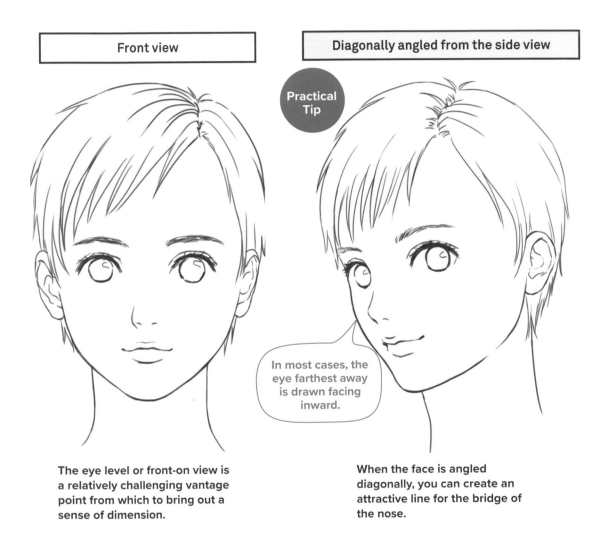

Front view

Diagonally angled from the side view

Practical Tip

In most cases, the eye farthest away is drawn facing inward.

The eye level or front-on view is a relatively challenging vantage point from which to bring out a sense of dimension.

When the face is angled diagonally, you can create an attractive line for the bridge of the nose.

TIP For highly distorted or chibi-style illustrations, it's easier to angle the face a bit more toward the viewer so the eye farthest away can be clearly seen.

It's Easier to Visualize the Position of the Features If the Face Is Viewed as a Cube

When drawing the face on an angle, if you're having trouble positioning the eyes, nose and mouth, try blocking in a cube shape. There are many complicated curved surfaces on the human face. It takes practice to capture their dimensions, so start by thinking of them as locations on a simple cube to make it easier to visualize positioning the facial features.

Visualize a cube

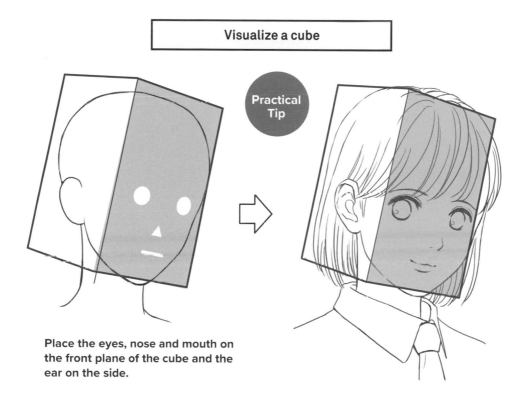

Practical Tip

Place the eyes, nose and mouth on the front plane of the cube and the ear on the side.

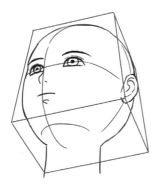

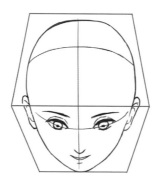

DIFFICULT ANGLES

For difficult angles in particular, drawing a cube makes visualization easier.

Use the Width of the Eye to Determine the Space Between the Eyes

Making the distance between the eyes "the width of an eye" creates a balanced look. Using this as a standard allows you to distinguish between the characters you draw and altering their appearance by shifting the eyes wider apart or closer together.

Leave a gap the width of one eye

Practical Tip

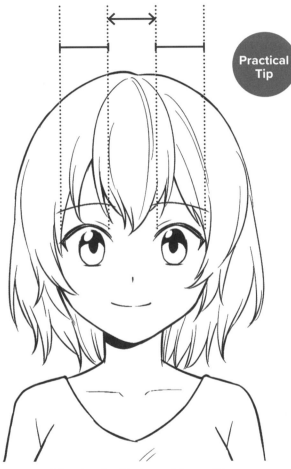

The standard balanced face with the eyes separated by a gap the width of one eye.

EYES ARE CLOSE TOGETHER

EYES ARE WIDE APART

Use the Position of the Eyes to Work out Where to Place the Ears

The ear begins above the line that extends out from the corner of the eye. Placing the ear just behind the midline of the head in profile yields a good sense of balance. If you're having trouble positioning the ears, mark in these guide lines to help you find the right location.

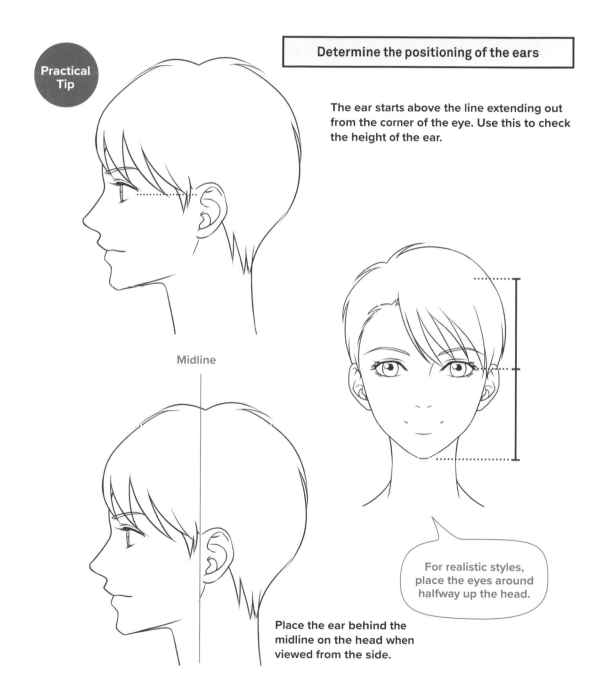

Practical Tip

Determine the positioning of the ears

The ear starts above the line extending out from the corner of the eye. Use this to check the height of the ear.

Midline

Place the ear behind the midline on the head when viewed from the side.

For realistic styles, place the eyes around halfway up the head.

Draw the Ears Slightly Tilted

When drawing the ears from the side, slightly tilting them will make them appear more natural. Visualize the line where they join the head as tilting just the slightest bit. There is a tendency to draw them upright or vertically oriented, so watch out for this.

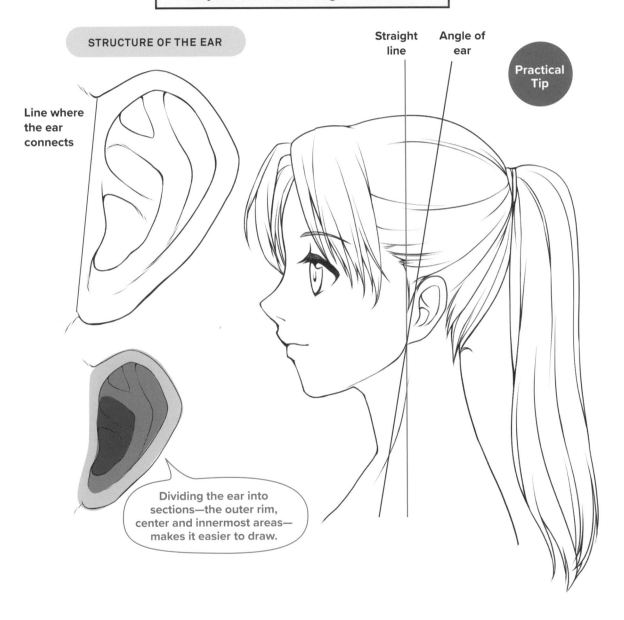

Pay attention to the angle of the ears

STRUCTURE OF THE EAR

Straight line

Angle of ear

Practical Tip

Line where the ear connects

Dividing the ear into sections—the outer rim, center and innermost areas—makes it easier to draw.

TIP The vertical height of the ear is about the same as the length from the eyebrows to the tip of the nose.

Pay Attention to the Eyeballs to Create a Sense of Solidity in the Eyes

In order to draw the eyes from different angles and shift the direction of the gaze, it's important to capture the eyeballs as three-dimensional objects. Visualizing the eyeballs as being covered by the eyelids makes it easier to capture their sense of solidity.

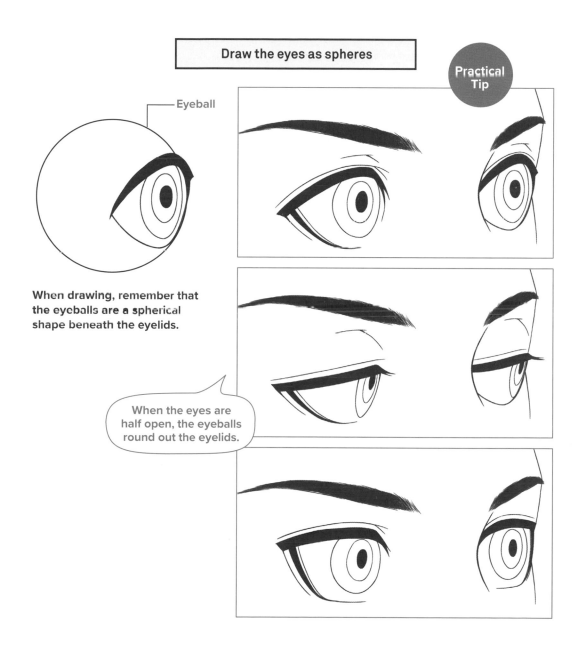

Draw the eyes as spheres

Practical Tip

Eyeball

When drawing, remember that the eyeballs are a spherical shape beneath the eyelids.

When the eyes are half open, the eyeballs round out the eyelids.

For Chibi-Style Eyes, Emphasize the Pupils and Upper Lashes

When drawing chibi-style eyes, make the pupils and upper lashes stand out. If you want to add more detail, include the irises and lower lashes. Simplifying the hairs in the eyebrows and eyelashes into thick lines makes for a neat and tidy impression.

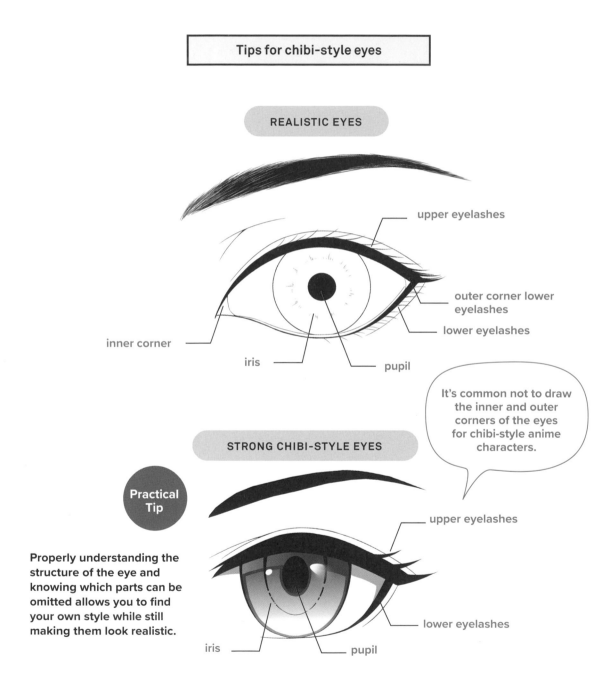

Tips for chibi-style eyes

REALISTIC EYES

upper eyelashes

outer corner lower eyelashes

lower eyelashes

inner corner

iris

pupil

It's common not to draw the inner and outer corners of the eyes for chibi-style anime characters.

STRONG CHIBI-STYLE EYES

Practical Tip

Properly understanding the structure of the eye and knowing which parts can be omitted allows you to find your own style while still making them look realistic.

upper eyelashes

lower eyelashes

iris

pupil

Bringing the Eyebrows and Eyes Closer Together Makes for a Well-Defined Face

The chiseled or sharp-featured faces of some male characters often have closely drawn brows and eyes. The proximity makes the eyes appear more powerful and piercing. Conversely, distancing the brows and eyes creates a soft, airy vibe.

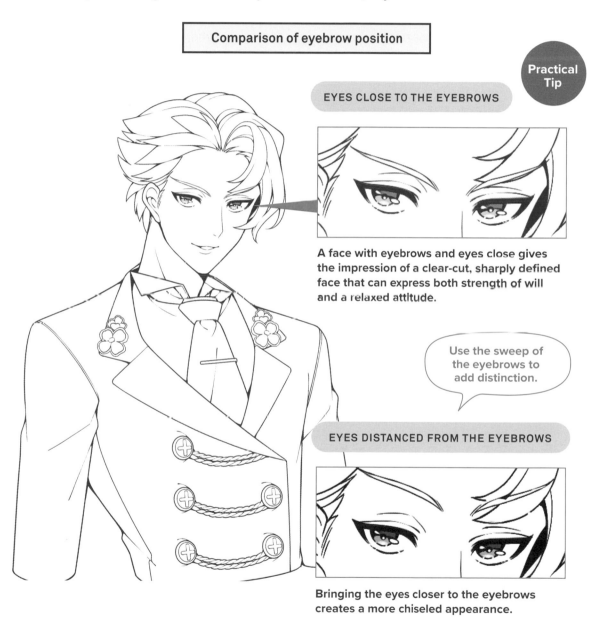

Comparison of eyebrow position

Practical Tip

EYES CLOSE TO THE EYEBROWS

A face with eyebrows and eyes close gives the impression of a clear-cut, sharply defined face that can express both strength of will and a relaxed attitude.

Use the sweep of the eyebrows to add distinction.

EYES DISTANCED FROM THE EYEBROWS

Bringing the eyes closer to the eyebrows creates a more chiseled appearance.

TIP Use the eyebrows to create expressions of increasing complexity. Is your character quizzical, condescending or appalled? Master the distinctions.

Taper the Eye Shape to Reflect the Character

The shape of a character's eyes help suggest attitude and personality. Long, horizontal eyes work for cool or alluringly aloof characters, while tall, vertical eyes make characters look inviting and appealing.

Impressions created by different eye shapes

Practical Tip

LONG, HORIZONTAL EYES

Practical Tip

TALL, VERTICAL EYES

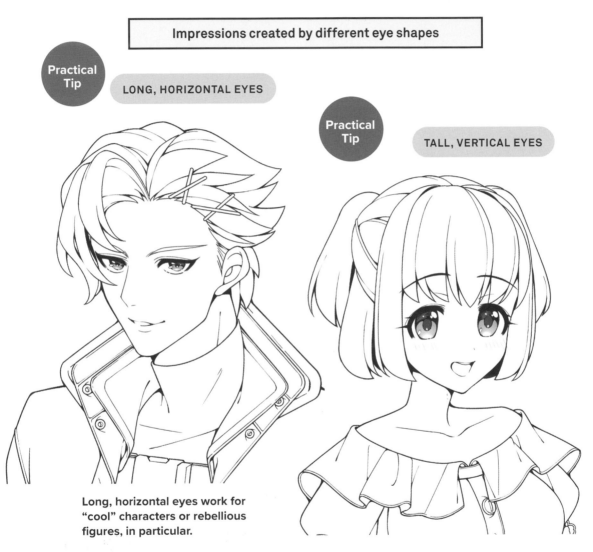

Long, horizontal eyes work for "cool" characters or rebellious figures, in particular.

Using ovals for the large eyes of some female characters helps strike the right balance.

Use Ovals to Easily Create a Balanced Look When Drawing Big Eyes

In reality, eyes are perfect circles, but when it comes to chibi-style characters, the eyes are often drawn as ovals. With tall, vertical eyes, the pupils can easily be rendered as circles, but some people prefer ovals.

Perfectly circular eyes	Elliptical eyes

Practical Tip

Tall, vertical eyes lend an appealing impression, a great choice for your story's heroine.

Eyes drawn as perfect circles give a slightly different impression from oval eyes.

TIP Even in chibi-style illustrations, the eyes can be drawn as perfect circles. Depending on your personal preference or if you want to depict the eyes as being rounder, circles may be used. Try varying shapes to find what kind of eyes work best for your style of illustration.

Lesson 19

When Drawing a Dot For the Nose, Place It at the Tip

With chibi-style illustrations, it's common to express the nose simplified to a dot. But if it's incorrectly positioned, it'll make the face look odd or off balance. Even when not drawing the entire nose, keep the facial composition in mind so that the dot is positioned to correspond with the location of the tip.

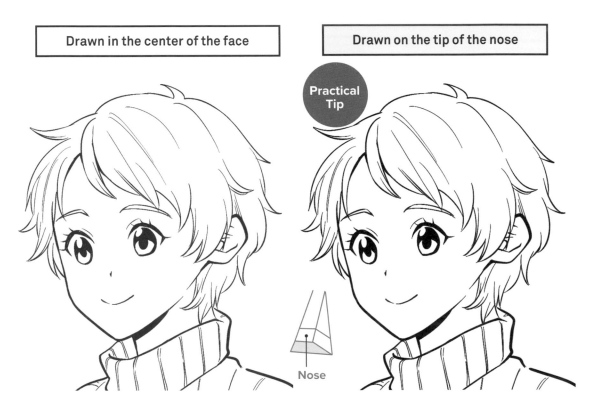

Drawn in the center of the face	Drawn on the tip of the nose

Practical Tip

Nose

Drawing a dot for the nose in the center of the face doesn't create much dimension.

Creating variation in the lines of the mouth allows the soft texture of the lips to be expressed. This technique can be used when creating a cuter persona, such as a young child or baby.

For a nose drawn with a line, positioning it to correspond with the bridge makes it look natural and creates the impression of a long, straight nose.

NOSE DRAWN WITH ONLY A LINE

A Gap Between the Lines for the Mouth Brings out the Texture of the Lips

Creating a gap between the lines of the mouth lightens the look of the face and brings out the lips' texture. It's a way to create a clean and neat impression at the same time as bringing out the look and feel of the lips. Depending on your drawing style, why not try using this technique in your own work?

Simple lips	Lips with texture

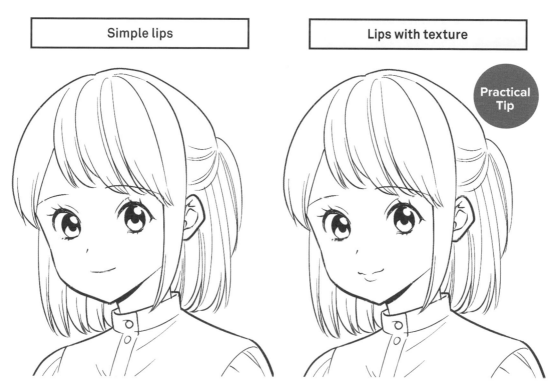

Practical Tip

Even just a dot for a nose brings out a sense of dimension when it's drawn to correspond with the tip.

A mouth drawn with a simple line creates a clean, well-defined impression. It's suited for expressing a simplified face, effective on characters drawn in a heavily distorted, chibi-style.

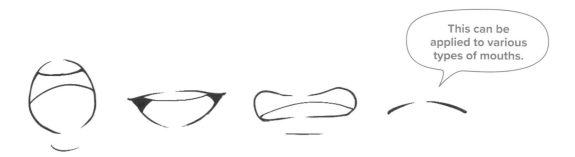

This can be applied to various types of mouths.

Don't Draw in the Teeth

For character illustrations, it's common to draw the teeth either in silhouette or to not draw them at all. Unless there's a particular point to doing so, it's better not to distinguish each tooth in detail.

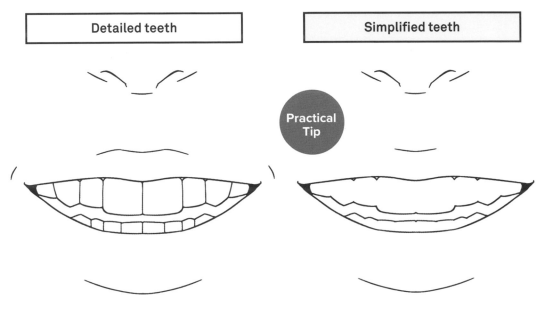

Detailed teeth	Simplified teeth

Practical Tip

Drawing in each individual tooth lends a look that can be overly realistic or scary.

Teeth that are depicted in a general outline or silhouette are free of unnecessary lines and thus have a greater sense of solidity.

There are various ways to simplify the teeth, such as only drawing the canine teeth or blacking out sections within the mouth.

Tip Variation

Learn Facial Perspective to Make It Easier to Draw from Low or High Angles

Perspective affects the face such that when viewed from a low angle, the eyebrows, eyes and nose appear closer together. When the figure is viewed from a high angle, the mouth and nose seem closer to each other but farther from the brows and eyes.

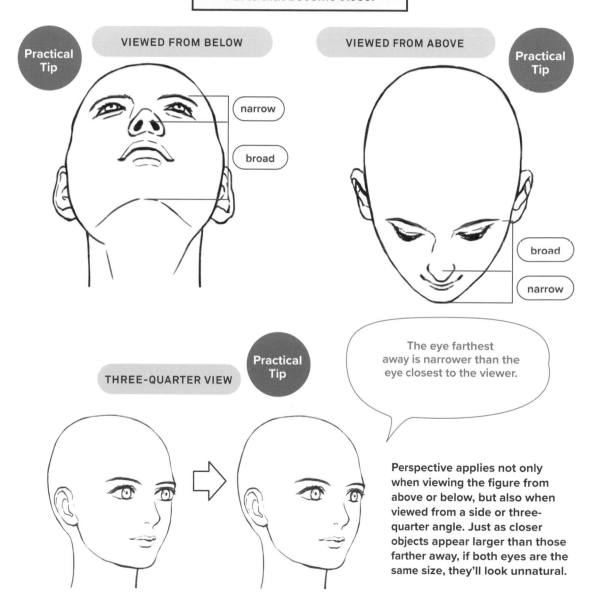

Parts that become closer

Practical Tip

VIEWED FROM BELOW

narrow

broad

VIEWED FROM ABOVE

Practical Tip

broad

narrow

THREE-QUARTER VIEW

Practical Tip

The eye farthest away is narrower than the eye closest to the viewer.

Perspective applies not only when viewing the figure from above or below, but also when viewed from a side or three-quarter angle. Just as closer objects appear larger than those farther away, if both eyes are the same size, they'll look unnatural.

LINGO **Low angle** An upward-slanting vantage point or looking up from below.
High angle A bird's-eye view or viewed looking down from above.

Viewed from a Low Angle, the Corners of the Eyes Turn Down

From a low angle, the curved surfaces of the face make the corners of the eyes appear to turn slightly downward. The eyes also appear rounder than when viewed from frontally or straight on.

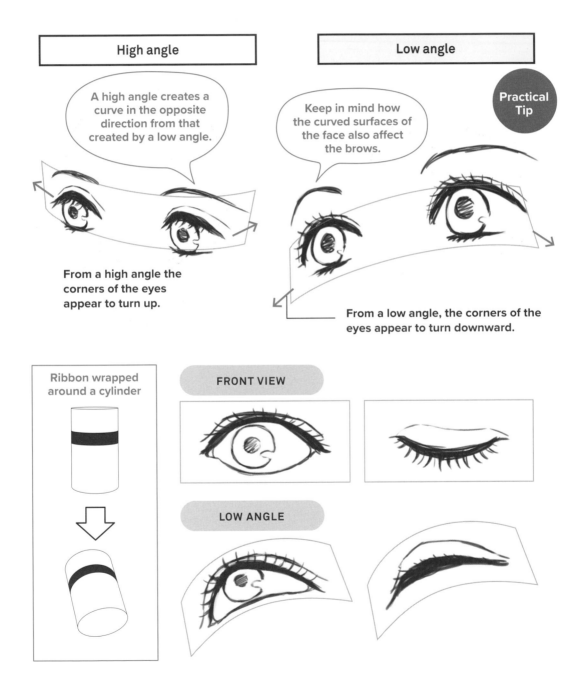

High angle

A high angle creates a curve in the opposite direction from that created by a low angle.

From a high angle the corners of the eyes appear to turn up.

Low angle

Keep in mind how the curved surfaces of the face also affect the brows.

Practical Tip

From a low angle, the corners of the eyes appear to turn downward.

Ribbon wrapped around a cylinder

FRONT VIEW

LOW ANGLE

At a Three-Quarter Angle, Bringing the Farthest Eye Inward Corrects the Character's Focus

For a three-quarter angle, a little tweaking is necessary to determine the position of the eye farthest from the viewer. If you try to match it to the eye that's closest to the viewer, the character's gaze may not appear to be in focus. Bring the farthest eye slightly inward to correct this.

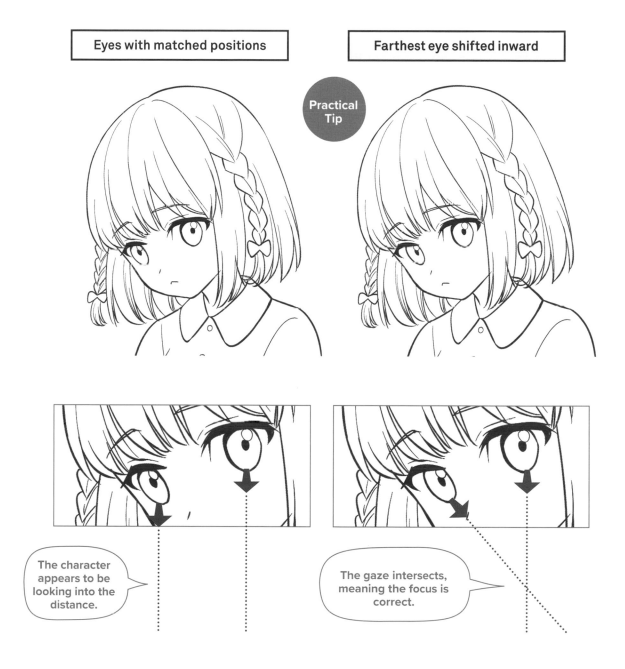

Eyes with matched positions

Farthest eye shifted inward

Practical Tip

The character appears to be looking into the distance.

The gaze intersects, meaning the focus is correct.

Lesson 25

Use Lines of Muscle to Create Different Impressions

In reality, there are fine wrinkles and muscles in the human face, but for some characters, omitting these brings out the softness of the skin. For a muscular character, depicting these lines lends the look of strength.

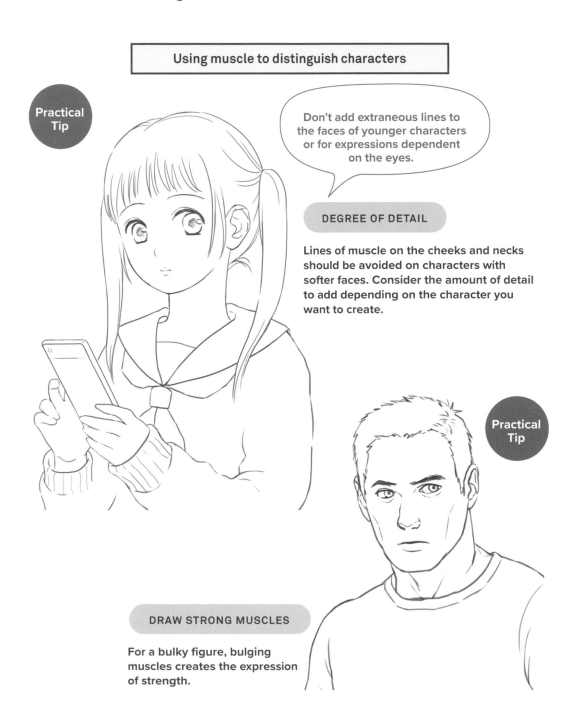

Using muscle to distinguish characters

Practical Tip

Don't add extraneous lines to the faces of younger characters or for expressions dependent on the eyes.

DEGREE OF DETAIL

Lines of muscle on the cheeks and necks should be avoided on characters with softer faces. Consider the amount of detail to add depending on the character you want to create.

Practical Tip

DRAW STRONG MUSCLES

For a bulky figure, bulging muscles creates the expression of strength.

For Chibi-Style Characters, the Eyebrows and Mouth Alone Can Create Emotional Expression

With chibi-style characters, the eyebrows and mouth are the focal points for a range of facial expressions. Using these features alone can create various emotional expressions. For creating more complex or detailed expressions, add wrinkles to the eyelids or between the brows or shift the placement of the eyes.

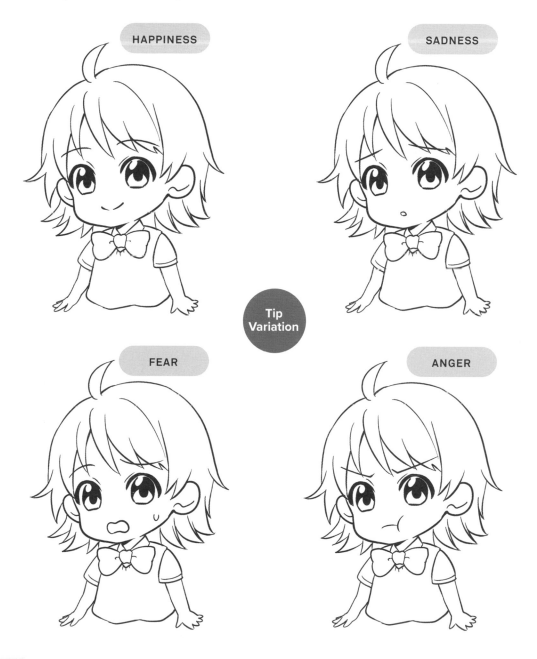

HAPPINESS

SADNESS

Tip Variation

FEAR

ANGER

TIP Expression is created by using the various muscles in the face, but adding detailed muscle movement to a chibi-style illustration complicates the simplicity of the illustration.

Mixing Two Emotions Allows for the Creation of Complicated Expressions

Smiling while shedding tears, clenching teeth while slyly smiling with the eyes. Complicated emotional expressions like these can be achieved by combining two facial expressions.

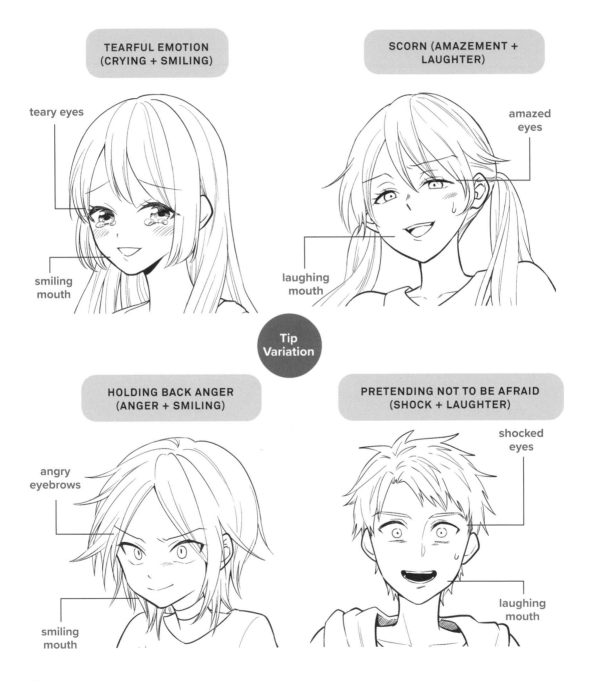

TEARFUL EMOTION (CRYING + SMILING)

teary eyes

smiling mouth

SCORN (AMAZEMENT + LAUGHTER)

amazed eyes

laughing mouth

Tip Variation

HOLDING BACK ANGER (ANGER + SMILING)

angry eyebrows

smiling mouth

PRETENDING NOT TO BE AFRAID (SHOCK + LAUGHTER)

shocked eyes

laughing mouth

TIP This hybrid or combination technique allows you to express both token and genuine emotions, and is useful when you want to add depth to a character.

The Direction of the Gaze Can Be Used to Express Emotion

When expressing characters' emotions through their expressions, pay attention to the direction of their gaze. Whether they are shifting their gaze up or down, glaring straight ahead or looking distractedly elsewhere, the direction of their gaze significantly alters the impression created.

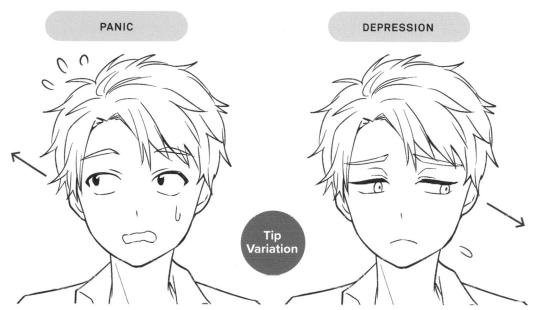

PANIC

DEPRESSION

Tip Variation

Directing the gaze diagonally upward creates an expression of panic.
It's effective when making it easily understood that a character is lying.

Shifting the gaze diagonally downward is often used to convey negative emotions. It can also be applied to serious expressions such as when the character is deep in thought.

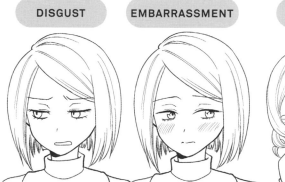

DISGUST

EMBARRASSMENT

RAGE

COYNESS

Make the eyes horizontal to convey that the character doesn't want to look at something she dislikes.

Casting the eyes down conveys embarrassment.

It's standard practice to make the eyes look upward in a glaring expression.

Directing the eyes upward can also be used when the character is fawning or acting cute.

Lesson 29

Concealing One Eye Emphasizes the Gaze

If one eye is concealed, the gaze of the other eye is emphasized, creating an expression that sparks curiosity about what the character is looking at. There are various ways to cover one eye, including using clothing or accessories such as an eye patch or placing an object in front of the eye.

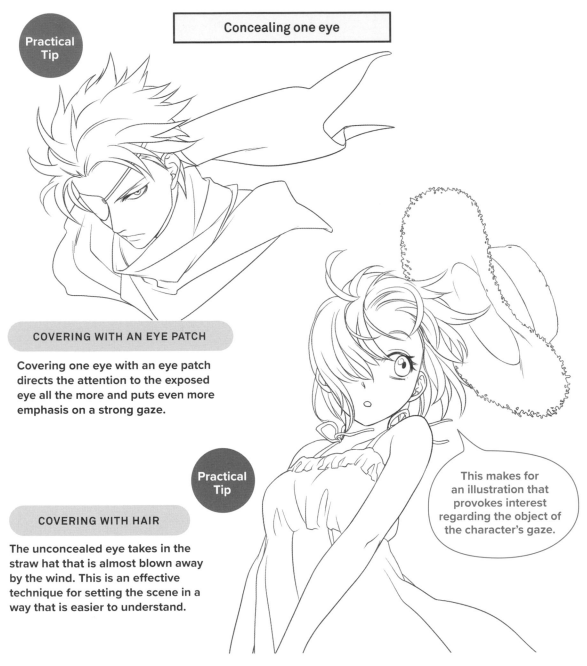

Practical Tip

Concealing one eye

COVERING WITH AN EYE PATCH

Covering one eye with an eye patch directs the attention to the exposed eye all the more and puts even more emphasis on a strong gaze.

Practical Tip

COVERING WITH HAIR

The unconcealed eye takes in the straw hat that is almost blown away by the wind. This is an effective technique for setting the scene in a way that is easier to understand.

This makes for an illustration that provokes interest regarding the object of the character's gaze.

TIP Other standard methods for covering one eye include holding a hand in front of the face, concealing the eye with an item that is being carried and covering it with a bandage.

For Some Characters, Don't Include Too Many Facial Details

If you're trying to capture a character's gentle air, use a rounded facial outline like that of a child. The curve and shape of the jawline, cheekbones and chin significantly affect the impression a character makes.

Clearly marked undulations	Undulations omitted

Practical Tip

Clearly drawing in the chin and being conscious of the undulations in the bones makes for a more real looking illustration.

Reducing or omitting the undulations creates an overall roundness for a cute impression.

Positioning the swelling of the cheeks on the area around the cheekbones makes for a realistic look.

Slightly swelling out the cheeks opens up the face creating softness and balance.

TIP Be sure to apply this technique not only to the face but also to other body parts such as the shoulders and hands.

Divide the Hairstyle into Blocks to Make It Easier to Handle

Capturing the hair in blocks at the front (bangs), top and sides makes it easier to understand its flow and the differences between hairstyles. It's a good idea to pay attention to the hairline as well.

| Capture the hair in blocks |

Practical Tip

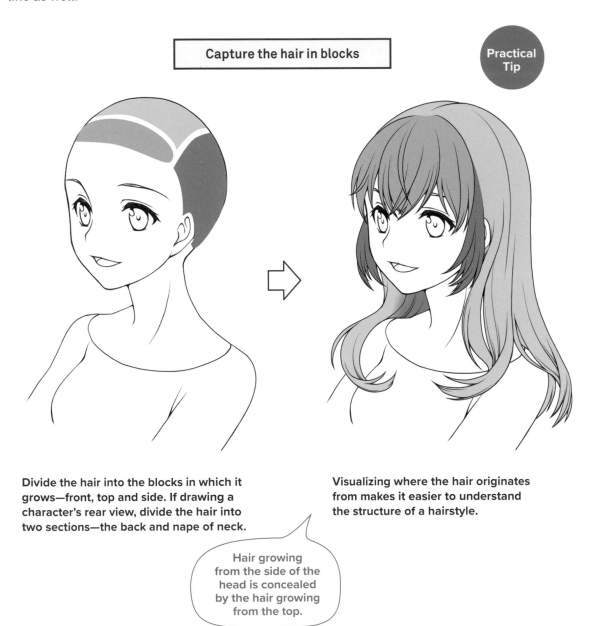

Divide the hair into the blocks in which it grows—front, top and side. If drawing a character's rear view, divide the hair into two sections—the back and nape of neck.

Visualizing where the hair originates from makes it easier to understand the structure of a hairstyle.

Hair growing from the side of the head is concealed by the hair growing from the top.

TIP Depending on the hairstyle, the hair may be parted on either side, and you may need to block off the sideburns as well.

Capture Hanks of Hair in Strips to Make Them Easier to Draw

For long hanks of hair, visualize them in band-like strips. Draw them as fluttering strips in settings and situations in which the hair is being blown by the wind.

Use strips for hanks of hair

Practical Tip

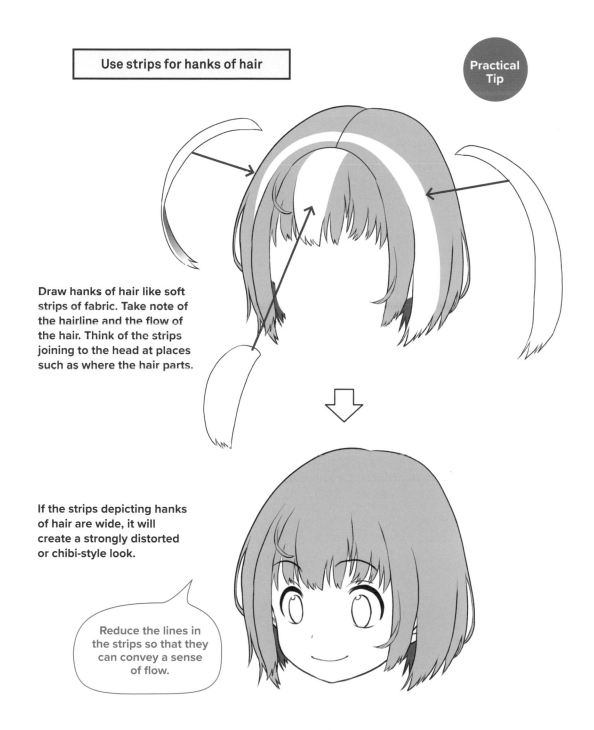

Draw hanks of hair like soft strips of fabric. Take note of the hairline and the flow of the hair. Think of the strips joining to the head at places such as where the hair parts.

If the strips depicting hanks of hair are wide, it will create a strongly distorted or chibi-style look.

Reduce the lines in the strips so that they can convey a sense of flow.

The Flow of Long Hair Is Determined When the Head Is Blocked In

Long hair is drawn so that it flows to follow the shape of the head. For this reason, add the hair in after blocking in the head. Start the hair at the part or the hairline and be conscious of where it is supported by the head and where it trails down due to gravity.

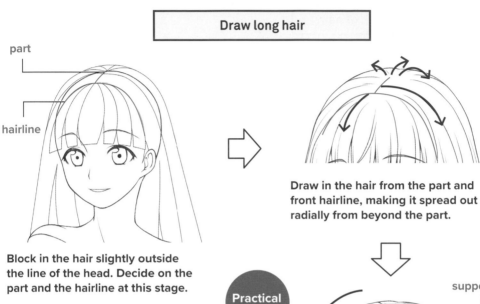

Draw long hair

part

hairline

Draw in the hair from the part and front hairline, making it spread out radially from beyond the part.

Block in the hair slightly outside the line of the head. Decide on the part and the hairline at this stage.

Practical Tip

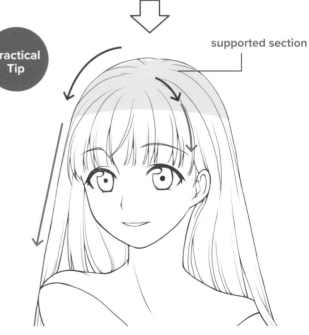

supported section

COMMON MISTAKES

If you draw the hair without blocking it in, it's easy to make mistakes such as not creating enough volume in the top section.

Draw the hair supported by the head so that it follows the shape of the skull, with the unsupported sections of hair trailing down.

Make the Ends of the Hair Irregular for a Natural Look

Make the ends of the hair different sizes to create an authentic impression. It's also a good idea to make the ends flow in random directions. Just make sure that hair is all the same length.

Tapered ends	Irregular ends

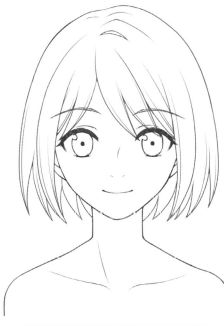

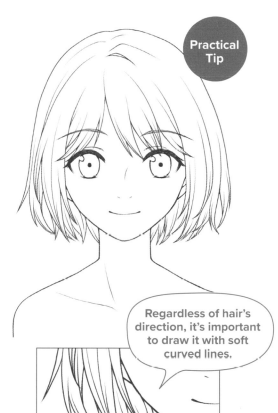

Practical Tip

Regardless of hair's direction, it's important to draw it with soft curved lines.

For a strongly chibi-style illustration, this would work, but as the flow of the hair in this example has been drawn in detail, it looks unnatural for only the ends of the hair to be simplified.

While there is a certain regularity to the direction of the hair ends, they are also random. Be conscious of hair's natural flow by slightly shifting pieces even if they're moving in the same direction as other sections.

Lesson 35

Add Fine Lines to Express Smooth, Silky Hair

Adding fine lines to the hair brings out a silky look and makes the hair seem lighter. When adding lines, make sure they follow the flow of the surrounding hanks of hair. Also, when adding the finishing touches to the illustration, use colors that are clearly light or dark.

Without added lines	With added lines

Practical Tip

Too many lines makes can overwhelm, so keep them to a moderate amount.

The hair with no additional lines.

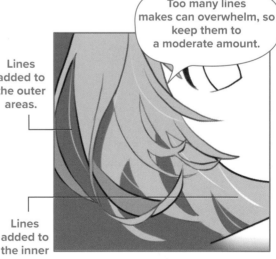

Lines added to the outer areas.

Lines added to the inner areas.

Use a fine, hard brush to add lines to the hair. Use the same color as the rest of the hair when adding lines to the outer sections, but use a lighter color on the inner sections.

The Gaps Between Zigzag Lines Can Be Used to Simplify the Hairline

The hairline is an area that needs to be simplified, so that it doesn't end up looking awkward. It's common to use zigzags or short lines to simplify exposed areas such as the hairline around the forehead.

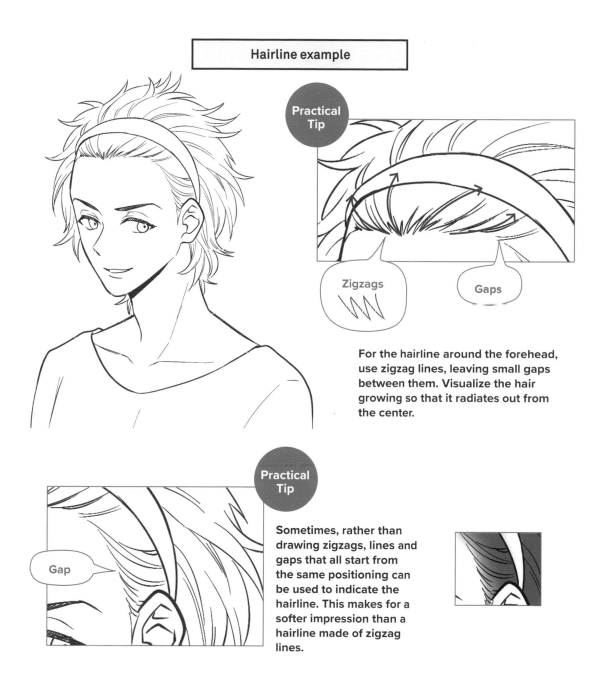

Hairline example

Practical Tip

Zigzags

Gaps

For the hairline around the forehead, use zigzag lines, leaving small gaps between them. Visualize the hair growing so that it radiates out from the center.

Practical Tip

Gap

Sometimes, rather than drawing zigzags, lines and gaps that all start from the same positioning can be used to indicate the hairline. This makes for a softer impression than a hairline made of zigzag lines.

TIP For color illustrations, you can apply gradation to the lines with the gaps between forming the hairline.

Lesson 37

Fine Pigtails and Ponytails Make the Character Look Young

As children's hair is finer and softer than that of adults, when hair is tied back, their pigtails and ponytails are also thinner. If you're trying to make characters look young and they have pigtails or a ponytail, make the hair thin and fine.

> **Pigtails**

THICK PIGTAILS

THIN PIGTAILS

Practical Tip

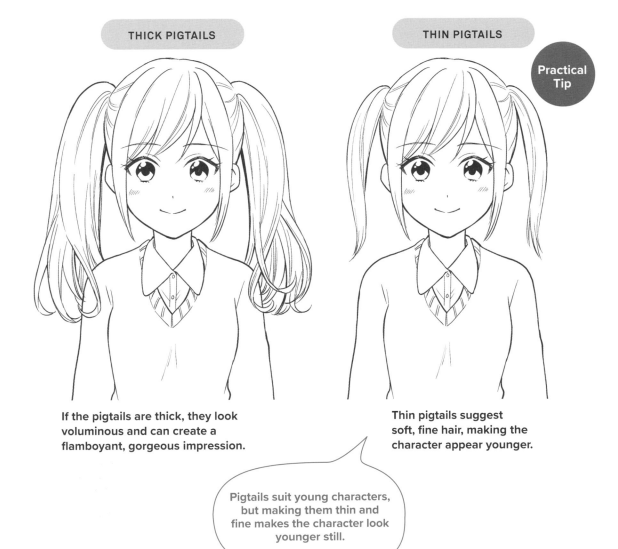

If the pigtails are thick, they look voluminous and can create a flamboyant, gorgeous impression.

Thin pigtails suggest soft, fine hair, making the character appear younger.

Pigtails suit young characters, but making them thin and fine makes the character look younger still.

TIP Pigtails allow for plenty of variety simply by altering the height at which they are tied.

Create Irregular Rhythm For Fluttering Items

When drawing scarves, ribbons, long hair or anything that is in long strips, interrupting or breaking up the rhythm of the flow allows you to make the element appear to be moving more naturally.

Random fluttering

Practical Tip

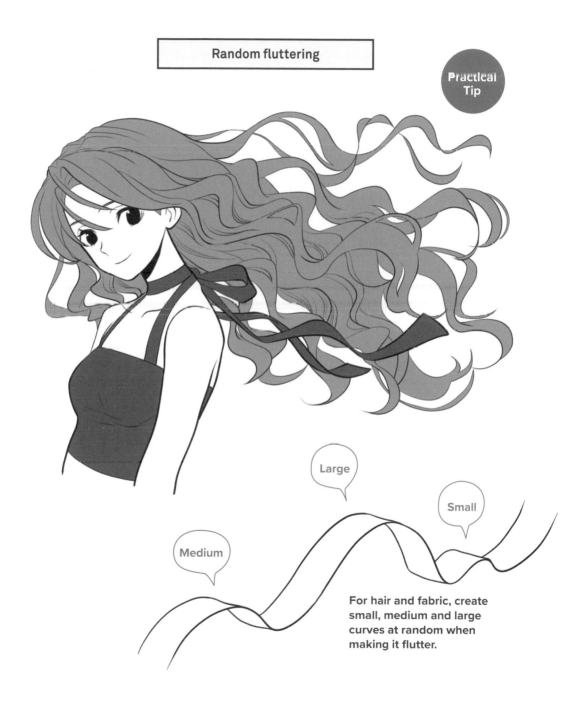

Large

Small

Medium

For hair and fabric, create small, medium and large curves at random when making it flutter.

When the Arms Are by the Figure's Sides, the Wrists Are in Line with the Crotch

When the arms are resting at the sides, the wrists come to about the same position as the crotch (or lower, if drawing the figure to have long arms). Keep this in mind as a benchmark for the length of the arms. Think of the shoulders as the pivot point for the range of motion in order to grasp the length of the arms when they're raised.

Short arms	Wrists at the level of the crotch

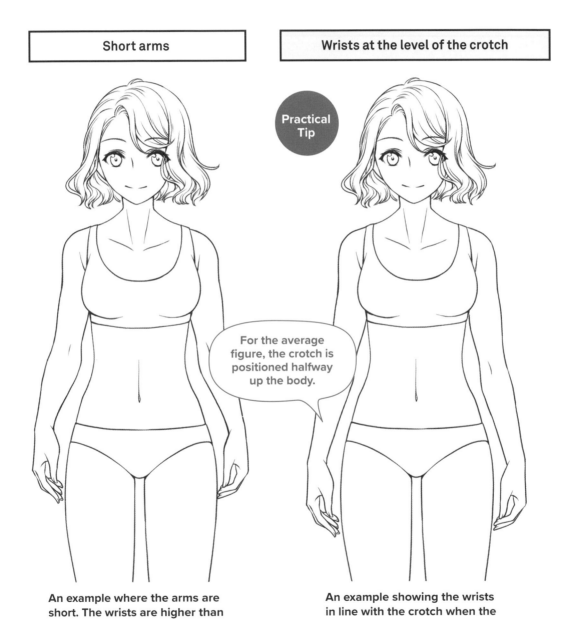

Practical Tip

For the average figure, the crotch is positioned halfway up the body.

An example where the arms are short. The wrists are higher than the crotch when the arms are at the sides.

An example showing the wrists in line with the crotch when the arms are at the sides.

Make the Width of the Shoulders More Than Twice the Width of the Head for a Strong Look

It's usual to make the shoulders twice the size of the head (two heads' width). For characters with broad shoulders, this width should be around 2.5 times that of the head. However, this doesn't apply for chibi-styles where the characters have bulbous or exaggeratedly large heads.

Use the width of the shoulders to bring out strength

Practical Tip

WIDTH FOR STRONG SHOULDERS

Making the shoulders more than twice the width of the head creates a strong-looking physique.

Determine the character's shoulder width depending on his or her physique and gender.

NARROW SHOULDERS

When drawing a slender physique, make the shoulders slightly less than two heads wide.

The Position of the Navel Is Determined by the Narrowing of the Waist

The navel is the most prominent part of the abdomen, and is the key to making the abdomen look realistic. It sits just below the point where the waist narrows. Make sure not to get the position wrong.

Navel position

Practical Tip

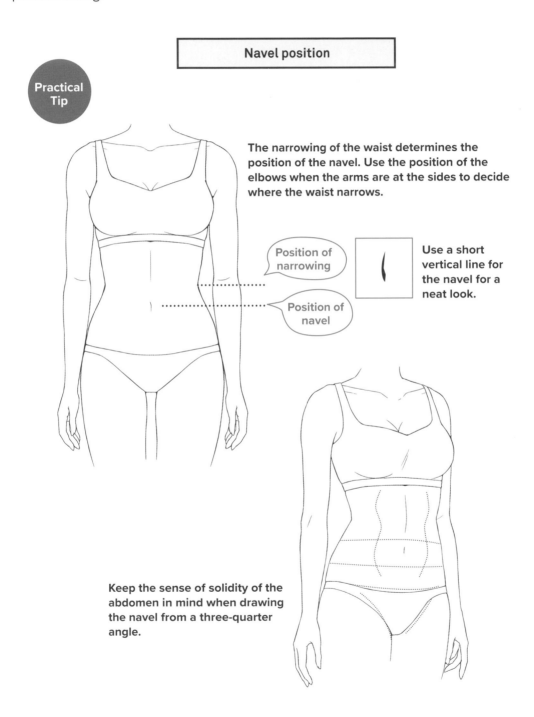

The narrowing of the waist determines the position of the navel. Use the position of the elbows when the arms are at the sides to decide where the waist narrows.

Position of narrowing

Position of navel

Use a short vertical line for the navel for a neat look.

Keep the sense of solidity of the abdomen in mind when drawing the navel from a three-quarter angle.

The Upper and Lower Sections of the Leg Should Be the Same Length

Drawing the thigh joint to the knee (upper leg) and the knee to the ankle (lower leg) the same length creates a realistic, natural balance. If drawing long legs, lengthen the section from the knee down.

Practical Tip

Leg proportion

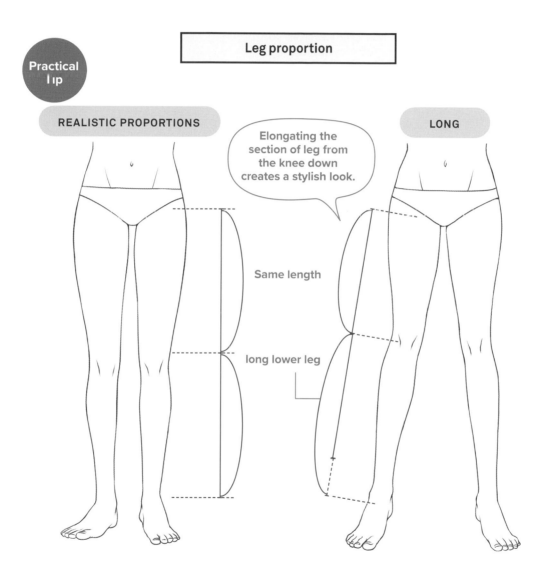

REALISTIC PROPORTIONS

Elongating the section of leg from the knee down creates a stylish look.

LONG

Same length

long lower leg

Here, the upper and lower legs are the same length, creating realistic proportions. Consider this to be the standard proportions.

Anime and manga characters often have legs that are longer from the knee down.

Angle the Neck Slightly

Beginners have a tendency to make the neck vertical, but in reality, it is slightly tilted on a diagonal angle. Viewed from the side, the line from the neck to the back is on a slight angle. Use a smooth curved line to draw the section from the neck to the back of the head for a natural look.

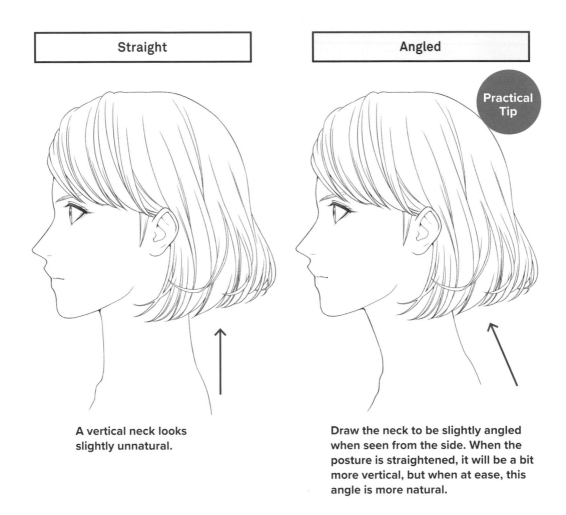

Straight	Angled

Practical Tip

A vertical neck looks slightly unnatural.

Draw the neck to be slightly angled when seen from the side. When the posture is straightened, it will be a bit more vertical, but when at ease, this angle is more natural.

TIP The standard neck is about half to just less than two-thirds the thickness of the head. Depending on the character, it can be tapered or slimmed even more.

When Seated on the Floor, the Figure's Height Is Half that of Its Standing Height

It's a good idea to learn height comparisons for when the figure is seated or bending over. For example, when seated on the floor with her knees bent, the figure will be half the standing height. When seated in a chair, it depends on the chair's height, but the figure should be about as tall as its usual chest height when standing.

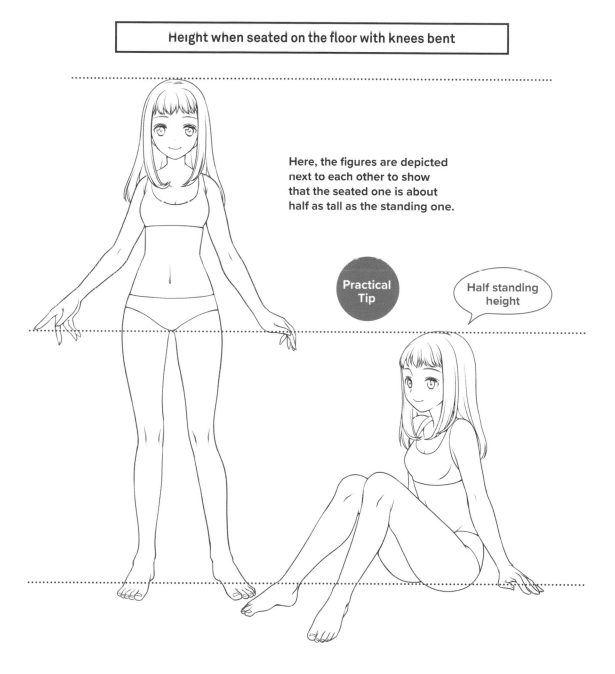

Height when seated on the floor with knees bent

Here, the figures are depicted next to each other to show that the seated one is about half as tall as the standing one.

Practical Tip

Half standing height

Use the Pelvis to Highlight Male and Female Differences

The pelvis plays a significant role in differentiating male and female physiques. As females have a wide pelvis, the line of the body broadens from the waist to the buttocks. The male pelvis is not that different from the width of the ribs, so the buttocks do not become larger and there is no narrowing in the waist.

Drawing males and females differently

Practical Tip

MALE PELVIS

FEMALE PELVIS

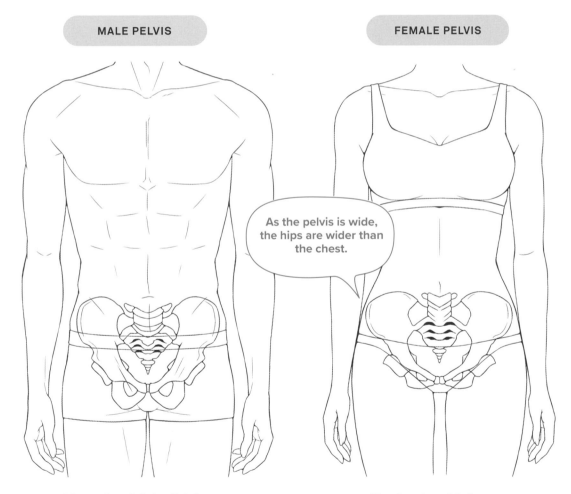

As the pelvis is wide, the hips are wider than the chest.

The male pelvis is slightly longer than that of the female pelvis.

The female pelvis is characterized by its width.

The Clavicle Extends Right up to the Shoulder

The collarbone extends right up to the shoulder. It doesn't particularly stand out, but drawing in small protrusions next to the shoulders makes for a realistic appearance. This gets simplified when drawing in a chibi or distorted style, but it's still good to visualize the position of the clavicle.

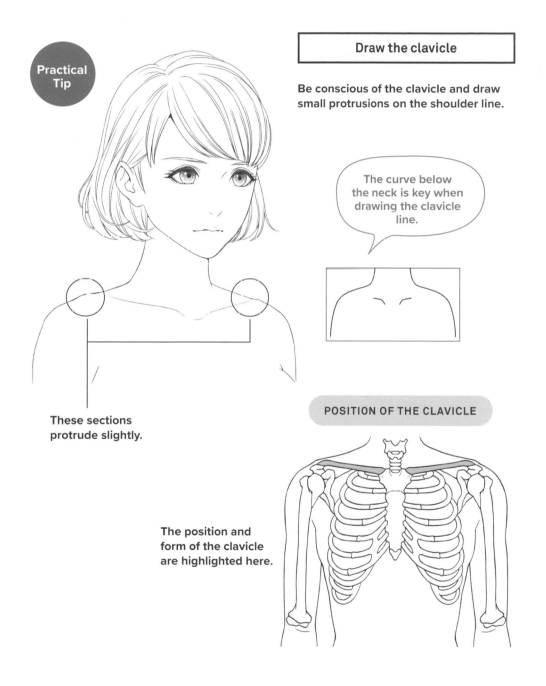

Practical Tip

Draw the clavicle

Be conscious of the clavicle and draw small protrusions on the shoulder line.

The curve below the neck is key when drawing the clavicle line.

These sections protrude slightly.

POSITION OF THE CLAVICLE

The position and form of the clavicle are highlighted here.

The Fingers Are Arranged in a Fan Shape

Drawing the fingers extending out in a fan formation creates a natural look. Line up the finger joints from the index to the little finger so that they are also in fan formation. In particular, be aware that if the second joints of the fingers are lined up straight, it will look unnatural.

Unnatural joints	Natural joints

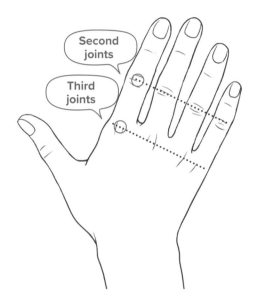

Second joints

Third joints

Practical Tip

If the second and third finger joints are lined up straight, it creates an unnatural appearance.

When the fingers are spread out, the line connecting the joints forms a fan shape.

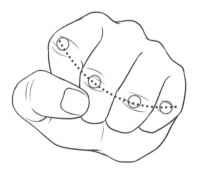

THE JOINTS WHEN THE HAND FORMS A FIST

Viewed from front on, when the hand forms a fist, the line connecting the second joints usually forms a fan shape.

When the Fingers Bend, the Palm Curves Too

The joint that connects the fingers to the palm of the hand (the third joint) is part of the palm. For this reason, when the fingers bend from this joint, the palm of the hand curves too. The thumb, in particular, has a broad base and has a large area of movement.

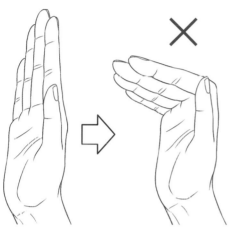

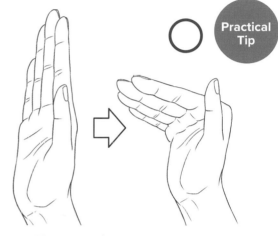

It's unnatural for only the fingers to bend.

The top section of the palm curves as if folding.

Practical Tip

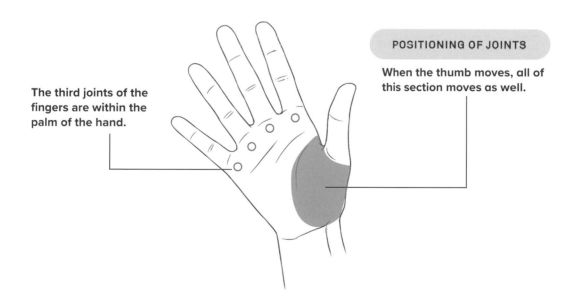

The third joints of the fingers are within the palm of the hand.

POSITIONING OF JOINTS

When the thumb moves, all of this section moves as well.

Bending Back the First Joint Brings Out Expression in the Hand

Bending back the area around the first joint of the fingers is a tried-and-tested way of lending expression to the hand. When bending the fingers, bend them from the second joint, visualizing the first joint bending as the result of being affected by that movement.

Fingers not bent back	Fingers bent back

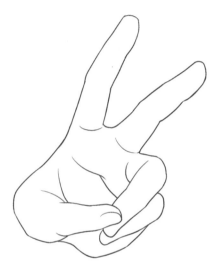

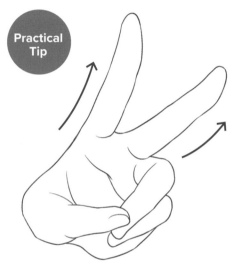

Practical Tip

The fingers are lightly bent when relaxed. Here, they look natural, but there is no sense of movement.

Bending the fingers back creates a dynamic look. Keep this in mind for a pose with vigor and movement.

Bending the fingers back makes them look longer and also draws more attention to them.

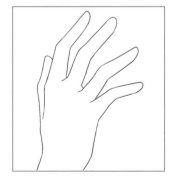

TIP When drawing simplified fingers, omit the first joint and bend the fingers from the second joint.

Building up the Trapezius Muscles Makes for a Well-Defined Look

The trapezius muscles are the group of muscles extending from the neck to the back. Training this group builds the muscles from the neck to the shoulders and creates a chiseled, well-defined physique. Apart from the trapezius muscles, building up the shoulders (deltoids), sides (latissimus dorsi) and chest (pectoral muscles) adds to this impression of strength.

Building up the trapezius muscles

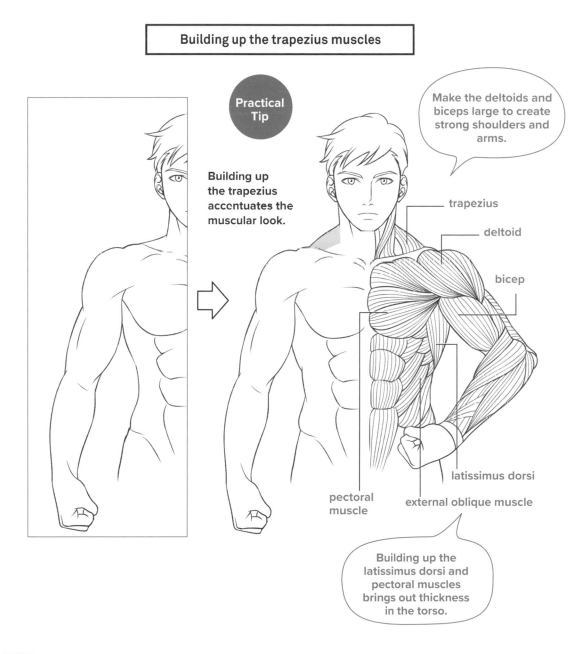

Practical Tip

Building up the trapezius accentuates the muscular look.

Make the deltoids and biceps large to create strong shoulders and arms.

trapezius

deltoid

bicep

latissimus dorsi

pectoral muscle

external oblique muscle

Building up the latissimus dorsi and pectoral muscles brings out thickness in the torso.

TIP Drawing the lines of the external oblique muscles creates a more muscular appearance.

The Flesh Is Thin Beneath the Collarbone

As the flesh is thin in the area beneath the clavicle, make it look slightly flat. Unless you keep this slightly flat section in mind when drawing, proportions will be affected, with the breasts being too high.

Without creating the flat section	Creating the flat section

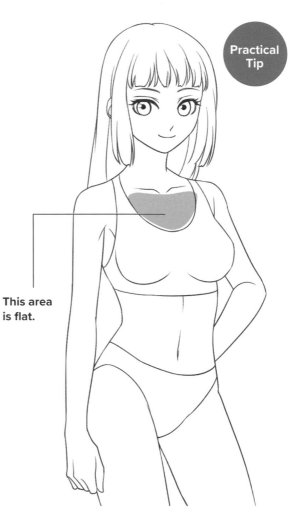

Practical Tip

This area is flat.

The chest should be positioned slightly lower for a natural look.

Creating a flat section beneath the clavicle makes for a natural position.

TIP Draw the breasts to point slightly outward rather than straight ahead.

Use a Bra Shape to Block in the Breasts

To create a realistic-looking chest for a female character, it's a good idea to draw a bra as part of the blocking in. As a bra is designed to naturally mold around the fullness of the breasts, it makes a good reference for accurately capturing their shape.

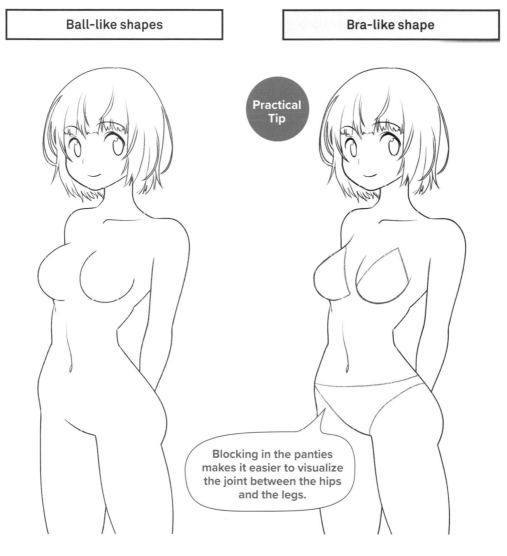

| Ball-like shapes | Bra-like shape |

Practical Tip

Blocking in the panties makes it easier to visualize the joint between the hips and the legs.

Depending on the style of illustration, breasts may be drawn in ball-like shapes, but this doesn't make for a realistic look.

Blocking in a bra makes it easier to visualize an accurate-looking bust.

Lesson 53

When Fully Bent, Elbows Are Pointed but Knees Are Not

When the arms are bent, the elbows appear pointed. This is because the protrusion in the humerus is visible. However, the knees shouldn't be depicted the same way. When bent, a slightly flat area forms on the knees.

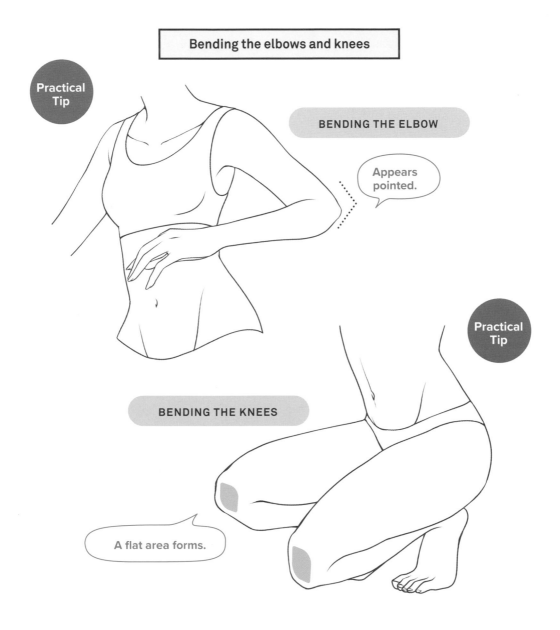

Bending the elbows and knees

Practical Tip

BENDING THE ELBOW

Appears pointed.

Practical Tip

BENDING THE KNEES

A flat area forms.

Use an S to Capture the Shape of the Legs

Using straight lines to draw the legs makes for a stiff, rigid look. Using a loose S shape makes it easier to create natural-looking legs. Softly curved lines make for legs that are realistic and dynamic.

Legs drawn with straight lines	Legs drawn with curved lines

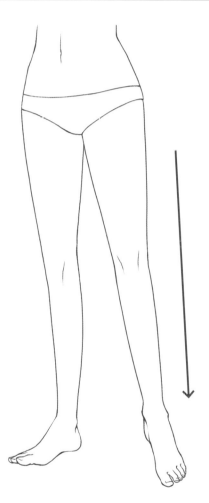

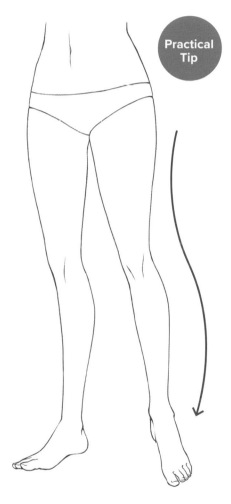

Practical Tip

Straight legs result in a picture that is lacking in a sense of movement.

Use a slight S-shaped curve to draw legs.

The Posture Supporting the Body Is Determined by the Line of Gravity

For drawings of standing figures, if the center of gravity is not correctly supported, the figure's posture will look unnatural. Think of the center of gravity as being just beneath the navel and draw a line coming straight down from it. This enables you to visualize more easily what kind of posture is necessary in order to support the figure's weight.

Center of gravity is not supported	In this example, it is

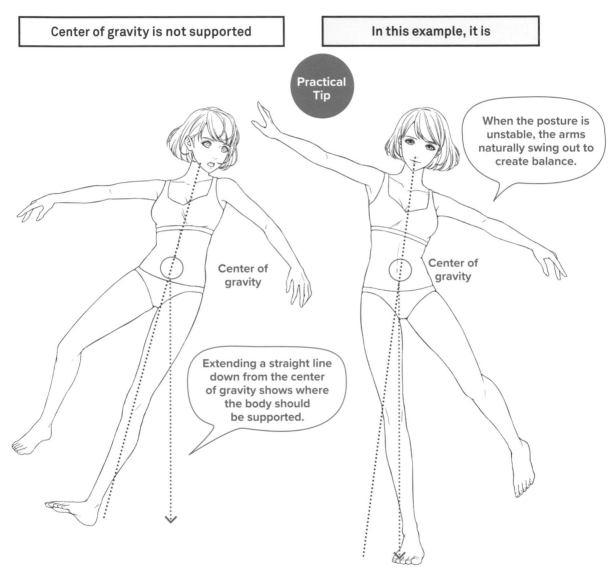

Practical Tip

Center of gravity

Center of gravity

When the posture is unstable, the arms naturally swing out to create balance.

Extending a straight line down from the center of gravity shows where the body should be supported.

If the line passing through the midline of the body is on an angle, the center of gravity cannot be supported unless the foot is on the side of the line.

The outside of the calves and the inside of the ankles are aligned roughly with the center of gravity.

Make the Outer Sides of the Calves Higher

The line of the legs is slightly complicated, but if you remember the rules, it will be easier to draw. Make the outer sides of the calves higher, the inner sides of the ankles higher and fill out the outer sides of the thighs.

Level calves	Calves with higher outer sides

Practical Tip

The line of the thighs that starts above the hips is fullest near the crotch.

When a figure is standing on one leg, it's best to place the supporting foot directly below the head.

The lower body with the calves and ankles drawn to be level. This works for a chibi-style illustration, but is slightly lacking in realism.

Turn the Drawing into a Silhouette to See Problems with Proportions

Changing the illustration into a silhouette allows you to see the overall size of the figure without being confused by lines. It makes it easier to tell if things are out of proportion in size or length. It's a technique you can use to check things such as whether one arm is longer or thicker than the other.

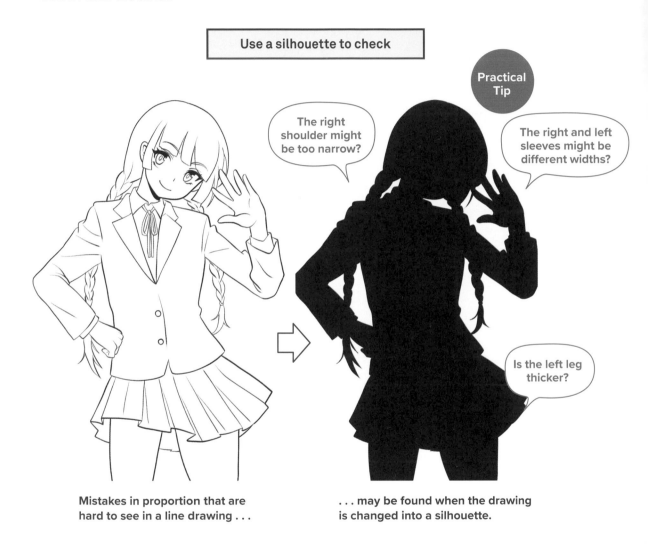

Use a silhouette to check

The right shoulder might be too narrow?

Practical Tip

The right and left sleeves might be different widths?

Is the left leg thicker?

Mistakes in proportion that are hard to see in a line drawing . . .

. . . may be found when the drawing is changed into a silhouette.

TIP If you can capture the figure as a solid form, it's easier to express its volume and weight.

Use a Rectangle to Check Perspective and Balance

When placing a figure against a background, drawing a rectangle to serve as a guide makes it easier to get perspective right. Drawing lines to connect diagonal corners makes it clear where the center is, thus helping to balance out the figure.

Use a rectangle to make supplementary lines

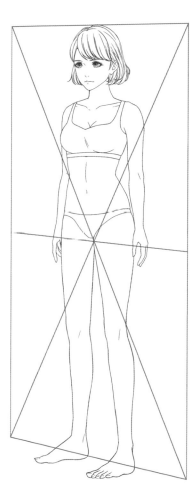

CONFIRM THE CENTER

 Practical Tip

Join the diagonal corners to work out the center and position the crotch there to make it easier to draw the entire body.

USE AS A GUIDE FOR TRICKY PERSPECTIVE

When the figure is prone and the head is closest to the viewer, perspective needs to be applied to the legs and feet. It's times like these when using a rectangle can be handy.

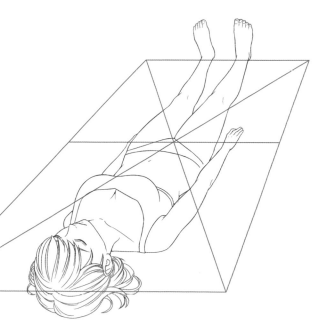

Block in Cylinders to Create a Sense of Solidity

When drawing figures, think of them as a series of cross-sections in order to capture them as solid forms. If it's difficult to visualize this, use cylinders to block in the cross-sections. It's useful to visualize cross-sections when drawing around the edges of clothing or adding creases.

Flat-looking figure	Solid-looking figure

Practical Tip

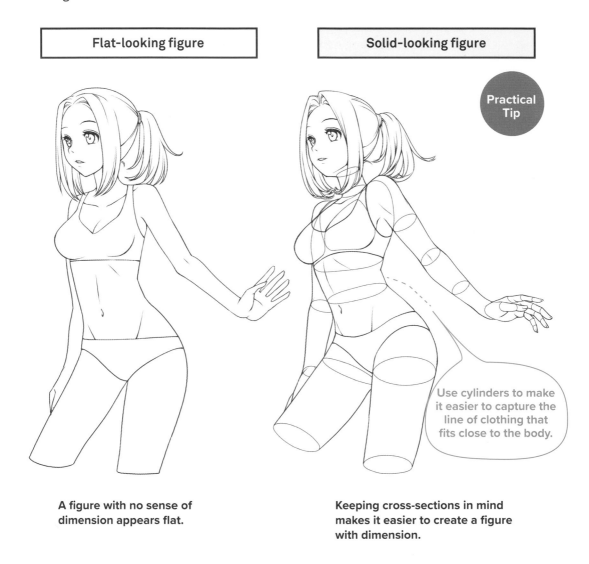

Use cylinders to make it easier to capture the line of clothing that fits close to the body.

A figure with no sense of dimension appears flat.

Keeping cross-sections in mind makes it easier to create a figure with dimension.

TIP It's easier to draw a realistic-looking wrist if you visualize it as being flat.

Chapter 2

Clothing and Other Items

In this chapter we look at some key points for drawing clothes, learn a few tricks for adding patterns to clothing and examine the wrinkly world of creases.

Sketch the Body Even if It Will Be Concealed by Clothing

Roughly sketch in the line of the body that will be covered by clothing in order to maintain the integrity of the sketch. It's particularly difficult to grasp the positions of arms and legs for characters wearing loose clothing, so at the rough sketch stage, it's best to think of them as being naked and then adding clothes to them.

Add clothing to a nude figure

Practical Tip

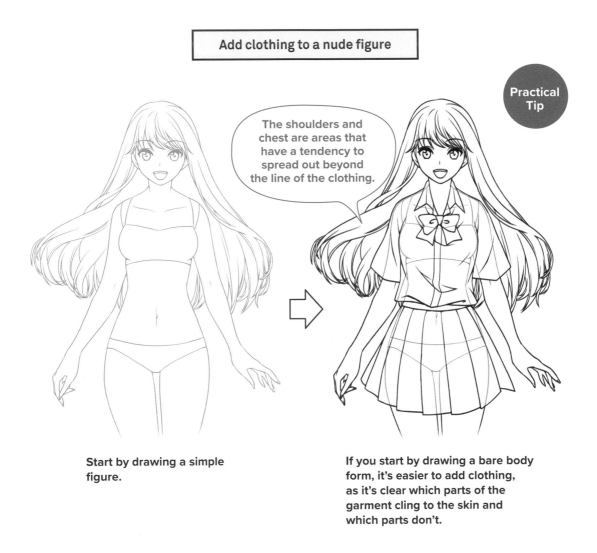

The shoulders and chest are areas that have a tendency to spread out beyond the line of the clothing.

Start by drawing a simple figure.

If you start by drawing a bare body form, it's easier to add clothing, as it's clear which parts of the garment cling to the skin and which parts don't.

TIP In digital illustration, working in two separate layers—bare figure and clothing sketched on—makes it easier to make corrections. Separate the rough sketches for the hair, facial features and facial outline into layers also.

Wrinkles in Clothing Form Around the Joints

Wrinkles in clothing tend to form around the joints, such as the shoulders, elbows, leg joints and knees. When the joints are bent, the fabric on the outer side is pulled taut while wrinkles form on the inner side.

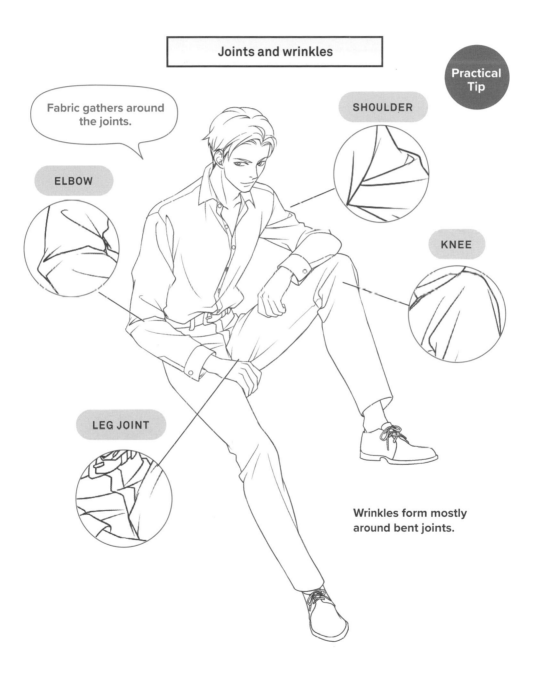

Joints and wrinkles

Practical Tip

Fabric gathers around the joints.

SHOULDER

ELBOW

KNEE

LEG JOINT

Wrinkles form mostly around bent joints.

It's Easier to Draw Wrinkles If You're Conscious of the Part of the Body Supporting the Fabric

When drawing clothing, visualizing the parts of the body that are supporting the fabric makes it easier to determine the position of wrinkles. The parts of the garments that fit close to the body don't tend to wrinkle, while sections that hang down form draped creases.

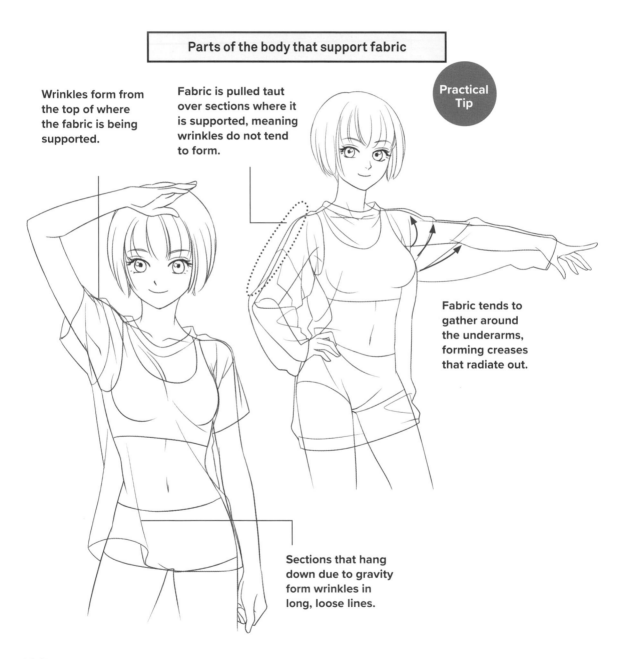

Parts of the body that support fabric

Wrinkles form from the top of where the fabric is being supported.

Fabric is pulled taut over sections where it is supported, meaning wrinkles do not tend to form.

Practical Tip

Fabric tends to gather around the underarms, forming creases that radiate out.

Sections that hang down due to gravity form wrinkles in long, loose lines.

TIP Use lines that are finer than the main lines for the wrinkles.

Use the Volume of Wrinkles to Convey the Thickness of the Fabric

As wrinkles don't tend to form in thick fabric, keep them to a minimum when drawing a suit made of heavy fabric. Keep the fabric in the area from the neck to shoulders pulled firmly for a good fit. Conversely, a lot of creases can indicate that the fabric is lightweight.

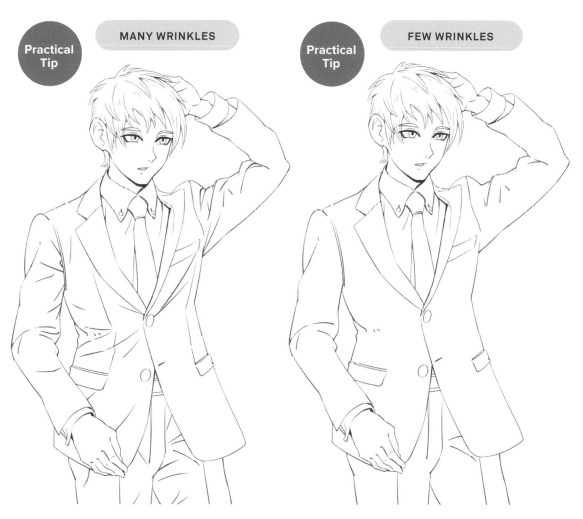

Use the amount of wrinkles to create difference

Practical Tip — MANY WRINKLES

Practical Tip — FEW WRINKLES

A suit with a lot of wrinkles appears to be made from lightweight fabric.

A suit with few wrinkles appears to be made from thicker fabric.

TIP Few wrinkles in a suit create a neat, tidy impression, while a very wrinkled suit makes for a rough, casual look.

There Are Rules About Clothes That You Should Know

Remembering the general theories about clothing, such as which side of a shirt overlaps the other and the number of buttons, will help you to bring your characters' outfits and ensembles to life. For example, men's shirts always have the buttons on the right-hand side.

Examples of rules

Practical Tip

OVERLAPPING

Western clothing

Men's clothing fastens with buttons on the right and women's clothing fastens with buttons on the left.

Japanese dress

In the case of Japanese dress, it is common practice for the left side to wrap over the right for both men and women. Wearing a garment with the right side wrapped over the left is reserved for the dead.

NUMBER OF BUTTONS

Shirts

On average, shirts have seven buttons.

Jackets

It's usual for jackets to have two buttons, although they often have three. It's considered good manners to leave the lowest button undone.

Japanese school uniform

It's usual for the jacket of this uniform to have five buttons.

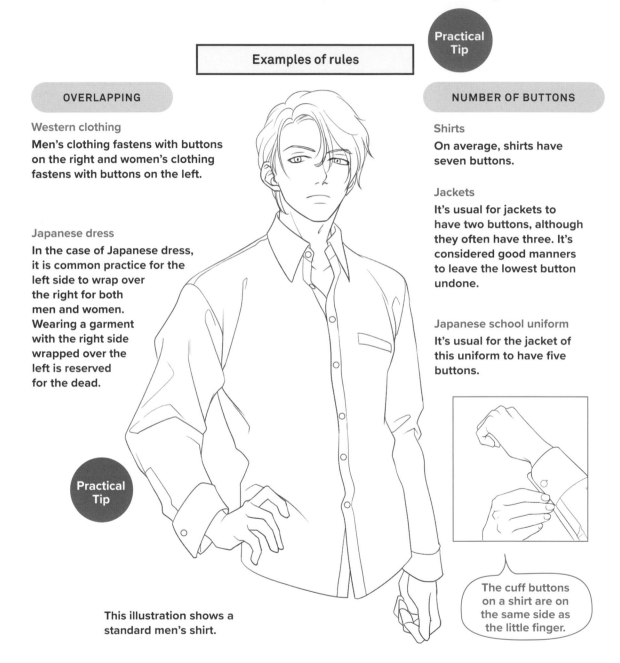

Practical Tip

This illustration shows a standard men's shirt.

The cuff buttons on a shirt are on the same side as the little finger.

LINGO **Overlapping** The part of the clothing where the left and right fronts overlap. **Bodice** The section of a garment that covers the body, excluding the collar and sleeves.

Learning Where Seams Are Positioned Makes It Easier to Draw Details

In order to draw clothing realistically, it's a good idea to look carefully at how clothes are constructed and learn the positions of the seams. On a shirt, there are seams around the collar, shoulders, cuffs, sides and pockets. The shoulder seams are particularly important because this is where the flow of wrinkles changes.

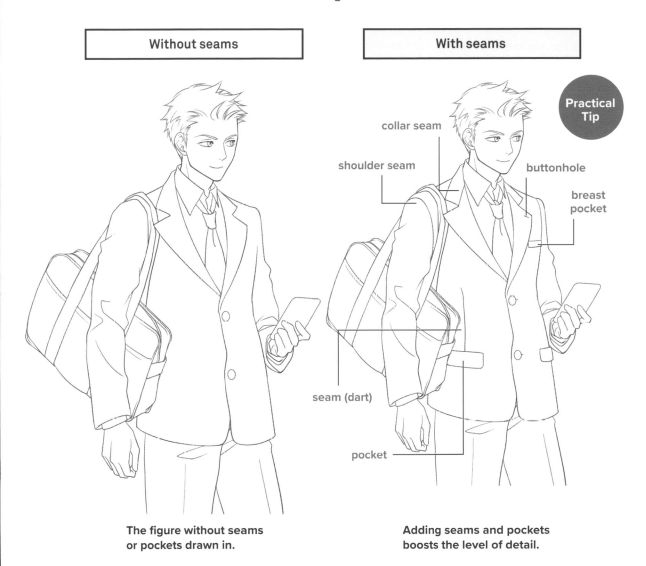

Without seams	With seams

Practical Tip

collar seam

shoulder seam

buttonhole

breast pocket

seam (dart)

pocket

The figure without seams or pockets drawn in.

Adding seams and pockets boosts the level of detail.

TIP Seams, like wrinkles, should be drawn using fine lines.

Use an Unconnected Line to Express Depth in the Line of the Collar

Drawing lines that don't connect to others is a way to express thickness or depth. You can add thickness to the collar, cuffs and folds of a shirt by adding in a line that ends before it connects to another one. Conversely, for expressing fine fabric, it's fine for lines to connect.

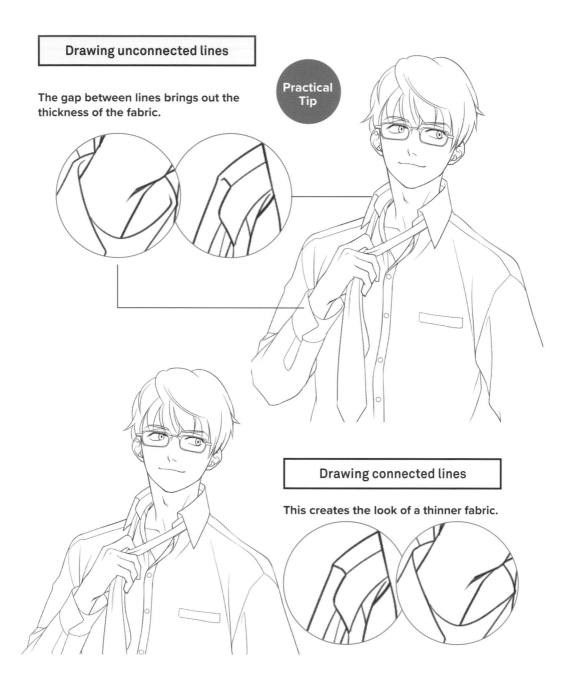

Drawing unconnected lines

The gap between lines brings out the thickness of the fabric.

Practical Tip

Drawing connected lines

This creates the look of a thinner fabric.

Dividing a Shirt Collar into Two Parts Makes It Easier to Draw

The collar of a shirt is on a slight angle, making it surprisingly difficult to capture its shape and sense of solidity and dimension. When it's hard to visualize it in three dimensions, dividing it into the collar and wing sections makes it easier to draw.

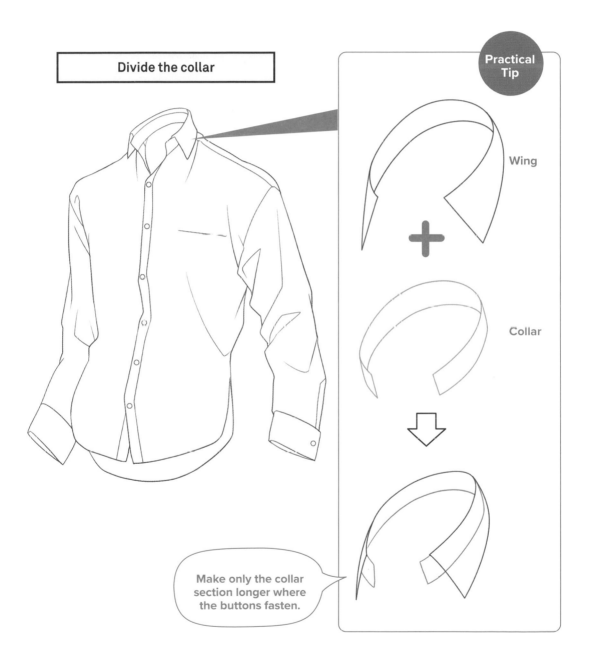

Divide the collar

Practical Tip

Wing

Collar

Make only the collar section longer where the buttons fasten.

Make Drawing a Skirt Easier by Starting from the Hem

For a skirt with multiple pleats, it's easier to start drawing from the hem. In terms of the order of drawing, begin with a cone-like shape for the skirt overall, then draw the line for the hem and the vertical lines of the pleats. This method of starting from the hem can also be used for skirts with frills.

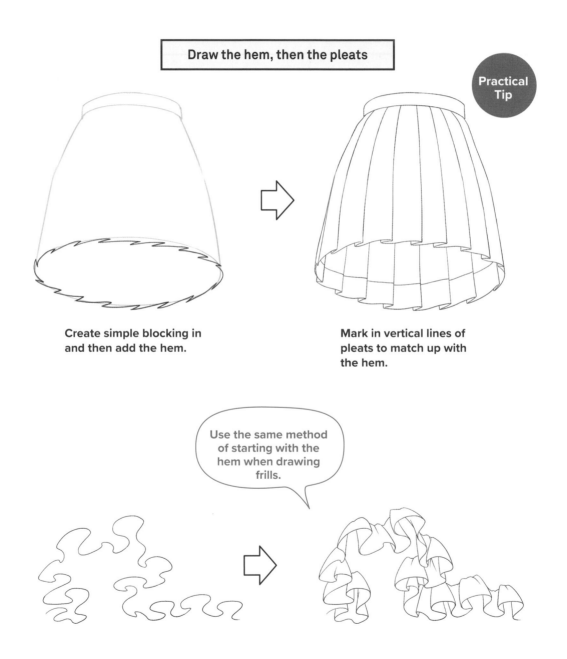

Draw the hem, then the pleats

Practical Tip

Create simple blocking in and then add the hem.

Mark in vertical lines of pleats to match up with the hem.

Use the same method of starting with the hem when drawing frills.

Use Patterns on Clothing to Accentuate the Line of the Body

Patterns on clothing such as horizontal or vertical stripes can be used to emphasize the curves and contours of the body that don't show in the outline, such as the shape of the chest. If adding only shadow to a figure seems insufficient, use pattern to add greater visual complexity.

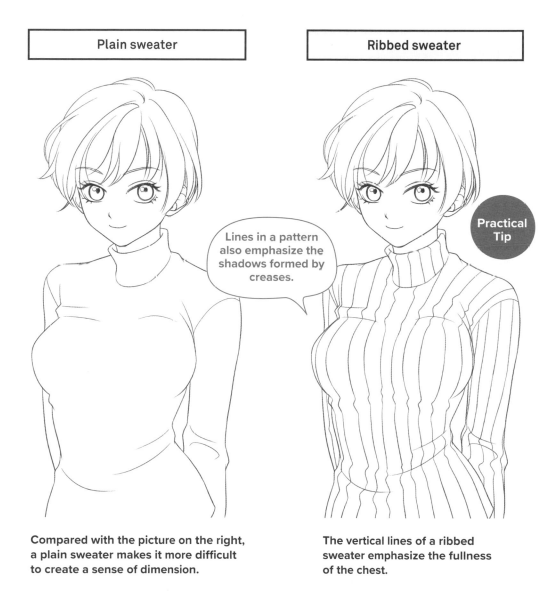

| Plain sweater | Ribbed sweater |

Lines in a pattern also emphasize the shadows formed by creases.

Practical Tip

Compared with the picture on the right, a plain sweater makes it more difficult to create a sense of dimension.

The vertical lines of a ribbed sweater emphasize the fullness of the chest.

TIP Some garments have straps that accentuate the line of the body, such as overalls.

Creating Differences in Flower Sizes for Floral Patterns to Achieve a Balanced Look

When drawing floral patterns, making the flowers different sizes prevents the pattern from becoming repetitive and makes it easier to create a sense of balance. In digital illustration, it's easy to copy and paste the floral motif you've drawn to create a pattern.

Floral pattern comprising large, medium and small flowers

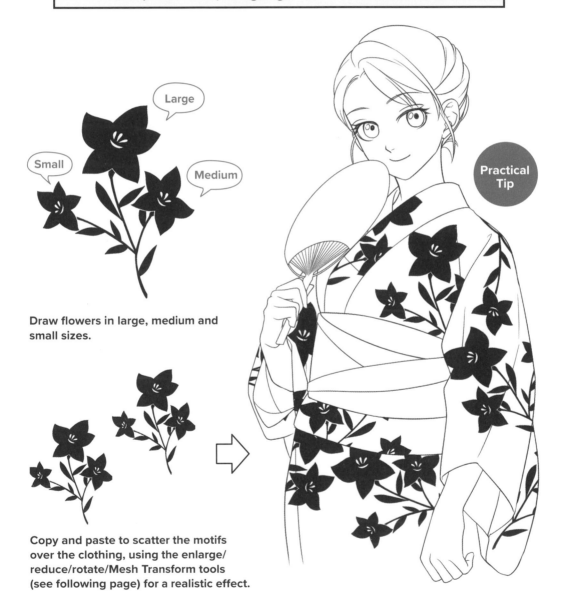

Large

Small

Medium

Draw flowers in large, medium and small sizes.

Practical Tip

Copy and paste to scatter the motifs over the clothing, using the enlarge/reduce/rotate/Mesh Transform tools (see following page) for a realistic effect.

Use the Transform Function to Match a Pattern to Its Shape

When pasting a pattern onto clothing, it's necessary to transform it to fit the curves and contours of the body and clothing. The Mesh Transform function makes this easier by allowing you to shift the grid guide around to transform complicated shapes.

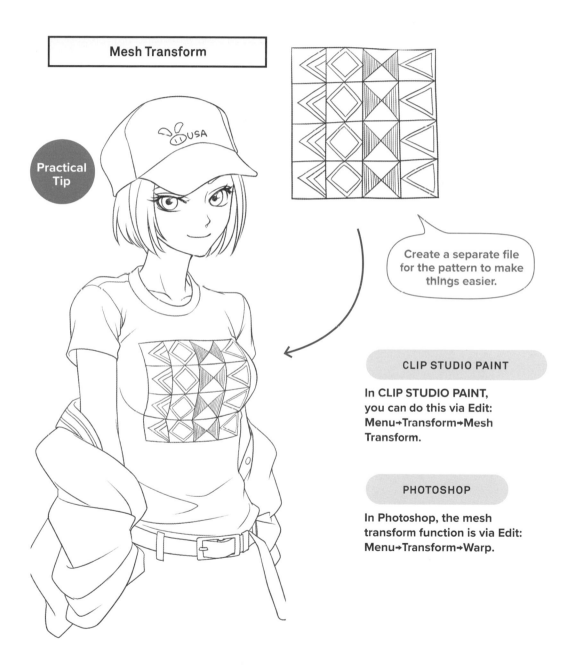

Mesh Transform

Practical Tip

Create a separate file for the pattern to make things easier.

CLIP STUDIO PAINT

In CLIP STUDIO PAINT, you can do this via Edit: Menu→Transform→Mesh Transform.

PHOTOSHOP

In Photoshop, the mesh transform function is via Edit: Menu→Transform→Warp.

Position Hats So They Tilt Toward the Back

When drawing characters with hats, tilt the hat slightly to the back so that the character's face can be clearly seen. Make the part where the brim or peak joins the hat sit just above the eyebrows.

Hat positioned flat	Hat tilted to the back

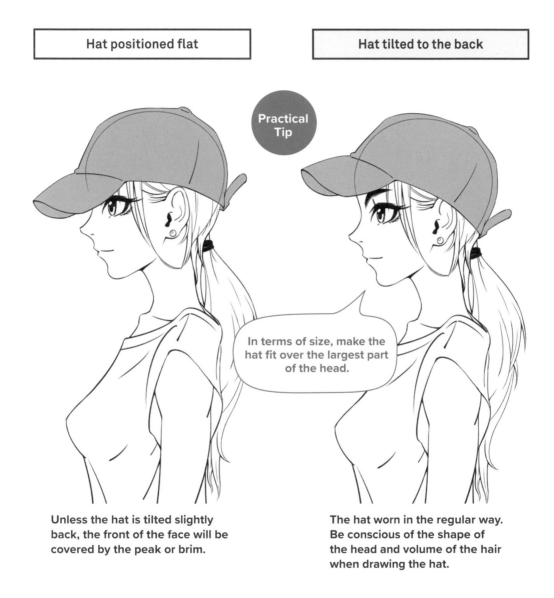

Practical Tip

In terms of size, make the hat fit over the largest part of the head.

Unless the hat is tilted slightly back, the front of the face will be covered by the peak or brim.

The hat worn in the regular way. Be conscious of the shape of the head and volume of the hair when drawing the hat.

TIP If the hat is pulled down over the face, it gives off the vibe that the character is hiding his or her true identity. This works for mysterious characters or shadowy figures.

Use the Lines of the Clothes to Create a Sense of Movement

The line of trajectory that represents motion is called the motion curve. If you make use of this curve when drawing the lines of hair and clothing, you can create a sense of movement and a feeling of dynamism. It makes it easier to convey the fluttery motion of long hair, skirts and strips of ribbon.

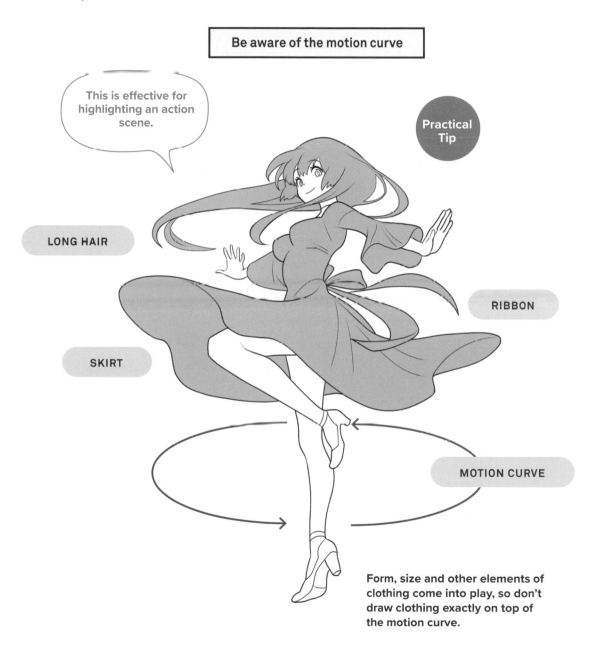

Be aware of the motion curve

This is effective for highlighting an action scene.

Practical Tip

LONG HAIR

RIBBON

SKIRT

MOTION CURVE

Form, size and other elements of clothing come into play, so don't draw clothing exactly on top of the motion curve.

Make Hair and Clothing Flutter in the Breeze

Even when a character is standing in a simple pose, you can create a dramatic impression by making clothing and hair flutter in the breeze. Skirts in particular are easy to animate with this kind of motion.

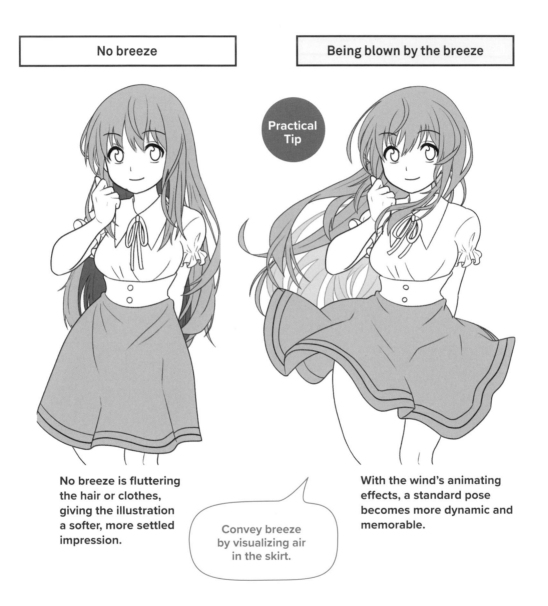

No breeze

Being blown by the breeze

Practical Tip

No breeze is fluttering the hair or clothes, giving the illustration a softer, more settled impression.

With the wind's animating effects, a standard pose becomes more dynamic and memorable.

Convey breeze by visualizing air in the skirt.

TIP Strong wind can be used as an effect to create a scene, expressing a change of heart or a hardship.

Block in Both Halves of Eyeglasses at Once to Make Them Easier to Draw

When drawing glasses, if you block in the right and left separately, it will be hard to get the balance correct. Using a long rectangle to block in both the right and left lenses at the same time makes drawing glasses much easier.

Block in a long rectangle

Practical Tip

Draw in the lower frame to be ⅓ of the way between the upper frame and the chin.

Fill in details after blocking in both lenses.

TIP Compared with the human figure, manufactured objects such as glasses stand out more if the use of perspective is incorrect. Blocking in with a rectangle makes it easier to get perspective right.

Design Items for the Character Before Incorporating Them into Illustrations

When drawing a character holding an item or object, if you attempt to draw everything all at once in the first illustration, the result will be vague and unclear. You will be unsure about the design and finer details of the object. Instead, firm up the design of the item on a separate piece of paper first.

Indecisive drawing	Drawing after designing

Practical Tip

Drawing without a design clearly in mind tends to yield a half-baked result.

Have some idea of the design in mind when drawing, then add in more details after checking the balance between the character and the object.

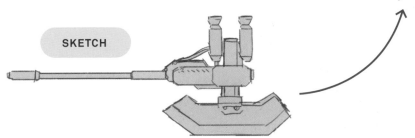

SKETCH

TIP When creating your own original outfits, hairstyles and accessories, sketch them first too in order to consider the design.

Use Objects' Positions to Guide the Viewer's Eye

Including items that attract the eye in illustrations allows you to create points of interest other than just the face. It's possible to direct the eye to various spots to showcase the entire illustration.

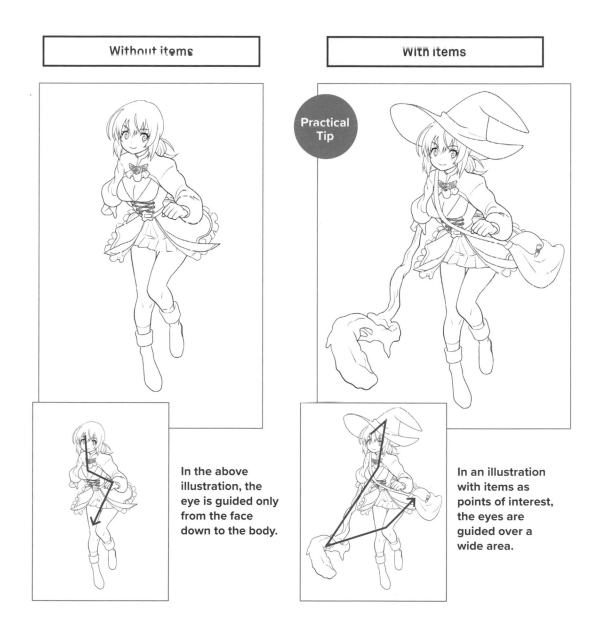

Without items

With items

Practical Tip

In the above illustration, the eye is guided only from the face down to the body.

In an illustration with items as points of interest, the eyes are guided over a wide area.

Items of a Reasonable Size Are Easy for Characters to Hold

Poses that incorporate items placed near the mouth are another way of introducing motion and detail. Small items that are easy to hold don't get in the way even when placed near the face, they're well-suited for this.

POPSICLE

Popsicles and candy are items often seen in illustrations of young women.

CANDY

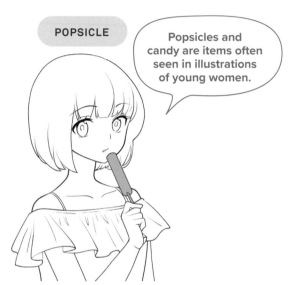

A standard item that works well in summer.

Tip Variation

Brings out a character's youthfulness.

PHONE

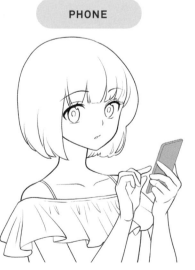

Gives a sense of the everyday.

LIPSTICK

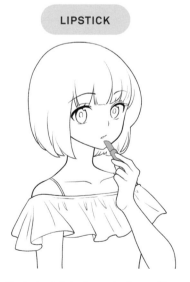

To suggest a character's vanity or physical attributes.

Food Looks Better When Colors Are Saturated

Color saturation is key to making food look appealing. Bright colors are psychologically appealing because they evoke a sense of freshness and activity. Making the shadows on food gray will lower the level of saturation, so be cautious when you reach this stage.

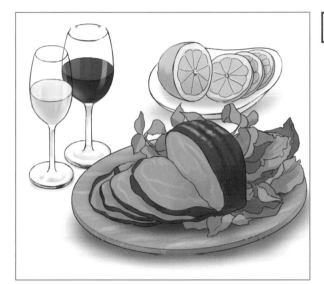

Low saturation

Low levels of saturation make for an unappetizing look.

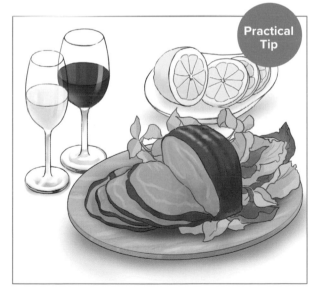

Practical Tip

High saturation

Using highly saturated color creates an appetizing look. Use a fresh green for the leaves and a vivid red for the meat.

Adjust the highlights so that the colors appear brighter and more vibrant.

TIP It's common for saturation levels to be boosted in photos for gift catalogs, menus and ads to make food look appetizing. Use them as a reference.

Items Scattered Through the Illustration Bring out Emotion

Scattering items such as fluttering petals creates movement and can infuse the illustration with a sense of emotion. Snow and leaves are other common choices. Not only do they add a sense of cohesion and a dynamic flow, these elements allow subtler scenes to be more successfully suggested.

No effects	Flowers falling

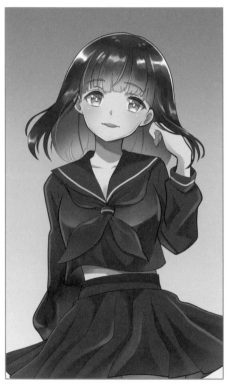

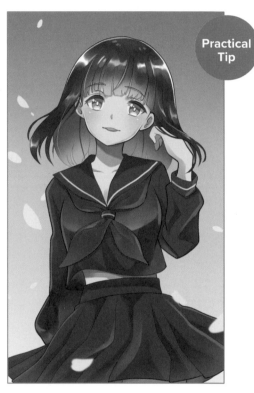

Practical Tip

Compared with the illustration at right with the petals falling, this illustration appears calm and subdued.

A gentle breeze makes for a calm impression, while a strong wind can strike sharper tones, bringing out a note of sadness or a sense of urgency.

If depicting petals scattered at random, make sure they don't end up becoming too uniform.

TIP Backgrounds may be similar in that they have flowers scattered through them, but they can create a completely different impression depending on the directionality of the illustration. For example, in an illustration of a cheerful, active character, flowers create a flamboyant look, while with a calm, quiet character, flowers lend a subdued feel.

Chapter **3**

Digital Line Drawing and Painting

Let's look at various tips for drawing
with digital tools, from line drawing
to completing your characters or scene.

Adjust Image Stabilization to Make Drawing Lines Easier

Paint tools such as CLIP STUDIO PAINT and Photoshop have functions that reduce blurring. Set it up for each brush in order to draw neat lines. It's best to experiment with drawing to adjust the settings to suit you, as the appropriate values vary from person to person.

Incorporating image stabilization

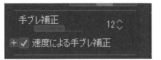
CLIP STUDIO PAINT

手ブレ補正　　　　12

☑ 速度による手ブレ補正

Practical Tip

In CLIP STUDIO PAINT blurring can be reduced by selecting "image stabilization" within the brush.

Choose "correction" from the "sub tool details" palette to further fine tune the settings.

PHOTOSHOP

滑らかさ : 15%

In Photoshop, set the "smoothness" value in each brush.

TIP In the case of CLIP STUDIO PAINT, settings such as "after correction" to correct lines after drawing and "sweep" to get rid of the fine lines that form after lifting the pen away from the tablet can also be adjusted. Both of these can be set up in the "sub tool details" palette "correction" category.

Vary the Thickness of the Line for a Dynamic Look

Varying the thickness of the line allows you to bring out a sense of dimension and makes the silhouette stand out. Use a thicker line for the outline and other main lines and a thin line for the wrinkles in clothing, the lines of muscles and other details.

No variation in thickness	Variation in thickness

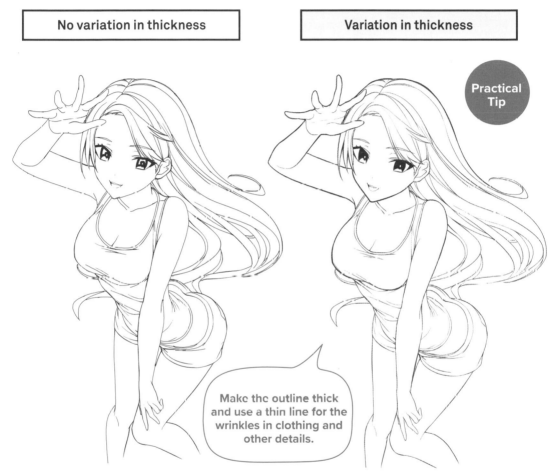

Practical Tip

Make the outline thick and use a thin line for the wrinkles in clothing and other details.

Lack of variation in the thickness of the line creates a flat impression. However, from a design point of view, some illustrations intentionally use lines of unified thickness.

The main lines should be thicker, but here, this is taken further by making the main lines closest to the viewer thick and the main lines farther away finer in order to create a sense of perspective.

TIP The appropriate brush size depends on the size of the canvas. Make test strokes on each canvas and set the brush size to the appropriate thickness.

Tapering in and out Creates Liveliness in the Line

Starting a line to be very fine, gradually thickening it and then making it fine again to complete it is called tapering. A line with tapering has variation and creates a livelier impression than one which is uniform throughout.

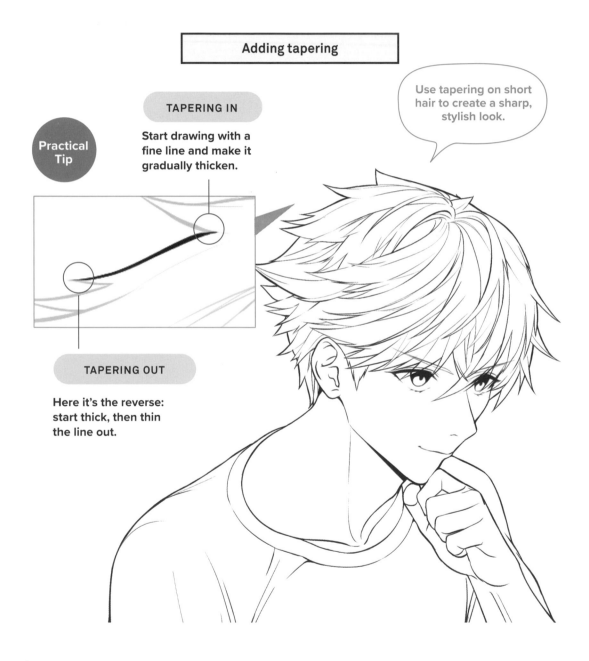

Adding tapering

Practical Tip

TAPERING IN

Start drawing with a fine line and make it gradually thicken.

Use tapering on short hair to create a sharp, stylish look.

TAPERING OUT

Here it's the reverse: start thick, then thin the line out.

TIP When joining short lines together to form a long line, using tapering makes it easier to connect them.

Trim Back Rough Lines to Neaten Them

For rough lines, use the "eraser" tool to make adjustments and neaten them. This easy correction technique is an advantage specific to digital tools. You can also use it to draw lines thickly on the assumption that you'll later clean up areas that have become distorted or whose shape needs adjusting.

Neatening rough lines

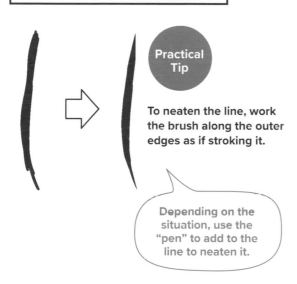

Practical Tip

To neaten the line, work the brush along the outer edges as if stroking it.

Depending on the situation, use the "pen" to add to the line to neaten it.

In CLIP STUDIO PAINT, use either the "eraser" tool on the "hard" setting or set the "pen" to a transparent color to make corrections.

In Photoshop, set the "eraser" tool mode to "brush" to make corrections.

MAKE A THICK LINE ON PURPOSE AND NEATEN IT LATER

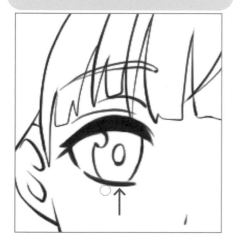

Mark in a thick line.

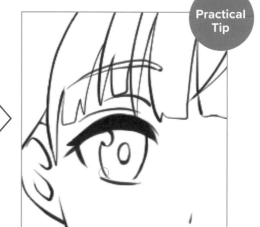

Practical Tip

Use the "eraser" to make changes.

Creating Pools of Ink Brings out Light and Dark in a Line Drawing

Creating pool-like sections of ink makes for variation in a line drawing. Ink pools are formed in areas where lines cross or which are farthest from the viewer. Those that are like small shadows bring out depth and can be used to give the drawing a sense of solidity.

Practical Tip

Creating ink pools

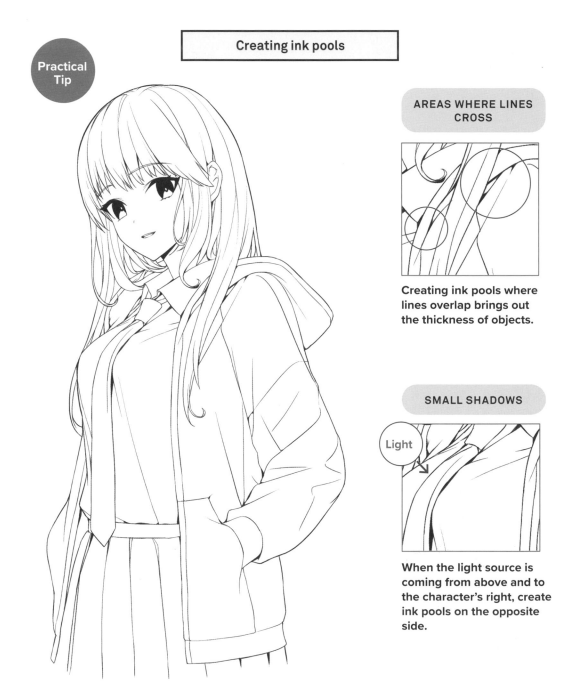

AREAS WHERE LINES CROSS

Creating ink pools where lines overlap brings out the thickness of objects.

SMALL SHADOWS

Light

When the light source is coming from above and to the character's right, create ink pools on the opposite side.

Use Your Arm, Not Your Wrist, When Drawing Long Lines

It's best to use your arm when making long strokes. For detailed areas, it may be easier to use your wrist, but for long lines, stabilizing the wrist and moving the arm makes it easier to create neat results.

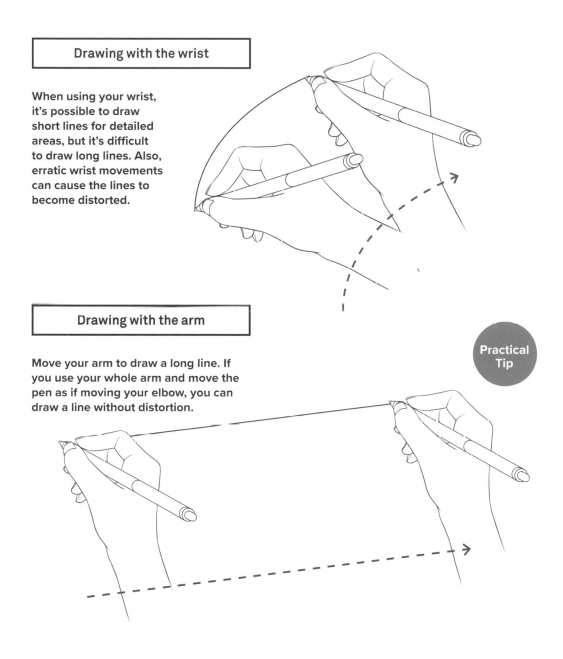

Drawing with the wrist

When using your wrist, it's possible to draw short lines for detailed areas, but it's difficult to draw long lines. Also, erratic wrist movements can cause the lines to become distorted.

Drawing with the arm

Move your arm to draw a long line. If you use your whole arm and move the pen as if moving your elbow, you can draw a line without distortion.

Practical Tip

TIP If you enlarge the canvas view too much, it will be difficult to draw a long line. If that's the case, try shrinking the display.

Look at the End Point, Not at the Tip of the Pen When Drawing a Line

When drawing a line, one tends to look at the area being drawn, but doing this limits the range of vision, making it difficult to see the overall picture. In order to make lines turn out the way you intend, look at the point where the line will end and move the pen accordingly.

Looking at the area being drawn

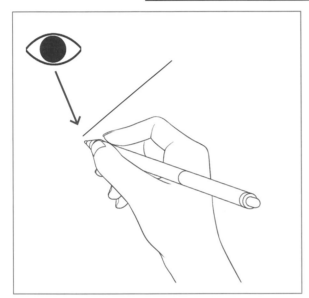

If you only look at the area being drawn, it's difficult to notice when the lines go off in the wrong direction.

In analog terms, this is like looking only at your hand.

Look at the end point of the line

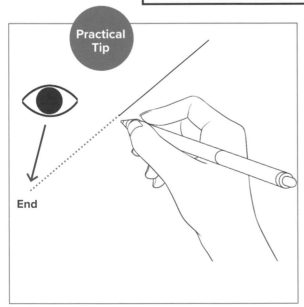

Practical Tip

Imagine where the end point of the line is and keep it in your field of vision to create a neat line.

End

Tilt the Canvas to Make It Easier to Draw Lines That Are on a Difficult Angle

It may be difficult to move your wrist or arm, depending on the angle of the canvas. If you're having trouble creating lines, rotate or reverse the image that you are working on so that it is on an angle that is easier to work with.

"NAVIGATOR" PALETTE (CLIP STUDIO PAINT)

Practical Tip

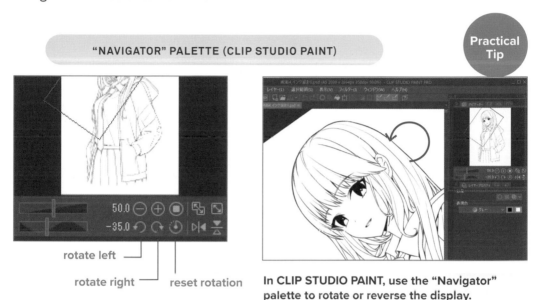

rotate left

rotate right reset rotation

In CLIP STUDIO PAINT, use the "Navigator" palette to rotate or reverse the display.

Practical Tip

"ROTATE VIEW" TOOL (PHOTOSHOP)

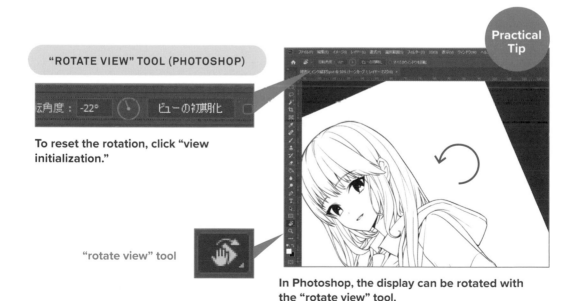

To reset the rotation, click "view initialization."

"rotate view" tool

In Photoshop, the display can be rotated with the "rotate view" tool.

TIP It's helpful to remember the shortcut for rotating the view in CLIP STUDIO PAINT.

For Thick Lines That Are Difficult to Draw, Make an Outline First

It's difficult to draw thick lines that narrow and widen neatly, but drawing an outline and then filling in the center makes for a neat result. In the same way, you can draw thick eyelashes by creating outlines and filling them in.

Make outlines around lines

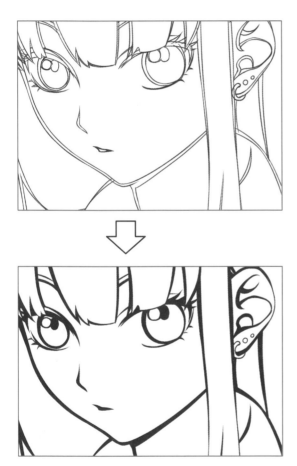

Practical Tip

Making an outline and filling in the center allows you to draw thick lines neatly.

Display the Sketch in Blue to Make It Easier to Clean Up

Displaying the sketch in blue makes it easier to distinguish between the sketch and the clean copy, making cleaning up easier. You can work in blue when creating the sketch, but depending on the paint tool, there is also the option to easily change the lines to be displayed in blue. You can also lower the opacity level of the layer to make it thinner, which makes it easier to clean up as well.

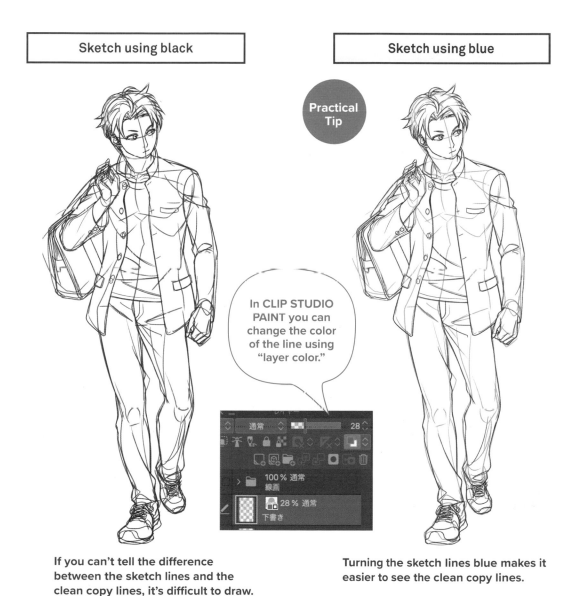

| Sketch using black | Sketch using blue |

Practical Tip

In CLIP STUDIO PAINT you can change the color of the line using "layer color."

If you can't tell the difference between the sketch lines and the clean copy lines, it's difficult to draw.

Turning the sketch lines blue makes it easier to see the clean copy lines.

TIP In Photoshop, you can place a layer painted blue over the top of the illustration and clip it. You can also use the color correction, hue & saturation and color unification functions to adjust the hue, saturation and brightness levels until all the lines are blue.

Digital Line Drawing and Painting

Using Vector Layers for the Line Drawing Makes Correction Easier

Vector images are an image format that allow the form and thickness of lines to be corrected. In particular, CLIP STUDIO PAINT has vector layers with a function that allows for instant correction of lines that are sticking out too far, making it useful when creating line drawings.

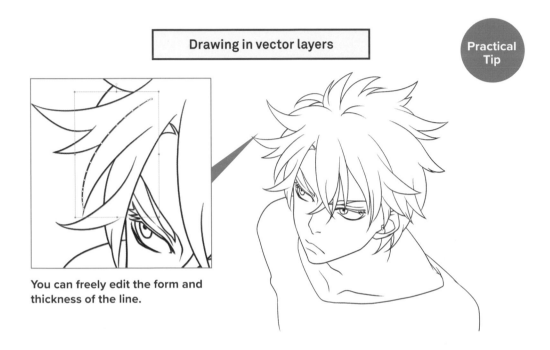

Drawing in vector layers

Practical Tip

You can freely edit the form and thickness of the line.

ERASER FOR VECTORS ONLY (CLIP STUDIO PAINT)

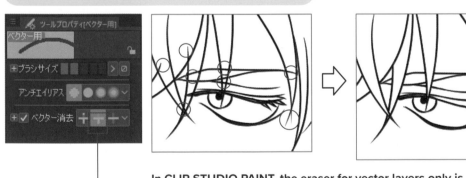

Up to the point of intersection

In CLIP STUDIO PAINT, the eraser for vector layers only is in [eraser] tools [for vectors]. If you turn on the settings to [up to the point of intersection] simply touching the line will correct any protruding sections.

TIP Vector layers and erasers "for vectors" are functions unique to CLIP STUDIO PAINT.

Use the Pen and Eraser to Create Brush-Like Lines

By correcting thick lines, it's possible to create the blurred touch of brushstrokes. Doing this leaves eraser residue like wood shavings, but by allowing it to remain, it creates a hand-drawn feel resembling splashes of ink.

Use the eraser to shave down the lines

Practical Tip

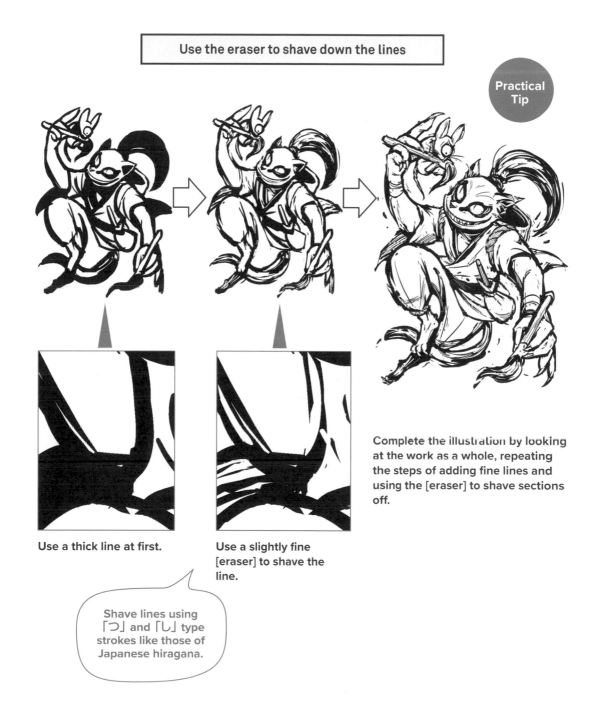

Use a thick line at first.

Use a slightly fine [eraser] to shave the line.

Shave lines using 「つ」 and 「し」 type strokes like those of Japanese hiragana.

Complete the illustration by looking at the work as a whole, repeating the steps of adding fine lines and using the [eraser] to shave sections off.

Stick Paper to a Pen Tablet to Stop the Pen from Slipping

If you stick paper to a pen tablet (or board tablet), it will prevent the pen from slipping and you can create the sense of drawing on paper. It will start to scrunch up after a while, so make sure to change the page regularly.

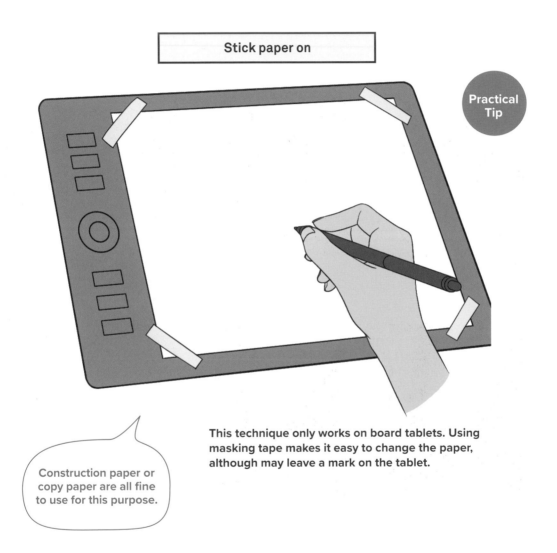

Stick paper on

Practical Tip

Construction paper or copy paper are all fine to use for this purpose.

This technique only works on board tablets. Using masking tape makes it easy to change the paper, although may leave a mark on the tablet.

TIP You can also stick a commercially available protective sheet to the tablet to prevent the pen from slipping (protective sheets are sold for both LCD and board type tablets).

Use Layer Masks to Make Corrections

Layer masks conceal the image as if it has been erased, but as the original image remains, it can be reactivated later. This method is easier to recorrect than if the image were removed with an eraser.

Correcting with a layer mask

Practical Tip

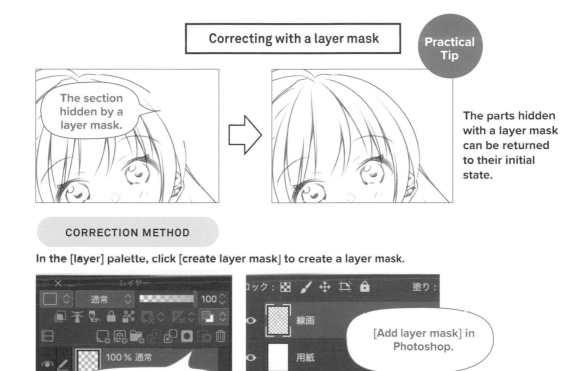

The section hidden by a layer mask.

The parts hidden with a layer mask can be returned to their initial state.

CORRECTION METHOD

In the [layer] palette, click [create layer mask] to create a layer mask.

[Create layer mask] in CLIP STUDIO PAINT.

[Add layer mask] in Photoshop.

The layer mask icon.

Masking using the [eraser].

Use a brush to deactivate the mask.

When you select the layer mask icon you can edit the concealed (masked) area. If you use [eraser], items will be masked, but they will be displayed again when you use a brush.

Use Gaps in the Lines for Tears and Sweat to Bring out a Sense of Translucency

When drawing tears or sweat, leaving gaps in the line allows a sense of translucency to be expressed. When drawing the tracks of tears, keep the solidity of the face in mind and draw arced lines.

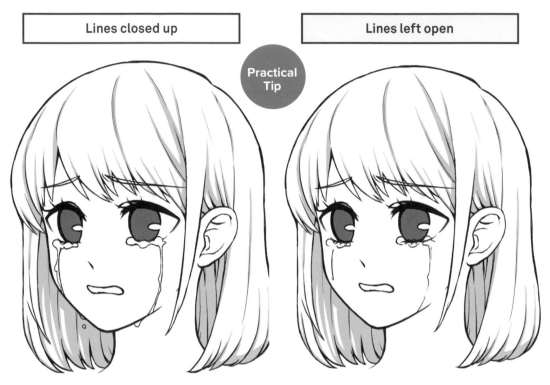

Lines closed up

Lines left open

Practical Tip

It's not the case that closing up the lines is a mistake. Although there is no sense of translucency, it does have the effect of making the volume of tears appear larger.

When doing a line drawing, gaps in the line express light and bring out a sense of translucency.

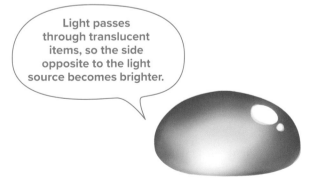

Light passes through translucent items, so the side opposite to the light source becomes brighter.

TIP Making the outside of a drop of water dark and adding in clearly defined highlights creates a sense of dimension. When drawing tears in color, visualize them as drops of water.

Reverse the Sketch to Find Irregularities

Reversing the image allows you to see distortions that you may not have noticed. You may have heard of people drawing on paper checking the image by holding the reverse side of the paper up to the light. When drawing digitally, you can check the canvas with the reverse view function instead.

Reverse the image to check it

Reverse the image and check for distortions in the outline and differences in the eyes and other features.

CLIP STUDIO PAINT

Click [reverse image] in the [navigator] palette, or from the [edit] menu, go to [rotate or reverse canvas] → [reverse image].

Reverse image

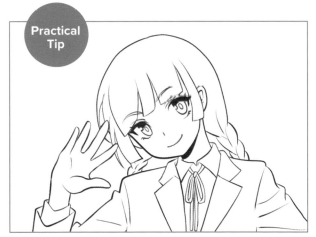

Practical Tip

PHOTOSHOP

From the [Image] menu, go to [rotate image] → [reverse canvas].

TIP It's handy to create shortcuts for functions that you use often, such as [reverse image].

Use the Modification Tools to Correct the Sketch While Maintaining Balance

Sometimes it's better to process the data digitally with modification functions so that you can make objective judgments while making corrections. Adjusting the size of the eyes or the angle of the hands are two examples. The image may become messy due to the modifications, but if it's at the sketch stage there's no need to worry.

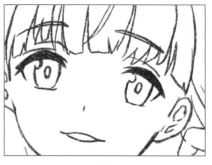

Use modification to correct

Use the modification functions to correct balance, such as making sure the left and right eyes match. Here, the line drawing for the eyes is modified to adjust the size and position.

CLIP STUDIO PAINT

[Edit] menu [Modify] → [Enlarge·Reduce] Rotate `Ctrl` + `T` or [Modify freely] `Ctrl` + `T` is useful.

PHOTOSHOP

[Edit] menu [Freely modify `Ctrl` + `T` is effective. Pressing the `Ctrl` key while dragging the handle allows you to create distortion.

Practical Tip

TIP Some people use the modification tool even when at the actual painting stage. Particularly for thickly painted-style illustrations that don't use line drawings, any degradation of the image after it's modified becomes less obvious. If degradation stands out, it can be repaired afterwards with retouching.

Make the Colors Used in the Rough Sketch into a Palette

When creating a color illustration, use a colored rough sketch with color lightly applied to consider the palette and overall composition. If you export the color rough as a separate file and line it up next to the file for production, you can use it as a palette for the drawing's colors.

Take colors from the colored rough sketch

Practical Tip

CLIP STUDIO PAINT

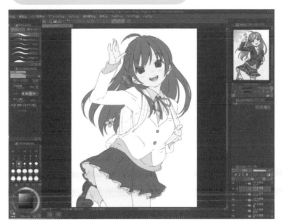

In **CLIP STUDIO PAINT**, open the colored rough sketch in the [sub view] palette. You may find it useful to use the Auto Eyedropper tool, which changes to Eyedropper only while the cursor is over the image in the [sub view] palette.

Automatically changes to Eyedropper

PHOTOSHOP

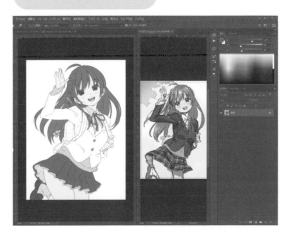

Practical Tip

[Window] menu [Arrange] ➔ [order all from left to right] allows you to display all opened files lined up together.

TIP For coloring rough sketches, use a large brush size to roughly apply color. The brush to use is up to individual illustrators' tastes, most illustrators use standard brushes such as [thick pencil] (in CLIP STUDIO PAINT) and [hard circular brush] (in Photoshop) is relatively high.

Turn Color into Black and White to Check Contrast

Changing a color illustration into black and white makes it easier to check contrast, allowing you to make sure areas that you want to stand out are not obscured and that the picture isn't creating a distracting·impression over all.

Check the contrast

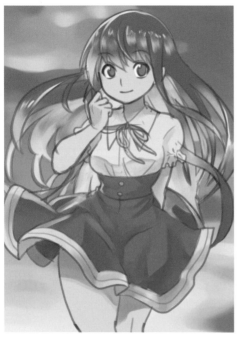

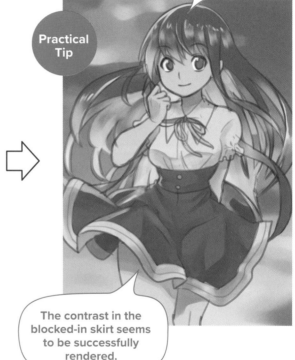

Are the brightness levels of the hair and background too similar?

Practical Tip

The contrast in the blocked-in skirt seems to be successfully rendered.

Consider the color scheme by using the rough sketch. Temporarily change it to black and white to check the contrast.

TEMPORARILY CHANGING WORK TO BLACK AND WHITE (CLIP STUDIO PAINT)

[Layer] menu [New color correction layer] select [Hue·Saturation·Brightness] and set [saturation] value to -100 to make the image black and white. To return the image to color, hide the color correction layer.

TEMPORARILY CHANGING WORK TO BLACK AND WHITE (PHOTOSHOP)

[Layer] menu [New color correction] select [Hue·Saturation] and set [saturation] value to -10 to make the image black and white. To return the image to color, hide the adjustment layer.

LINGO **Contrast** The difference in intensity between light and dark colors.

Creating Variation with Added Objects Allows You to Guide the Eye

Drawing in detailed additional objects only in areas that you want to make stand out creates variation in the illustration. Create areas with dense lines and areas without. Placing items in sections where you want to draw the eye also makes it possible to increase the number of lines.

Objects randomly drawn in	Increasing objects in one area

Practical Tip

The flowers are placed randomly and spill out all over the place, making for a picture lacking in cohesion.

Concentrating the flowers around the face increases the density of lines and attracts the gaze.

TIP If scattering objects around the illustration at random, place them evenly over the background to form a pattern. In the illustration on the left, the placement distracts the eye.

Lesson 101

Separate the Layers to Make It Easier to Correct Facial Expressions

If there are other lines on top of the ones you're correcting, they'll have to be erased. Dividing a line drawing so that each facial feature is separate means you don't have to worry about erasure loss, and it's also easy to make corrections. For facial expressions with a lot of elements or details, it's easiest to divide the face into segments.

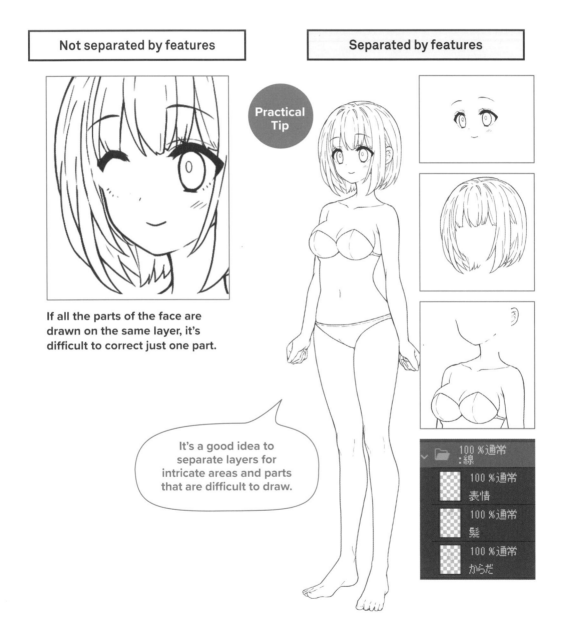

Not separated by features

If all the parts of the face are drawn on the same layer, it's difficult to correct just one part.

Practical Tip

Separated by features

It's a good idea to separate layers for intricate areas and parts that are difficult to draw.

Apply Color More Efficiently by Using Clipping on the Undercoat

Prepare the undercoat by dividing the image into layers and roughly applying the base color. Then create clipped layers over the top and add the shadow, reflections and other refinements for an efficient application of color.

Undercoat and clipping

Practical Tip

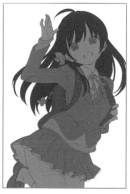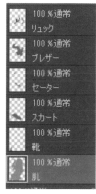

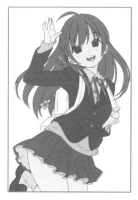

Divide the image into layers for each part, then apply undercoat as if color coding. As light colors are difficult to distinguish from the white background and may be forgotten in the painting process, paint them a dark color temporarily.

Adjust the undercoat to your intended color scheme. If you fill in color with the [lock translucent pixel] function on, you can change the color of the undercoat.

Create the clipped layer over the undercoat layer and then add the color over the top.

CLIPPING IN CLIP STUDIO PAINT

From the [Layer] palette, switch on [Clipping the layer below].

CLIPPING IN PHOTOSHOP

Right clicking on the layer [Create clipping mask] allows you to use clipping.

TIP There are various ways to change the color of the undercoat. In CLIP STUDIO PAINT, use [Edit] menu [Change line color to rendering color]. With Photoshop, it's [Image] menu [Color correction] [Color replacement].

Use Colors of the Same Vibrancy to Create a Cohesive Look

If there's no sense of color cohesion in terms of the vibrancy, the color scheme will appear disjointed. It's particularly difficult to create a cohesive look when using strong, vivid colors. If a color scheme doesn't seem to be working, it might be a good idea to tone the colors down a little.

| Not color-balanced | Vibrancy and color are in balance here |

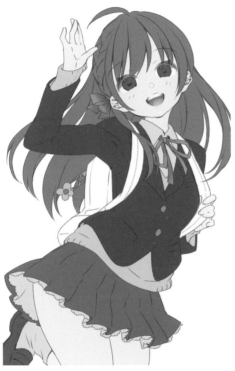

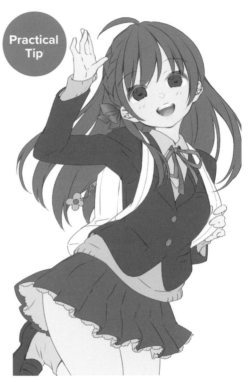

Practical Tip

If only some parts are vibrantly colored, the image will lack a sense of cohesion, creating an unattractive scheme over all.

Create a color scheme in which there are no significant differences in terms of vibrancy. Using pale, light colors for the base is recommended.

TIP When matching the vibrancy within a color scheme, getting caught up in the saturation values limits the range of colors you can use. So it's best to just let your eyes be the judge.

Deepen the Shading by Adding Shadow 2 to the Basic Shadow 1

In the case of color application with anime coloring as a base, add the darker tones (the second stage shadow) to the first, basic layer of shadow. Applying the shadowing effect in stages creates depth and increases the sense of dimension.

Add shadow 2 to shadow 1

SHADOW 1

SHADOW 2

Practical Tip

Practical Tip

For shadowing, the first stage is the main one. Apply the effect while being conscious of the light source, allowing some illuminated areas to remain.

Adding darker shadows creates variation and brings out depth.

TIP Increasing the number of stages used to create shadows makes for a more dimensional expression. As too many stages can create a heavy impression, in anime coloring, limit it to two or three.

Use Gradation to Bring out Dimension in Anime Coloring

Anime coloring is a style of painting where color is applied evenly to the illustration, using this as a base to which to add layers of shadowing and shading are added. Using this effect, you can suggest the subtle change in light and color created by the gradation.

| Anime coloring | Adding gradation |

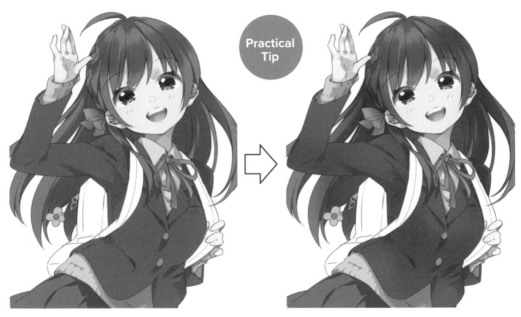

Practical Tip

Adding shadow to a flat illustration.

Adding gradated shadows creates dimension and depth.

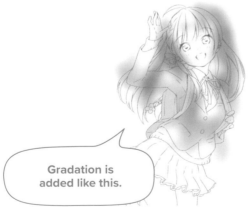

Gradation is added like this.

TIP In terms of brushes, in CLIP STUDIO PAINT, use the [airbrush] tool, and in Photoshop use a brush with [firmness] set to 1%.

Add Cooler Tones to Shadows to Prevent the Color from Becoming Dull

Using cooler colors such as blue for shadows prevents the overall shading from becoming too dull. Shadow hues can also be created by mixing gray into the base color, but this results in a slightly subdued color. Cooler-colored shadows enrich and enhance the overall palette of your illustrations.

Shadows in neutral colors	Blue-toned shadows

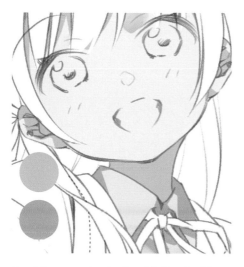

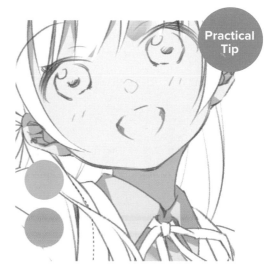

Practical Tip

Applying gray in the [multiplication] layer adds duller tones to the base color.

Mixing a blue tinge into the base color results in a vibrantly colored shadow.

EXAMPLE OF HOW TO CREATE SHADOW COLOR

The shadow color of the skin in the example is made by moving the color wheel toward blue, to add a cool color to the base palette. The brightness levels are reduced ever so slightly, while the saturation levels are increased.

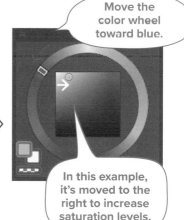

Move the color wheel toward blue.

In this example, it's moved to the right to increase saturation levels.

When Drawing Few Shadows, Cast Shadows Are Important

Shadows formed by an object are called "cast shadows," while that aren't cast (the dark areas) are called "natural shadows." When completing an illustration with few shadows, simplifying or omitting natural shadows and drawing only cast shadows allows you to express light and shade with interesting variations.

Gradation shadows	Cast shadows

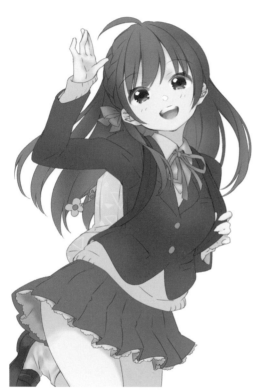

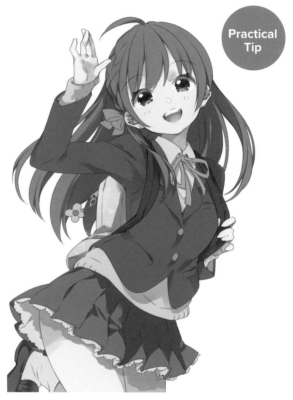

Practical Tip

When you look at an example of gradation shadowing, it's fuzzy and a bit blurred, lacking in distinction.

It's easy to adjust the shading (here falling on the figure's right side) for an added layer of depth and realism.

Using only cast shadows makes for a more "anime" result.

LINGO **Cast Shadow** The shadow created when light is blocked by an object. In the digital animation and art worlds, this type of shadow is also called a thrown shadow.

Make Reflective Color a Warm Shade for a Vibrant Look

Reflections can be created by increasing the brightness level of the base color. Mixing in warmer shades such as yellow or orange creates a richer tone. This works particularly well for outdoor scenes to convey the sun's illumination.

White reflection

This reflection is whitish. The color is not vibrant, but it looks realistic when depicting light in an indoor setting.

Reflection in warm shades

Practical Tip

Reflections using warm shades create a colorful appearance.

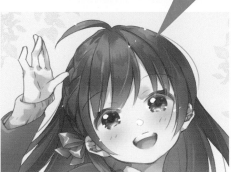

Psychologically, orange creates the sense of warmth and openness, making for a cheerful impression.

Highlights with Little Blur Bring out Shine

Crisply defined highlights create the look of shine. To draw them clearly, use a brush with minimal blur. A brush such as the one used for line drawings also works well.

Blurred reflection	Reflection with little blur

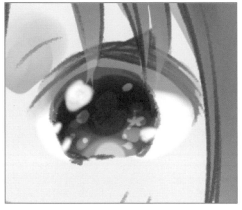

Practical Tip

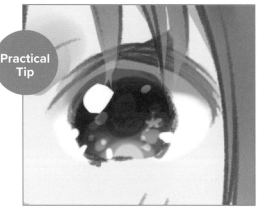

Using a brush with blur to add in highlights makes it difficult to bring out the lens-like quality of the eye.

Using a brush with a hard tip and little blur to add highlights allows you to give eyes a glistening luster.

Highlights with shine create variation in the paintwork.

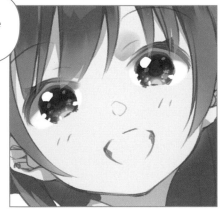

Adding Highlights over the Line Drawing Yields a More Luminous Look

In many cases, highlights are drawn in to indicate or suggest a strong light source. It's common to create a colored layer underneath the line drawing layer, but for highlights, adding them over the line drawing makes it easier to suggest an intense or powerful source of light.

Highlights beneath the line drawing	Blurred reflection

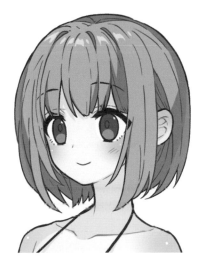

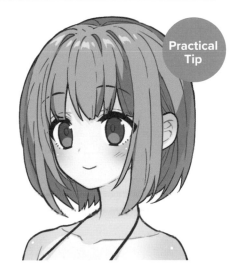

Practical Tip

If the line drawing is over the highlights, the appearance of strong light will be weakened.

In order to express strong light, add highlights over the line drawing.

Highlight ———

Line drawing ———

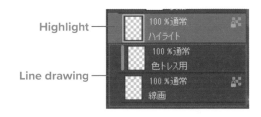

Make the Top of the Gradation in the Eyes Dark to Prevent a Heavy Look

When adding gradation to the eyes, make the upper part dark. Darkening the lower part creates a heavy, subdued impression. Additionally, darkening the upper part sets off the highlights, emphasizing the sparkle in the eyes.

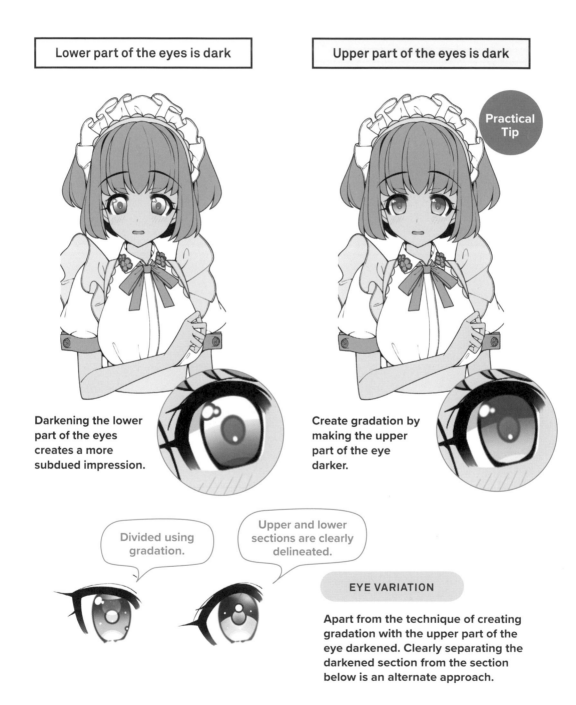

Lower part of the eyes is dark

Upper part of the eyes is dark

Practical Tip

Darkening the lower part of the eyes creates a more subdued impression.

Create gradation by making the upper part of the eye darker.

Divided using gradation.

Upper and lower sections are clearly delineated.

EYE VARIATION

Apart from the technique of creating gradation with the upper part of the eye darkened. Clearly separating the darkened section from the section below is an alternate approach.

Adding Shadow from the Eyelids to the Whites of the Eyes Creates a Sense of Dimension

There are not many elements that can be tweaked in the whites of the eyes, making it difficult to create detail. But if you want to add something extra, draw in some shadow. Faintly adding in the shadow cast by the eyelids allows you to create a sense of solidity and depth.

Whites of the eyes with no shadow added	Whites of the eyes with shadow added

Practical Tip

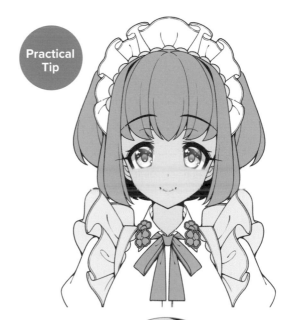

The whites of the eyes with no shadow applied. Compared to those with shadow added, they seem flat.

Adding the shadow cast by the eyelids to the whites of the eyes creates a sense of dimension.

Even in anime, for close-up scenes, it is common to add in the shadows from the eyelids.

Regardless of the Hair Color, Use a Dark Color to Make Eyelashes Stand Out

Even for characters with light-colored hair (or blue or pink hair!), make their eyelashes black or dark brown. Adding a dark color to the eyelashes creates contrast in the illustration and makes them stand out, drawing more attention to the eyes.

Eyelashes the color of the hair	Black eyelashes

Practical Tip

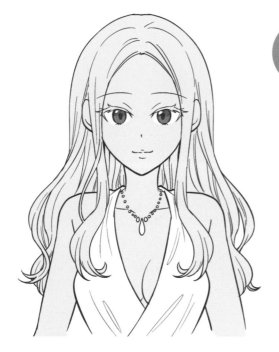

An illustration where the eyelashes match to the hair color. The area around the eyes lacks impact and definition, but for mysterious characters, this effect works.

An illustration where the eyelashes are black. It's common to use the darkest color in the color scheme for the eyelashes in order to emphasize the eyes.

Matching the eyelash color to the hair is always an option for expressing a character's individuality.

TIP The more defined the eyelashes, the stronger the face will appear.

Adding Warm Colors to the Eyelashes Creates a Soft Impression

The key is to add the coloration around the edges using blurred gradation. Using soft colors, this is a useful technique for highlighting a character's authority or appeal.

Without warm colors

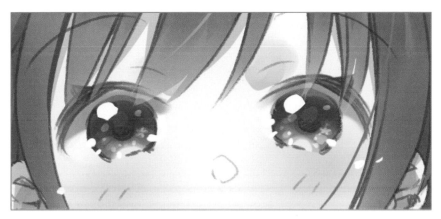

Colorless lashes.

With warm colors added

Practical Tip

Using a blurry brush to mix warm colors into the edges creates a much softer appearance.

Mix in Cool Shades to the Skin Tone to Bring out a Sense of Translucency

Mixing a cool color in when applying the skin color allows you to create skin with a sense of translucency. Work by placing colors such as blue or sky blue on the image and mix and extend it out. The best place to put the color is in the shadows at the edges.

Mix blue into the skin

Practical Tip

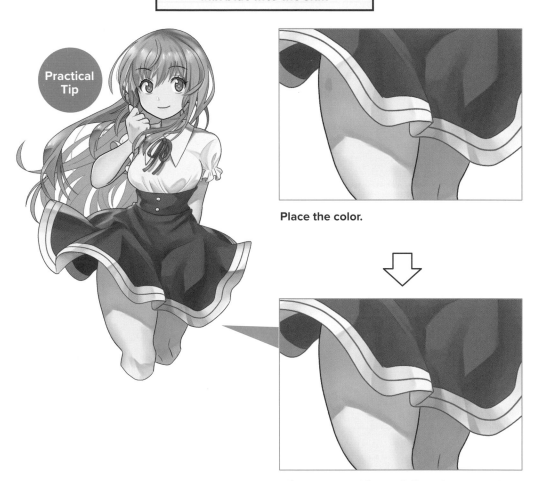

Place the color.

Mix and extend it out. Adjust the strength of the blue tint via the opacity level in the layer.

CLIP STUDIO PAINT

The [Mix colors] tool or [Watercolor blend] options in the [Brush] tools allow color to be mixed and blended out.

PHOTOSHOP

Lower the [Flow rate] setting on a brush to mix and blend color.

Hard Textures Make the Softness of the Face Stand Out

Contrasting hard and soft surfaces accentuates the texture and qualities of both. For example, incorporating an item with a hard, metallic quality into an outfit and placing it near the face emphasizes the softness of the features.

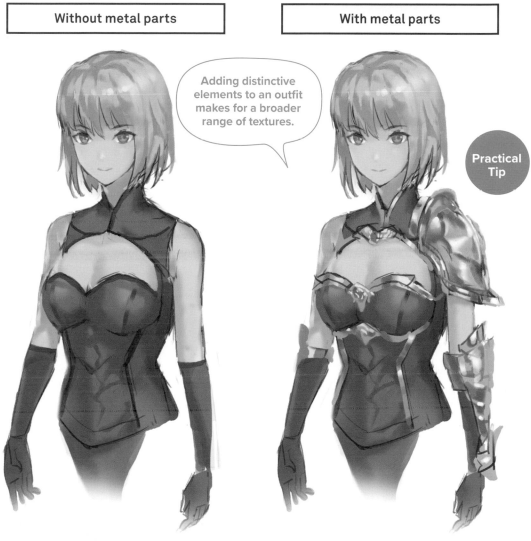

> **Without metal parts**

> **With metal parts**

Adding distinctive elements to an outfit makes for a broader range of textures.

Practical Tip

Illustration without metal armor or embellishment.

The hard quality of the metal provides a contrast to the softness of the skin.

TIP It's easy to incorporate armor and other metallic materials into sci-fi and fantasy scenarios. For realistic settings, consider using metal accessories.

Know the Most Common Looks for Redness in the Cheeks

Ruddy cheeks are often included to suggest a healthy glow as well as to convey shyness or other emotions. There are various ways to integrate this effect. Choose the method that best suits you and the character you're creating.

LINES

Redness created using lines only results in a manga-style look.

GRADATION

Redness is drawn to blend in with the skin. This is a natural way to add redness.

Tip Variation

ADDING HIGHLIGHTS TO GRADATION

Adding highlights to gradation brings out luster and emphasizes redness.

ADDING LINES TO GRADATION

Redness using gradation and lines creates a soft impression suggestive of chibi-style illustrations.

Adding Pink to the Joints Lends Refinement to the Character

Adding blurred touches of pale pink or redness to the skin allows you to heighten a character's appeal or authority. Standard areas for adding redness or ruddy tones include the cheeks, shoulders, elbows and around the joints.

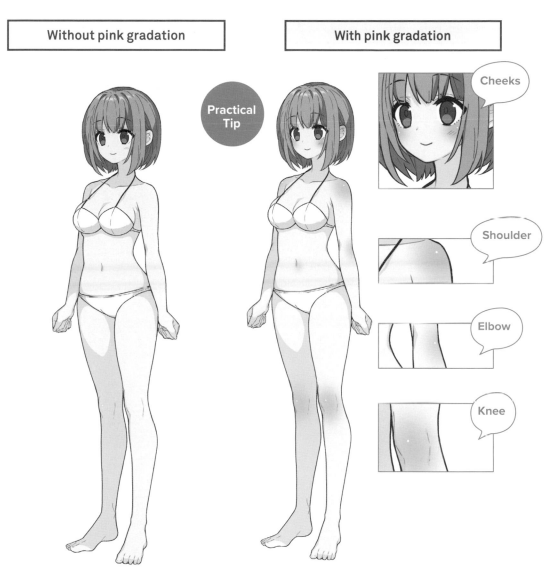

Without pink gradation

With pink gradation

Practical Tip

Cheeks

Shoulder

Elbow

Knee

Illustration without pink gradation. There's nothing wrong with it, but in comparison with the illustration at right, it lacks depth and visual appeal.

Adding pink gradation to the cheeks and joints contributes a healthy glow, making for a more visually lively character.

You Can Enhance Black Hair by Mixing in Red or Blue

The base layer for hair is painted in half-tones, with darker colors used for the shadows. The base used for black hair is gray, but mixing in red or blue to the gray creates black hair with a more richly colored appearance.

Black hair with blue mixed in

Practical Tip

Mixing in blue results in black hair with a subtle sheen.

Black hair with red mixed in

Practical Tip

Mixing in red gives the hair the more natural look of shining in the light.

Neutral black hair

Mix color into black hair to work with the image's overarching color scheme.

If only the hair in a colored illustration is neutral or achromatic, it can look out of place.

To Create a Halo Effect, Draw a Ring and Then Adjust the Shape

To create the halo-like reflection that forms on the top of the head, start by drawing a ring shape on the head. Be aware of the light source, and then shave it out in select places to adjust the shape to your liking. There are various types of halo effects. Choose one to suit your character and style of drawing.

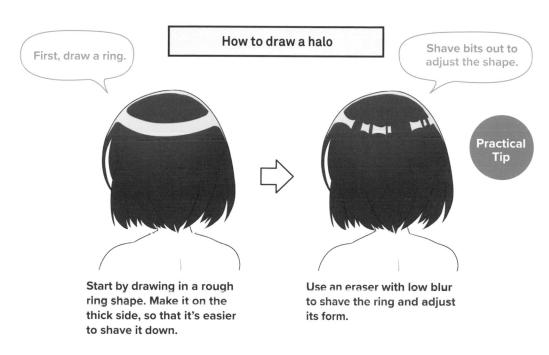

First, draw a ring.

How to draw a halo

Shave bits out to adjust the shape.

Practical Tip

Start by drawing in a rough ring shape. Make it on the thick side, so that it's easier to shave it down.

Use an eraser with low blur to shave the ring and adjust its form.

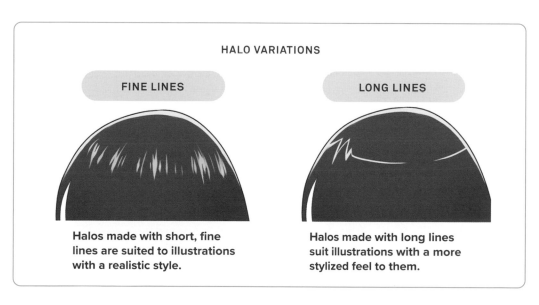

HALO VARIATIONS

FINE LINES

LONG LINES

Halos made with short, fine lines are suited to illustrations with a realistic style.

Halos made with long lines suit illustrations with a more stylized feel to them.

Adding the Color of the Skin to Bangs
Brings out a Sense of Translucency

Mixing in skin color to sections of hair that border the face makes the hair look transparent and creates a sense of translucency. It's particularly effective when used on the bangs. Lightly apply skin color using an extremely blurry brush such as an airbrush.

Without skin color mixed in

The illustration before skin color was mixed in.

Practical Tip

With skin color mixed in

Use a very blurry brush to softly apply skin color to the hair around the face.

The area around the face will become brighter, lending a glistening effect to the skin.

Adding Light to the Hair in the Background Creates Depth

Adding light to the background pieces of hair makes the contrast more obvious. Use cool colors for the light in order to bring out a sense of perspective. If using compositing mode, using [Screen] is easiest.

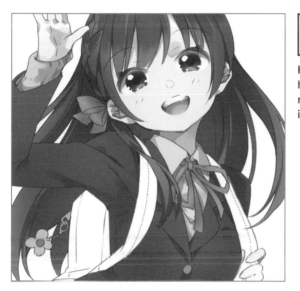

No light on the hair in the background

Here, light has not been added to the hair furthest from the viewer. There is not as much of a sense of depth in this illustration as there is in the one below.

Practical Tip

Light added to the hair in the background

Light has been added to the hair farthest from the viewer. The relationship between the hair in the background and the hair in the foreground, and the blazer is clearer, creating depth in the illustration.

This is a standard technique in illustrations of characters with long hair.

Make Hair Covering the Eyes Transparent

If you place the hair layer over the facial features, the eyes may end up being covered by the bangs. Use a separate layer only for the part that hangs over the eyes and lower the opacity to make only this section seem transparent.

Can't see through the hair

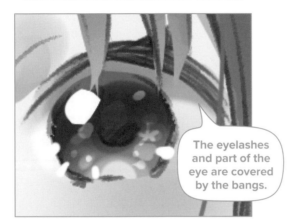

The eyelashes and part of the eye are covered by the bangs.

Can see through the hair

Practical Tip

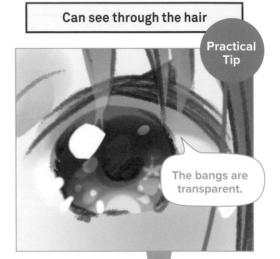

The bangs are transparent.

LAYER STRUCTURE

Create a separate layer that combines the hair coloring layers and remove the hair coloring that covers the eyes. Here, it's placed over the [face line drawing] that includes the eyelashes, which can be seen through the hair.

100％乗算
髪線画

55％通常
目の上の髪

100％乗算
顔線画

100％乗算
線画

100％通過
塗り

100％通過
パーツ — Line drawing for eyelashes

100％通過
髪 — Hair coloring

100％通過
目 — Eye coloring

Mix the Skin Color into the Clothing to Create the Look of Lightweight Fabric

Mixing in a little of the skin color to the clothing allows you to create the look of lightweight fabric. Black stockings are a good example of this. The areas where the fabric is thin or where light is hitting them and making them transparent look better with skin color mixed in.

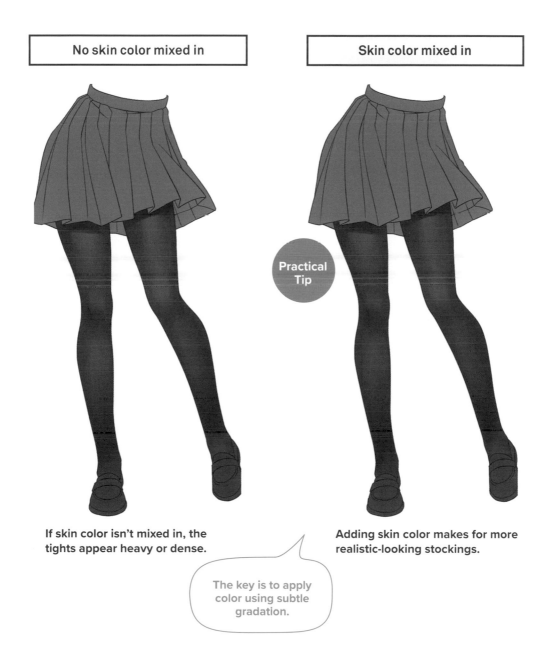

| No skin color mixed in | Skin color mixed in |

Practical Tip

If skin color isn't mixed in, the tights appear heavy or dense.

Adding skin color makes for more realistic-looking stockings.

The key is to apply color using subtle gradation.

Create a More Realistic Look by Drawing Reflected Light in the Middle of the Shadow

In order to create a more accurate representation of light, reflections need to be integrated as well. Reflected light is weaker than the glare from a direct light source and is created even within a shadow.

Without reflected light

The image before adding reflected light.

With reflected light

Practical Tip

Here, an "overlay" of pale purple is used over the reflected light.

Blurry reflected light is added here.

Drawing the reflected light makes it possible to express realistic textures.

Reflected light is added to the skirt shadow also. The colors of the shadow become more complex due to the reflected light.

Create Realistic Light with a Blurring Effect

Creating blur around a bright area makes for a sparkling expression, as if light is being emitted or strongly reflected. It's a technique that can be used for highlights, starry skies and other effects.

Examples of blurred background elements

Select the section of the shining object for drawing.

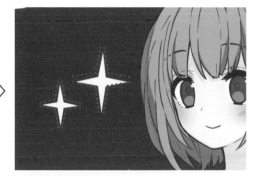

Slightly expand the selected area.

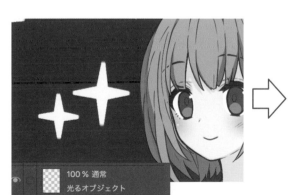

Create a blurred layer behind the shining object and fill in the selected area with a bright color.

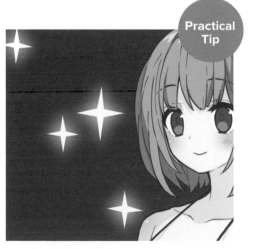

Practical Tip

Blur the image using a blur filter such as [Gaussian Blur].

Deepening the Edges of Shadows Creates a Sense of Dimension

Deepening the edges of shadows emphasizes its shape and gives it a more solid look. Lighter-colored areas bordering the shadow are also made to stand out, creating stronger contrast and lending variation to the image. However, for soft fabrics, making the edges of the shadows too dark may cause the texture to be lost, so adapt the effect accordingly.

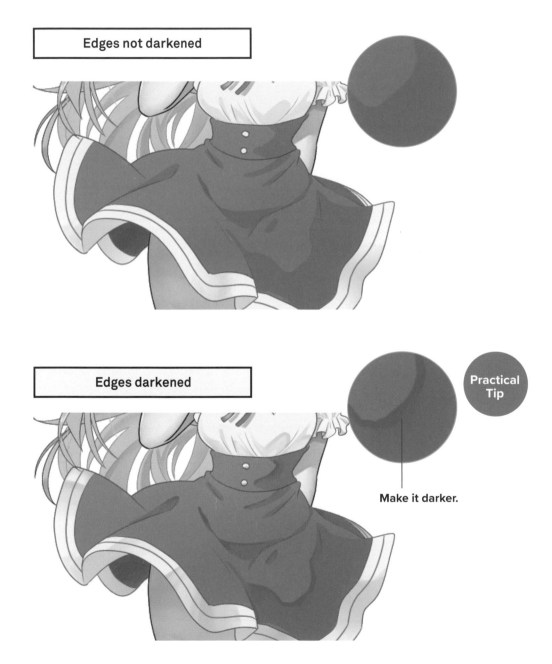

Edges not darkened

Edges darkened

Practical Tip

Make it darker.

Adding Highly Saturated Color Around the Edges of Light Makes It More Vivid

In some photos and images, you may see various colors blurred around the reflected light. In the same way, adding highly saturated color to the edges of highlights and reflected light makes for more vibrantly saturated colors.

No blurred colors	Blurred colors

Practical Tip

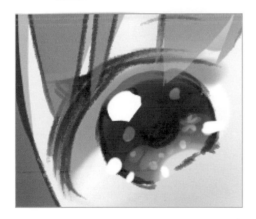 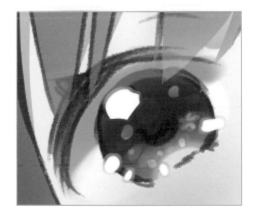

Pink or light yellow are good colors to apply to the edges.

An illustration with pink added to part of the edges of the highlights.

TIP When applying bright colors, put them in areas where the highlights and darker colors are next to each other, so that the vividness and contrast of the color stand out.

Use Two-Tone Color and an Accent Color to Create a Cohesive Scheme

If your colors aren't striking the right balance, start by creating a two-color scheme. Adding an extra color that stands out makes for a balanced color scheme. Color schemes with multiple colors are difficult, starting by considering combinations with just a few colors.

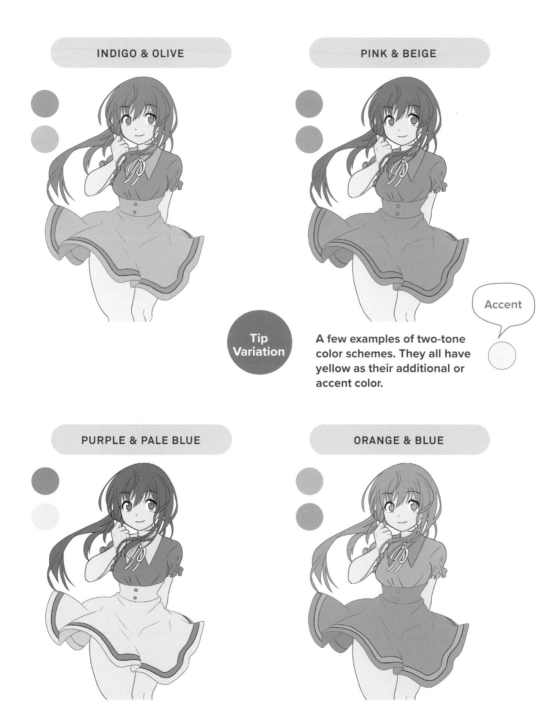

INDIGO & OLIVE

PINK & BEIGE

PURPLE & PALE BLUE

ORANGE & BLUE

Tip Variation

Accent

A few examples of two-tone color schemes. They all have yellow as their additional or accent color.

Opposite Colors Stand out When Used as Accents

Opposite colors are pairs of contrasting tones or hues that make each other stand out, such as blue and yellow or red and green. Opposite colors complement each other, so they can be effectively introduced for accents, highlights and other effects.

Using a similar color	Using an opposite color

Practical Tip

You might think that cool colors work well together, but it's not necessarily the case. Here, they don't complement each other at all.

For example, a blue outfit is set off by a ribbon in an opposite color, such as yellow or orange. Make sure an accent color isn't too prevalent in the image.

The color wheel is a diagram that shows hues arranged in a circle. Colors opposite each other on the color wheel are called complementary colors.

TIP Placing opposite colors next to each other may cause too much contrast. This can be remedied by altering the level of saturation or brightness, or placing another color between them.

Red Highlights the Foreground, While Blue Adds Distance

In color perspective, warm colors such as red appear closer to the viewer while cool colors such as blue seem farther away. Additionally, when various colors are used together, red is the one that most draws the attention; so it needs to be handled carefully. Use it on items and in areas you want to stand out.

Blue figure, red background	Red figure, blue background

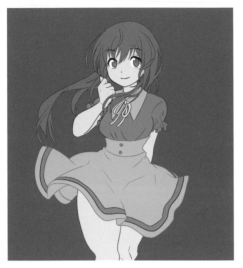

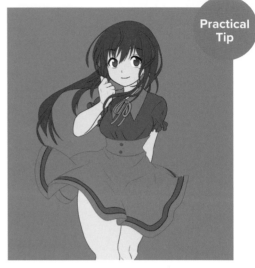

Practical Tip

As the background is red, the figure in blue appears to sink back slightly.

Using red for the figure's color scheme makes it stand out against the blue background.

RED IS A STANDOUT COLOR

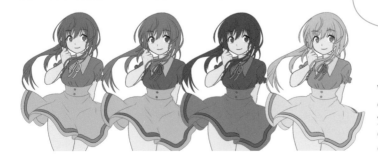

To the human eye, red appears close, while blue appears distant (in terms of color perspective).

When deciding on signature colors for each character, you should use red for the character you want to stand out the most.

LINGO **Color Perspective** To the human eye, warm colors such as red appear to protrude, while cool colors such as blue seem to recede. Color perspective makes use of these visual effects to express a sense of depth and distance.

For Thick Painting, Start with Dark Colors

In traditional oil painting, the basic rule is to start with dark colors and work through to the lighter ones. When producing digital illustrations that use thick applications of color, the same rule applies: Start with dark colors to make layering densely colored hues and tones easier.

Work from dark color → light color

Practical Tip

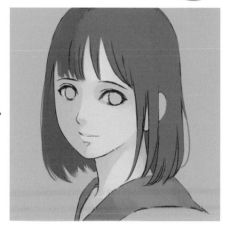

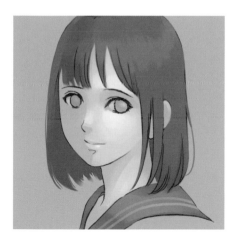

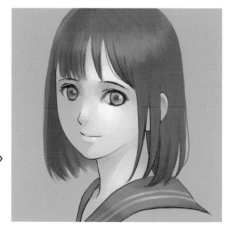

Pay Attention to the Surface of the Object to Bring out Dimension

In techniques where brushes tend to leave traces behind, the direction of the brushstrokes can alter the appearance of the coloration. The key is to pay attention to the surface being colored. Moving the brush to follow the object's surface brings out its texture and contributes a sense of solidity.

Pay attention to the face

Practical Tip

Be conscious of the surface. For coloring techniques where the brushstrokes add to the illustration, such as in thick painting, it's important to capture the flow of the surface to achieve a realistic result.

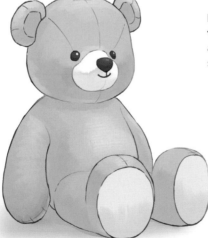

Pay attention to texture at the same time. Layer short strokes over one another to create the sense of the stuffed animal's fabric.

Use an Overlay to Color Achromatic Illustrations

The composite mode [overlay] and [color] allows color to be added while the contrast of the layer underneath is retained. It can be used when applying color to achromatic illustrations.

Painting using an overlay

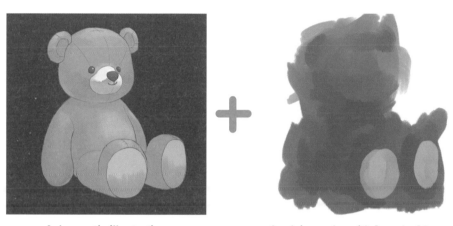

Achromatic illustration Applying color with [overlay] layer

Practical Tip

In the case of a black background, the color applied using the overlay will not appear in the background.

TIP The technique of painting in achromatic shades before applying color is called grisaille painting.

Place the Color on the Illustration and Spread It to Create Realistic Shadows

Placing the color on the illustration and then extending it with the brush allows you to create gradation that retains the look of brushstrokes. It's an appealing variation on the standard effects that can be achieved with the [gradation] or [airbrush] tools.

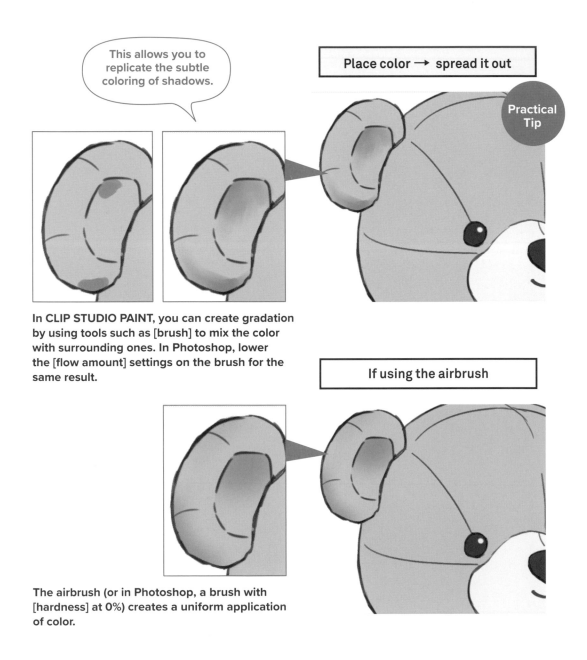

This allows you to replicate the subtle coloring of shadows.

Place color → spread it out

Practical Tip

In CLIP STUDIO PAINT, you can create gradation by using tools such as [brush] to mix the color with surrounding ones. In Photoshop, lower the [flow amount] settings on the brush for the same result.

If using the airbrush

The airbrush (or in Photoshop, a brush with [hardness] at 0%) creates a uniform application of color.

Use a Large Airbrush to Create Gradation

A brush that creates broad blur such as the [airbrush] tool is handy for creating gradation. Make the brush size as large as possible to increase the range of the gradation and create natural changes in the basic coloration.

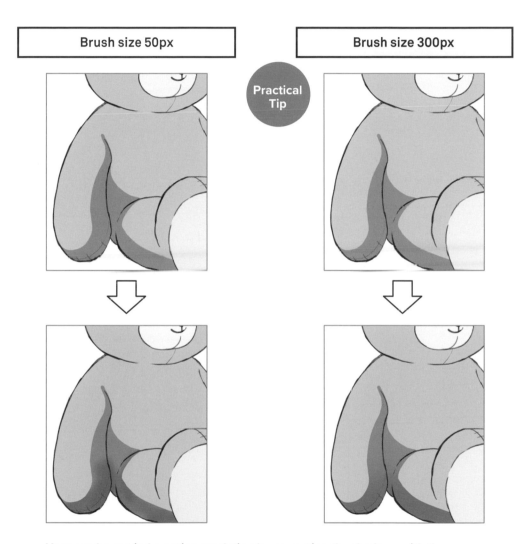

Here, we have tried creating gradation by correcting the shadows with the airbrush tool (in Photoshop, a brush with [hardness] set to 0%). A larger brush makes it easier to create smooth gradation.

TIP When painting in gradation with an airbrush as in the examples above, it's best to work the pen by placing it lightly on the image.

Pick up Intermediate Colors from the Color Boundaries

Using the [eyedropper] tool to pick up the colors that form in the borders allows you to paint with intermediate colors. This is useful when you want to add color to sections that fall between light and dark areas or blend the base color with the hues and tones of the shadows.

> **Paint with the eyedropper**

Practical Tip

Paint the shadow.

Use the eyedropper to pick up the section at the boundary of the shadow where the colors are mixed.

You can paint with the intermediate color.

Repeat the process of picking up color with the eyedropper and then painting to achieve gradation.

Lighting Alters the Look of an Illustration

The depth and shape of the shadows change in various ways depending on the light's direction and strength. Adapting the lighting to suit the character's expression and the mood you want to create allows you to produce a dramatically memorable illustration.

Various lighting

Practical Tip

LIGHTING FROM DIAGONALLY ABOVE

Basic lighting for shadows with no particular significance.

LIGHTING FROM DIRECTLY ABOVE

Shadows around the eyes create a gloomy look.

BLOCKING LIGHT WITH AN OBJECT

Shadows cast by objects create a sense of disruption or imbalance.

BACKLIGHTING

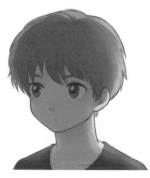

Light from behind brings out a dramatic air.

STRONG LIGHTING FROM BELOW

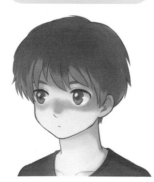

Light from below creates a sense of fear or anticipation.

STRONG LIGHTING FROM DIAGONALLY ABOVE

Deep shadow caused by strong light lends a serious mood or tone.

Use the Color Scheme to Convey the Time of Day

Applying shades of orange to the entire image creates the look of the sunset being reflected. Projecting the colors created by the scenery onto the characters allows you to express the light at different times of day.

Color scheme and time of day	Practical Tip

DAYTIME

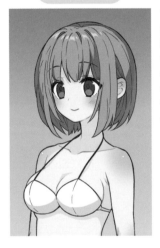

The daytime sunlight illuminates the character. Choose a bright color scheme with standard colors.

SUNSET

For a scene at sunset, use a color scheme that mixes oranges and yellows over the whole illustration.

NIGHT

Express night-time by using dark colors in the entire illustration. Blue-tinged colors make for an authentic dark-of-night look.

DUSK OR DAWN

The short period just before sun-rise or just after sunset is known for its suffused tones. Keep the colors dark, but use vibrant shades such as red and purple.

Use Image Processing Layers When Refining an Illustration

If you process the image with a [duplicate and merge all layers] image-processing layer, it's easy to start over if you make a mistake. This is a tool that's especially helpful when using a blurring filter.

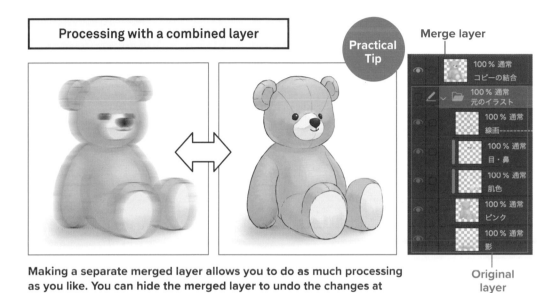

Processing with a combined layer

Practical Tip

Merge layer

Original layer

Making a separate merged layer allows you to do as much processing as you like. You can hide the merged layer to undo the changes at any time.

CLIP STUDIO PAINT
HOW TO MAKE A MERGED LAYER

Hide layers such as the paper layer and display only the layers you want to merge.

From the [layer] menu, choose [merge copies of displayed layers] to create a merged layer of the displayed layers.

This is useful because you can create the merged layer while retaining the existing layer.

PHOTOSHOP
HOW TO MAKE A MERGED LAYER

Display only the layers you want to merge to create a new layer.

With the newly created layer selected, Ctrl + Alt + Shift + E.

Use Layer Opacity to Adjust the Degree of Processing

The processes carried out to refine and finalize an illustration are mainly subtle adjustments, such as making slight tweaks to the color. When making detailed changes, you may want to process the image to a slightly stronger degree than expected and then adjust it using layer opacity.

Example of adjusting using opacity

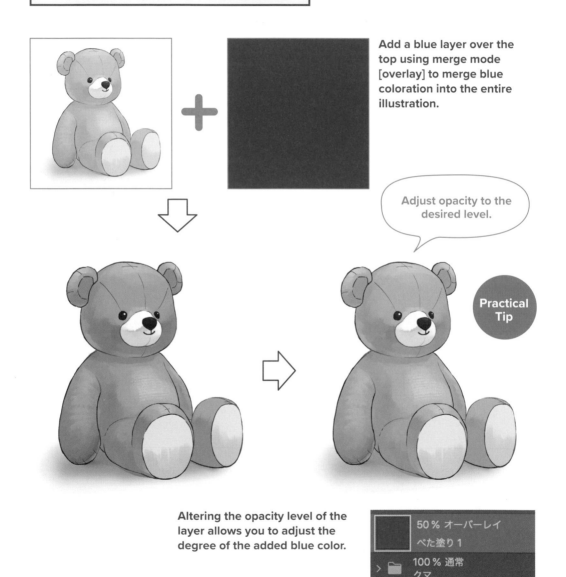

Add a blue layer over the top using merge mode [overlay] to merge blue coloration into the entire illustration.

Adjust opacity to the desired level.

Practical Tip

Altering the opacity level of the layer allows you to adjust the degree of the added blue color.

50％ オーバーレイ
べた塗り 1

100％ 通常
クマ

The Tone Correction Layer Can Be Recorrected After Setting

CLIP STUDIO PAINT and Photoshop have a function for creating a tone correction layer. As the values in the tone correction layer can be altered even after being set, it's a helpful tool when it comes time for editing tone.

Example of using the tone correction layer

EXAMPLE: TONE CURVE

Practical Tip

[Tone curve] is tone correction for contrast and color brightness. Add control points to make the graph resemble the S shape in the diagram in order to increase the contrast.

The tone correction layer settings can be changed multiple times.

The tone correction layer can adjust the tone of multiple layers.

CLIP STUDIO PAINT

Choose each type of tone correction from [Layer] menu [New tone correction layer].

PHOTOSHOP

Choose each type of tone correction from [Layer] menu [New adjustment layer].

TIP Raising the contrast may add a glaring brightness, so keep corrections subtle. In [tone curve], start by adjusting the S curve so that it's smooth and then make minor corrections.

Lesson 143

A 3D Model Can Be Used to Check the Lighting

Three-dimensional models are helpful not only for the purpose of considering poses and angles, but are also helpful for checking shadows. 3D artists' models are available as free applications, so give them a try. In CLIP STUDIO PAINT, you can use elements from 3D models as part of the drawing support functions.

Use the 3D model's shadow as a reference

Practical Tip

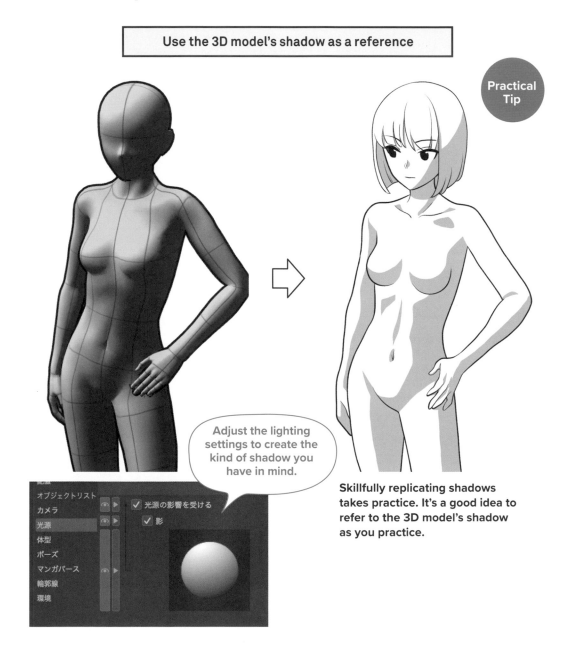

Adjust the lighting settings to create the kind of shadow you have in mind.

Skillfully replicating shadows takes practice. It's a good idea to refer to the 3D model's shadow as you practice.

TIP Free artists' model applications such as "Magic Poser" and "Easy Poser" are available in the App Store and on Google Play.

Use Quick Mask to Confirm the Area Selected

If you haven't created the selected area properly, you may end up painting areas unintentionally or accidentally leaving areas unpainted. Using Quick Mask makes it easy to find out which sections have not been selected.

Find unselected areas

If the selected area is detailed, it's hard to tell what's been selected.

Here, the [automatic selection] tool was used on the hair.

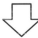

Practical Tip

CLIP STUDIO PAINT

Using [selected area] menu [Quick Mask]. Quick Mask is displayed with the selected area shown in red.

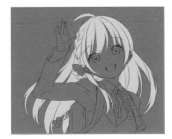

PHOTOSHOP

From the [selected area] menu, choose [edit in Quick Mask mode]. In Photoshop, areas outside the Quick Mask selected areas are displayed in red.

Quick Mask makes it possible to correctly confirm the selected area. Part of the bangs had not been selected.

TIP The Quick Mask area can be edited with a brush. Using a brush with blur allows you to blur the boundaries of the selected areas.

Lesson 145

Add a Dark Color to the Base to Find Areas That Have Been Left Unpainted

If there are sections of a character that have been left unpainted, when you fill in the background later, the background color will show through on the figure. Unpainted areas are particularly difficult to find in brightly painted sections. Adding a dark color to the character's base makes it easier to find areas left unpainted.

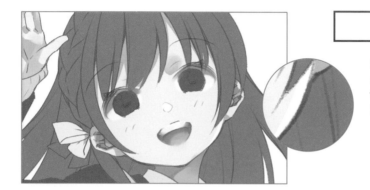

Without base

It's often difficult to find unpainted areas on skin that's been painted with a bright color.

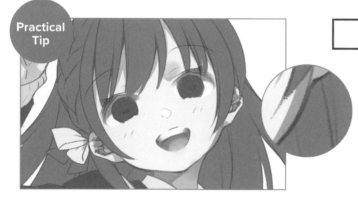

Practical Tip

With base

Add gray to the base to find unpainted areas.

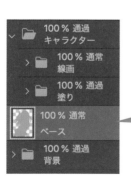

This is also helpful to prevent the background from showing through to the character's base.

TIP The border between the line and the paint is an area that's particularly easy to leave unpainted, so take care.

The Screen's Brightness or Darkness Can Be Adjusted with an Overlay

The [overlay] layer in composite mode has the special property of merging with the layer below it to make bright colors brighter and dark colors darker. For this reason, you can control the level of brightness or darkness while adding color by using [overlay].

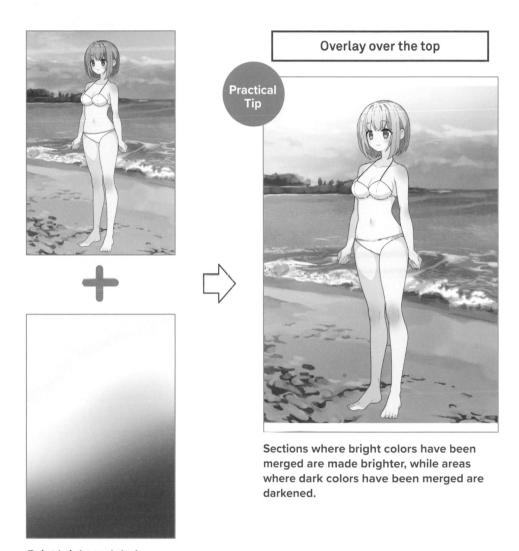

Paint bright and dark colors using the [overlay] layer in composite mode.

Practical Tip

Overlay over the top

Sections where bright colors have been merged are made brighter, while areas where dark colors have been merged are darkened.

TIP [Soft light] is also a composite mode that brightens and darkens colors, but it has lower contrast than [overlay]. So changes to color are minor.

Lesson 147

Use the Screen Option to Create a Soft, Airy Feeling

The [screen] option in composite mode lightens the color slightly. Use it to suggest soft daylight or an out-of-focus landscape.

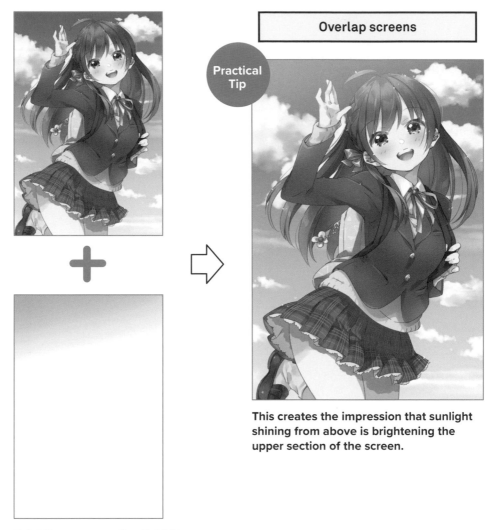

Practical Tip

Overlap screens

This creates the impression that sunlight shining from above is brightening the upper section of the screen.

Paint the upper section light blue on the layer with the composite mode set to [screen].

Use [Addition] to Make Light Even Stronger

Of the various options available for brightening in composite mode, [addition] makes things particularly bright. When colors with high brightness levels are combined, a shiny glare is produced. This works well for extremely strong sources of light.

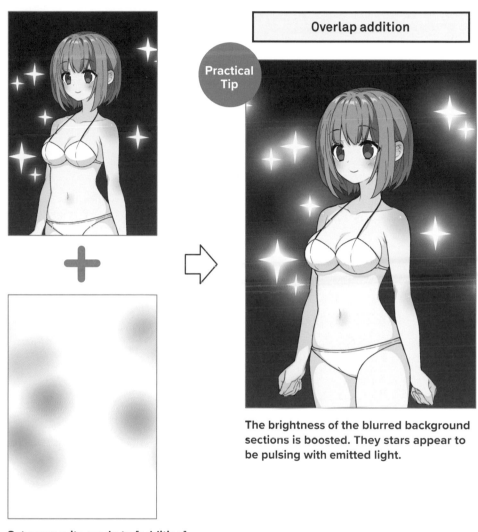

Practical Tip

Overlap addition

The brightness of the blurred background sections is boosted. They stars appear to be pulsing with emitted light.

Set composite mode to [addition] and draw the sections that you want to shine.

TIP The same effect can be achieved via [covering color].

Use Color Comparison (Bright) to Partially Alter Shadow Colors

[Color comparison (bright)] in composite mode is able to compare colors in overlapping layers to display the brightest one. You can make use of this to change the colors of the dark parts of shadows.

Add blue only to the dark parts of shadows

Place a layer filled with a dark blue over the image and choose the [color comparison (bright)] setting.

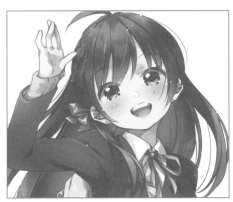

This reflects blue onto the dark areas of shadows only.

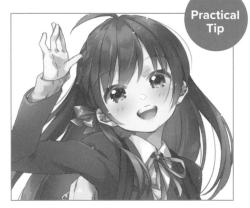

Practical Tip

Lower the layer opacity level to your taste to decide how much blue to mix into the dark shadows.

For the colors used, the hue is set slightly closer to blue-green, and the lightness and saturation are set slightly to the right of the center of the rectangular area.

Use Partial Tone Correction to Make Important Areas Stand Out

The range for tone correction can be restricted by using the layer mask function. If you learn the technique for correcting tone in certain areas, you can use it to increase the contrast of important parts so that they stand out.

Practical Tip

Restricting the tone correction range

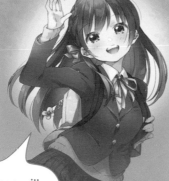

Mask icon

100 % 通常
トーンカーブ 1

100 % 通常
トーンカーブ 1

Select the mask icon and use the brush or [eraser] to edit the mask range.

The mask range will disappear in the area painted by the brush (the icon is the white section).

BEFORE CORRECTION

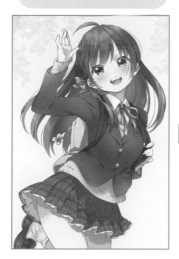

AFTER CORRECTION

Tone correction is not carried out in the masked section.

A Gradation Map Allows You to Change Colors for Each Tone

The gradation map is a function that allows colors to be substituted for the set gradation, making natural color change possible. Since the color to be changed can be set for each tone, you can mix warmer colors in bright areas and cooler colors in dark areas.

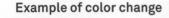
Example of color change

Practical Tip

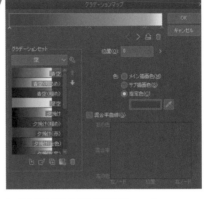

Settings were applied to change bright colors to yellow, then bright colors to pink, then dark colors to blue.

In **CLIP STUDIO PAINT**, apply settings from [Layer] menu [New tone correction layer] [Gradation map].

Practical Tip

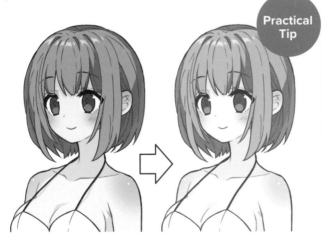

Appling the gray gradation setting makes the image achromatic.

In **Photoshop**, apply settings from [Layer] menu [New adjustment layer] [Gradation map].

Use Color Trace to Make Line Drawings Appear Softer

Changing the color of the line drawing so that it blends in with the colors around it is called color tracing. Using this feature blends the line drawing in with the other colors and lends the illustration an appealing softness.

Without color trace	With color trace

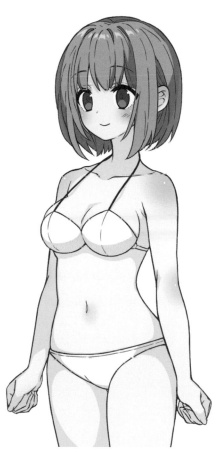

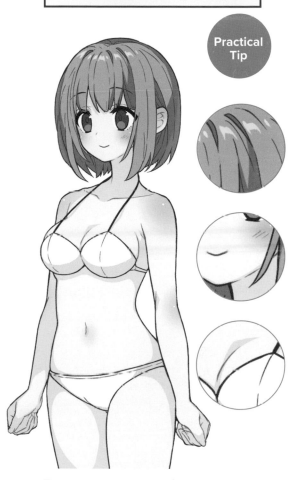

Without color trace

An illustration with a black line drawing. It appears slightly heavier than the illustration that has been color traced.

With color trace

The color of part of the line drawing has been changed to blend in with the hair and skin.

TIP Using the layer clipping function in order to color trace makes recorrection easier.

Use Layers to Make Characters Stand Out

Adding a layer of coloration between the character and the background brings out depth at the same time while making the character stand out more.

Set the composite mode to [screen] to make the effect slightly brighter.

Practical Tip

Add a layer of air to the borders

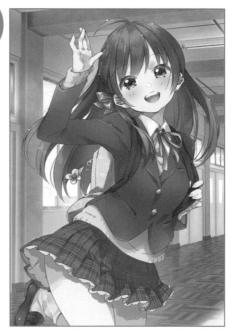

Adding a layer of coloration makes the character stand out.

TIP In the example above, only the colors around the character are altered, so it is slightly different from the realistic sense of perspective that aerial perspective technique achieves. Rather it's a technique aimed at making characters stand out.

Use a Focus Effect to Bring the Face into Clear Focus

The [blur] filter is a standard filter function in CLIP STUDIO PAINT and Photoshop, but it can be used in the same way as focusing a camera lens to create the effect of blurring around an object.

Focus effect procedure

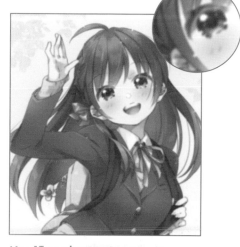

Create a duplicate of the layer containing the illustration you want to focus on and merge it.

Use [Gaussian blur] to blur it.

Practical Tip

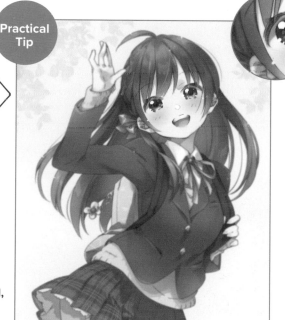

Erasing only the part you want to focus on will display the unblurred image beneath.

The focus effect is achieved, with the face appearing to be in clear focus.

TIP You can alter the strength of the blur by adjusting the opacity level of the layer.

Use the Glow Effect to Enhance the Character's Skin

Applying the glow effect allows you to give characters highlights and parts of their skin a soft glow. Use [level compensation] in tone correction, [Gaussian blur] in the [blur] filter and [screen] in composite mode.

Glow effect procedure

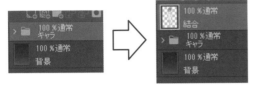

Create a duplicate of the character layer and merge it.

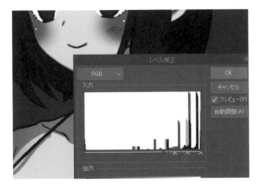

In level compensation, move the ▲ to the right to deepen the color. This corrects levels on the layer itself so the tone correction layer is not used.

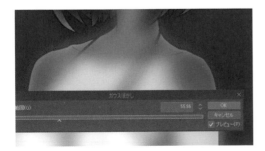

Use [Gaussian blur] to blur the image.

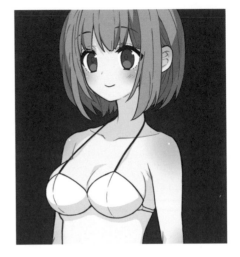

Practical Tip

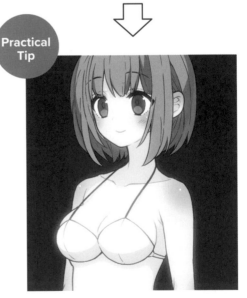

Blend so that light colors appear to glow. Alter the amount of glow by adjusting the layer opacity level. This completes the glow effect.

Lesson 156

Produce a Color Shift Effect

Chromatic or color aberration is a process where red, green and blue lines shift to create the appearance of misaligned plates in color printing. The misaligned colors also have the appearance of blurred light, creating a look that is stylish from a design perspective.

 Color aberration procedure

 Create a duplicate of the illustration for the color aberration process and merge it. Make three of these.

Red
R=100
G=0 B=0

Green
R=0
G=100
B=0

Blue
R=0 G=0
B=100

Make red, green and blue layers and overlay each of the three duplicate layers with [multiply].

Merge each of the red, green and blue layers with the one below it.

Make the two uppermost layers into [screen]. Move a few pixels on each layer to create color shift. This completes the color aberration process.

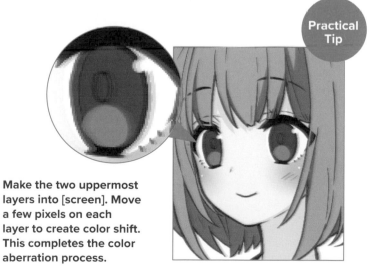

Practical Tip

Lesson 157

Use Backlighting to Make the Silhouette Stand Out

Backlighting makes it easy to create a dramatic atmosphere. It's one of the most popular processing methods. Adding strong light to the outline makes the silhouette stand out and lends the character a stronger presence.

Example of creating backlighing

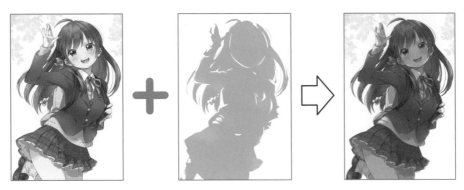

Paint shadow in the [multiplication] layer.
Here, mainly pale purple has been used.

Practical Tip

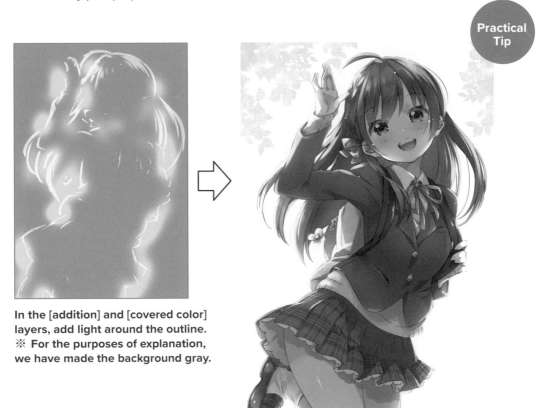

In the [addition] and [covered color] layers, add light around the outline.
※ For the purposes of explanation, we have made the background gray.

Use Paper Texture to Create an Analog Touch

Adding the texture of paper to an image is an easy way to create an analog look. For example, layering the texture of drawing paper over an illustration with a pale color scheme creates an effect like that of a watercolor painting.

Without texture	With texture

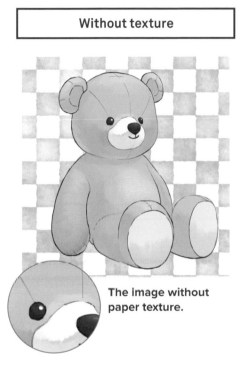

The image without paper texture.

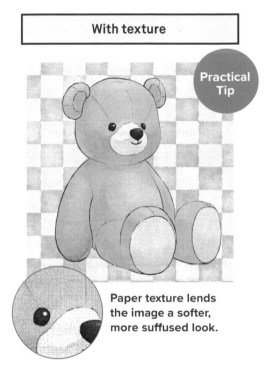

Practical Tip

Paper texture lends the image a softer, more suffused look.

CLIP STUDIO PAINT

In [Materials] palette [monochrome pattern] → [texture] there is a texture like that of paper. Turning on [merge texture] in [effects] from [layer properties] allows textures to synthesize in a natural way.

PHOTOSHOP

From the [layer] menu [new filled layer] [pattern], select paper texture. Merge textures by using [overlay] or [soft light] in composite mode.

Use the Contrast in Reflection to Suggest Hardness

Illumination effects and the differences in contrast created by shadows can be used to express texture. Hard objects reflect light in a clear, sharp way, while light is reflected back from soft objects in soft, blurred gradations.

Distinguishing reflections

Practical Tip

For readily reflective objects, use a brush with low blur to create reflection.

HARD

As objects with smooth, hard surfaces such as metal and precious stones are highly reflective, increasing the contrast in reflection allows their texture to be captured.

Practical Tip

For soft light, draw it blurred, as if blended with the surrounding colors.

SOFT

To draw soft materials with surfaces that aren't smooth and other objects without highly reflective surfaces, lower the contrast.

Chapter 4

Poses and Composition

Now it's time to put it all together: powerful poses,
striking scenes and taking the composition and arrangement
of your illustrations to the next level.

Use Contrapposto to Make a Pose More Complex and Appealing

A pose where the center of gravity rests on one foot and the line of both shoulders is in contrast to that created by the hips is called contrapposto. This brings movement to a standing figure and makes for a more attractive look.

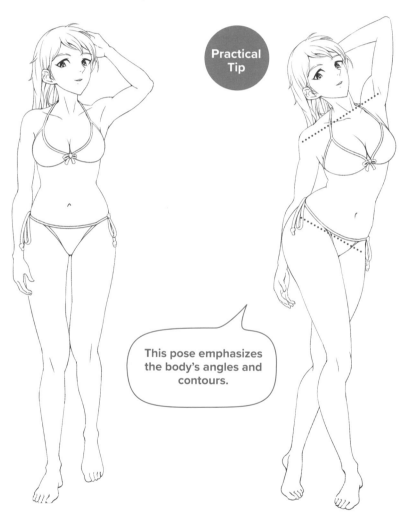

Standing upright

With an awareness of contrapposto

Practical Tip

This pose emphasizes the body's angles and contours.

When you want to create a less dynamic pose, it's fine not to consider contrapposto.

A pose that makes use of contrapposto. The body is twisted sideways through from the hips.

Lesson 161

Twist the Body for a More Dynamic Pose

A pose in which the body is twisted allows you to create lively, dynamic movement. The sketch for this kind of pose is more difficult than for a standard one, but the sense of dimension and dynamism created make up for it.

Straight body	Twisted body

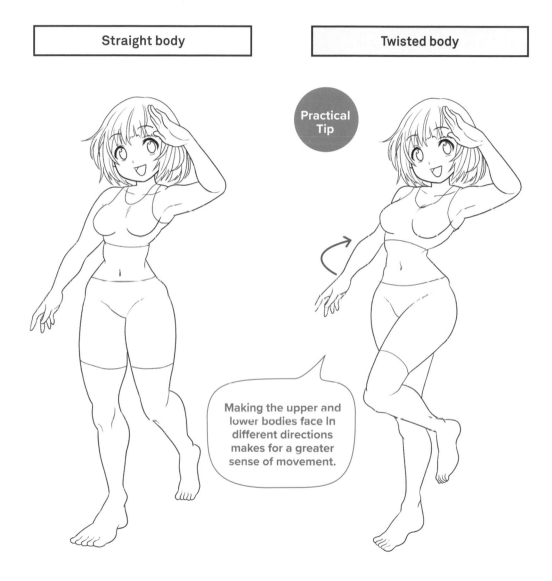

Practical Tip

Making the upper and lower bodies face In different directions makes for a greater sense of movement.

There is movement in this pose, but as the body is not twisted, it creates a less dynamic impression than the picture on the right.

The pose is similar to the one on the left, but twisting the body adds a greater sense of motion and flow.

Create a Sense of Excitement with a Pose That Opens Outward

A pose with the chest puffed out creates a bold impression. Making not only the chest but other body parts extend outward yields a dynamically memorable pose. Depicting the legs spread apart lends the figure a heroic air.

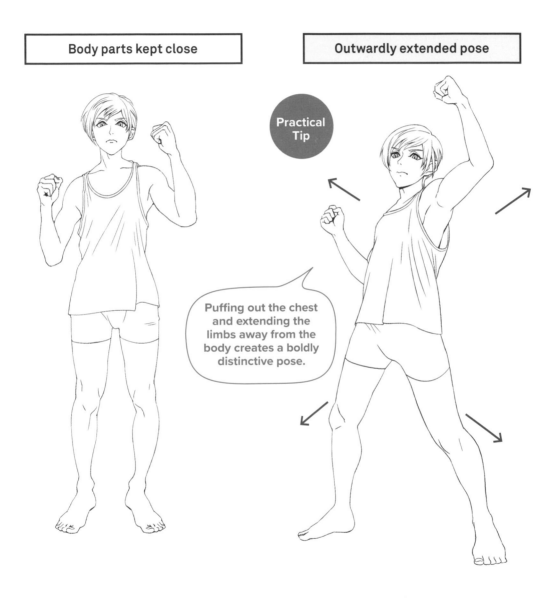

Body parts kept close

Outwardly extended pose

Practical Tip

Puffing out the chest and extending the limbs away from the body creates a boldly distinctive pose.

A pose in which limbs do not extend out to the sides creates a sense of calmness or stability.

A pose where the limbs are spread out as if to emit power has the effect of making the body appear much larger.

Use an Inward-Facing Pose to Bring out Quieter Emotions

A pose in which the shoulders are pulled inward as if to make the body smaller gives the viewer the impression of gentleness, shyness or modesty. An inward-facing pose with the arms close to the sides suits a withdrawn or laid-back character.

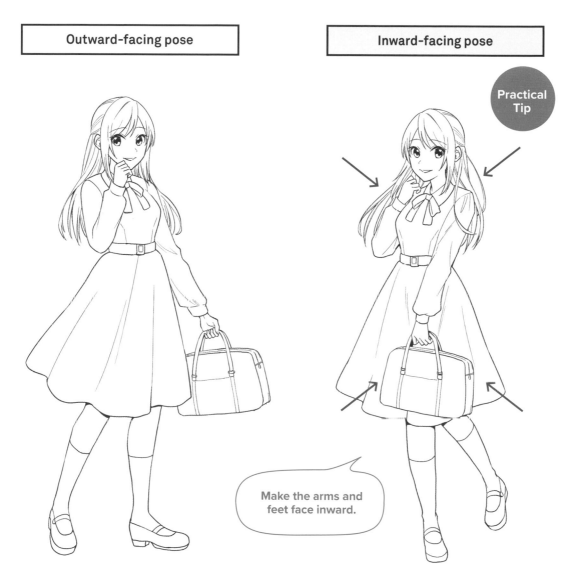

Outward-facing pose

Inward-facing pose

Practical Tip

Make the arms and feet face inward.

Inward-facing posture is not considered in this pose. This suits an energetic kind of character.

The arms are by the sides and the feet face inward in this modest pose.

Be Conscious of the Shape of the Spine to Create Natural Posture

Even when a figure is standing with a straight back, there are several visible curves in the human spine. Clearly capturing these curves in an illustration results in a natural pose and creates an attractive body line.

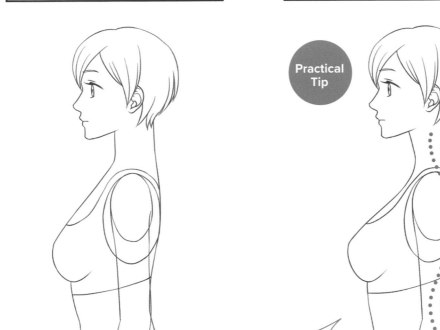

| Straight spine | S-shaped spine |

Practical Tip

Being aware of the spine makes it easier to visualize the line of the body.

This figure has a straight back and linear proportions. It creates a slightly stiff impression.

Viewed from the side, the spine is not straight. Pay attention to the angle of the neck and the curve at the waist.

Keep Movements to Within the Natural Range of Motion

When creating poses, if you don't understand the body's range of motion, an unnatural posture will result. For example, the arms cannot rotate in a circle from the shoulders when they are kept close to the body. Try standing in front of a mirror and posing to see for yourself.

| Impossible range of motion | Natural range of motion |

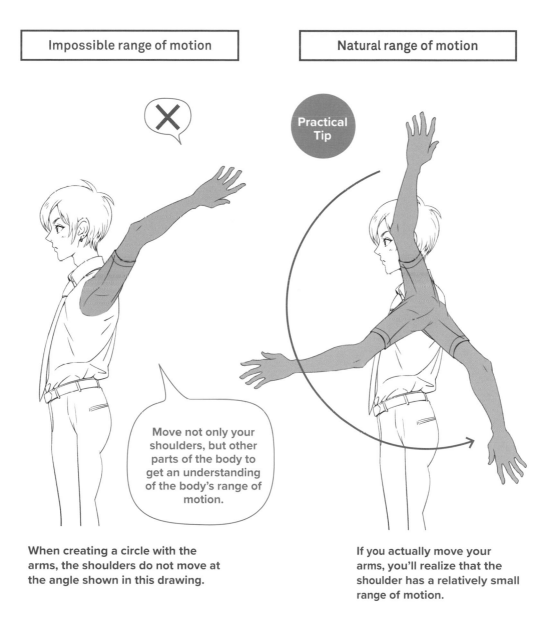

Practical Tip

Move not only your shoulders, but other parts of the body to get an understanding of the body's range of motion.

When creating a circle with the arms, the shoulders do not move at the angle shown in this drawing.

If you actually move your arms, you'll realize that the shoulder has a relatively small range of motion.

When Looking to the Side, the Shoulders Turn Too

In poses where the character is looking to the side, if only the neck is turned, it will create an unnatural impression. Slightly twisting the hips and rotating the shoulders yields a pose where the character is looking to the side without a forced, unnatural look.

Shoulders remain unmoved	Shoulders moved

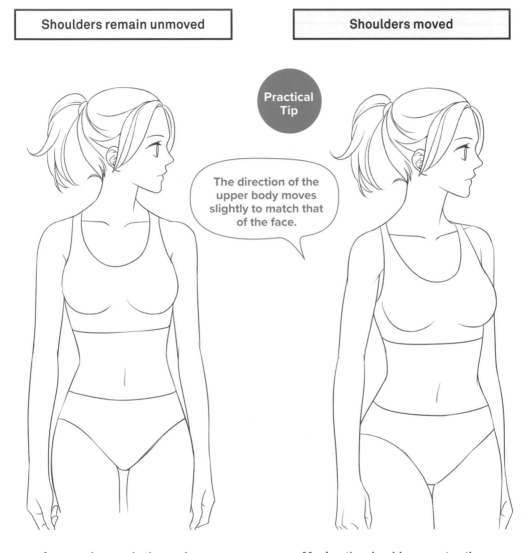

Practical Tip

The direction of the upper body moves slightly to match that of the face.

A pose where only the neck moves is unrealistic so the movement appears stiff and creates a flat impression.

Moving the shoulders creates the look of the entire body having moved in conjunction with the face, making for a realistic pose.

In a Pose Where the Figure Is Turning Back, the Eyes, Neck and Shoulders Shift Direction in That Order

When a character turns to the back or looks back, while the hips twist, the eyes, neck and shoulders move to shift the gaze. Make sure to capture the order of movement as eyes → neck → shoulders. The shift of the shoulders increases as the body turns back.

Only the face moves	Turning back naturally

Practical Tip

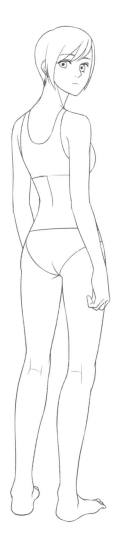

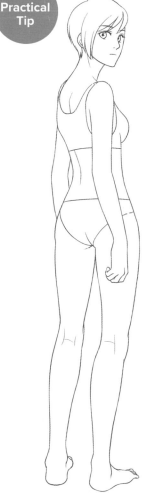

Eyes

Neck

Shoulders

Turning so that only the face is directed backward is unnatural.

Turning back is a standard pose, so try to create a natural posture.

In a Pose Where the Character Is Looking Up, Arch the Back

When beginners are drawing characters looking directly up, they tend to draw only the face pointing upward, resulting in an unnatural posture. Arching the back allows the gaze to be directed upward.

Only the neck moves	The back is arched

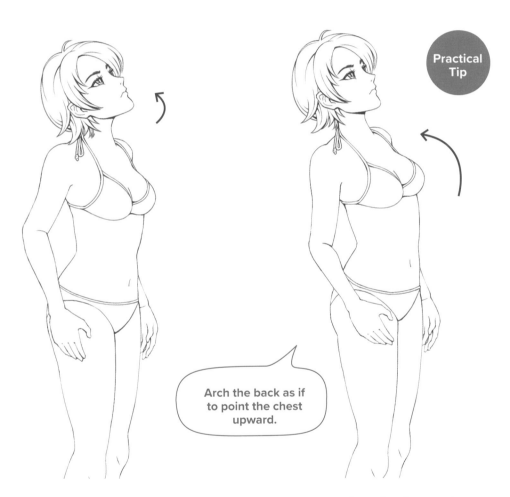

Practical Tip

Arch the back as if to point the chest upward.

When looking directly up, tilting only the face upward makes the pose look unnatural.

For a pose where the character is looking directly upward, arch the back to create a natural posture.

Arching the Arms and Back Makes for a More Energetic Impression

For a cheerful, energetic character, it's a good idea to create poses where the limbs are full of power. Stretching out the arms and back so that they arch creates a dynamic, active appearance.

Arms and back not arched	Arms and back arched

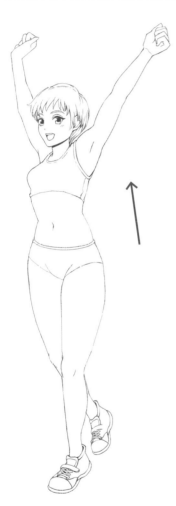

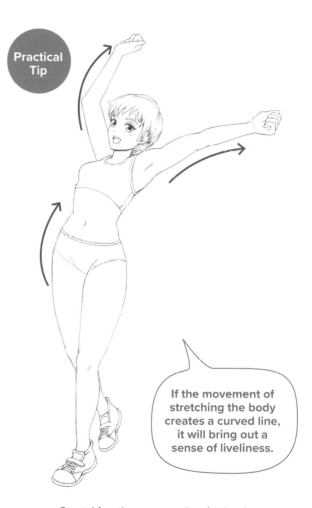

Practical Tip

If the movement of stretching the body creates a curved line, it will bring out a sense of liveliness.

While this pose is similar to the one on the right, as the arms and back are not arched it creates a comparatively subdued impression.

Stretching the arms and waist back and pushing out the chest creates an energetic, dynamic pose.

Poses That Can Be Understood Via the Silhouette Are Easy to Convey

When wanting to clearly show a character's actions, it's a good idea to draw how the pose would appear in silhouette form. This allows you to indicate at a glance the action or motion you're trying to convey.

Difficult to communicate

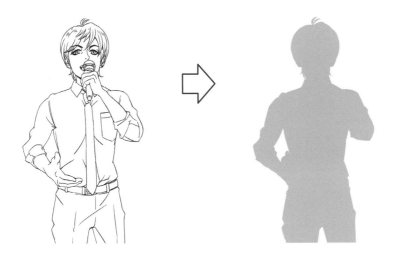

When it comes to poses that are difficult to understand in silhouette form, adding proper detail conveys the intent of the illustration. But it still may take a little while for the viewer to comprehend it.

Easy to communicate

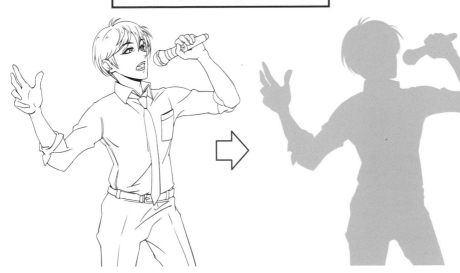

Practical Tip

The outstretched arms and microphone can be easily seen in the silhouette, making the illustration easy to understand.

The Farther Forward a Figure Is Leaning, the Faster It Appears to Run

When drawing a figure running at full speed, tilt the upper body forward and direct the gaze straight ahead. The farther forward the figure tilts, the more velocity and speed are suggested to the viewer.

Upright upper body	Tilted forward

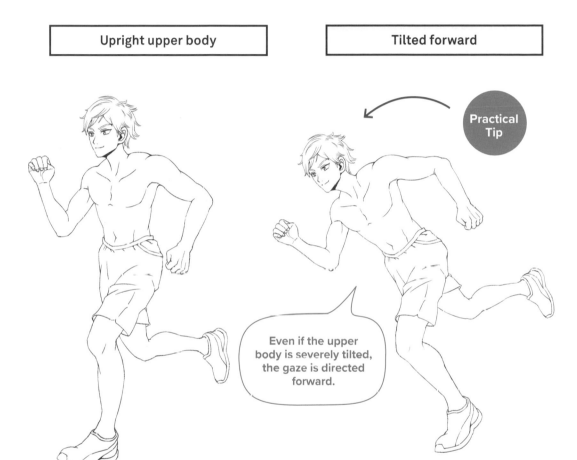

Practical Tip

Even if the upper body is severely tilted, the gaze is directed forward.

A pose where the upper body is held upright creates the impression of a light jog.

The farther forward the body is tilted, the faster the figure appears to run. Make the arms swing boldly too.

TIP For a figure running on a track, tilting the body to the inside of the curve makes for a realistic look.

Drawing the Moment Just Before or After an Action Creates a Sense of Dynamism

Try capturing an isolate moment in time, just before or after a key action or motion is being performed. This makes the viewer imagine the moments before and after the movement and creates a sense of realism.

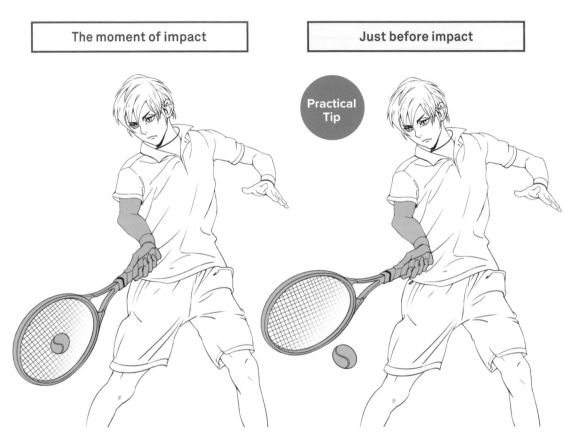

The moment of impact	Just before impact

Practical Tip

The moment when the tennis racket hits the ball makes for an illustration with impact; but in terms of dynamism it is not as successful as the illustration on the right.

This illustration shows the moment before hitting the ball. Drawing the moment just before a critical action creates a sense of dynamism that comes from making the viewer imagine what follows.

The point here is to suggest the impact and make the viewer imagine the result.

Placing the Hands Behind the Head Adds Complexity to a Pose

Normally, after the face, the hands are the parts of the body to which the gaze is drawn. A pose in which the arms are raised and brought behind the head conceals the hands at the same time as opening up the sides, emphasizing the lines of the body.

Hands down	Hands behind the head

Practical Tip

In a pose where the arms are down, the chest and line of the buttocks do not form a silhouette, making for a complex pose.

Raising both arms makes the line of the chest, waist and buttocks clearly visible.

Place the Hand Near the Face to Focus the Gaze

After the face, the hands are the parts of the body that draw the gaze. Placing them near the face has the effect of preventing the gaze from becoming scattered. When you want to emphasize the cuteness or coolness of a character's face, it's a good idea to bring a hand up close to it.

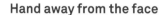

Hand away from the face	Hand near the face

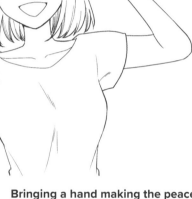

Practical Tip

Bringing a hand making the peace sign up close to the face centralizes and unifies the illustration.

Rather than just the face as a whole, the key is to bring the hand up to the eyes, cheek and mouth.

The gesture of sweeping back the hair is a natural movement for creating a pose where the hand is brought up next to the face.

TIP Apart from sweeping back the hair, it's good to be aware of the various other situations that bring the hand up near the face, such as when eating or adjusting glasses.

When One Arm Is Posed, Use the Other to Fill in Gaps

In poses where one arm is the main focus, you may not be sure what to do with the other one. Consider the options for its use or placement, such as putting it on the hip or in a pocket.

HAND ON HIP

PLACED ON THE OPPOSITE SHOULDER

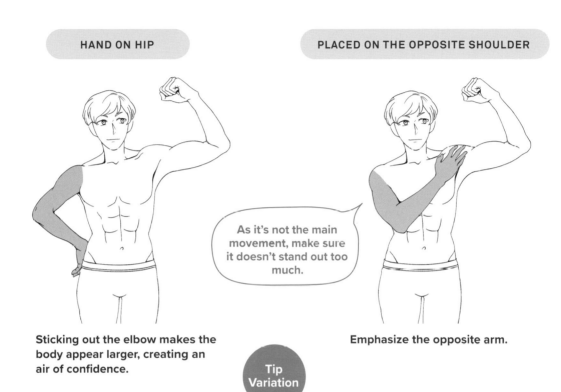

As it's not the main movement, make sure it doesn't stand out too much.

Sticking out the elbow makes the body appear larger, creating an air of confidence.

Emphasize the opposite arm.

Tip Variation

HOLDING AN OBJECT

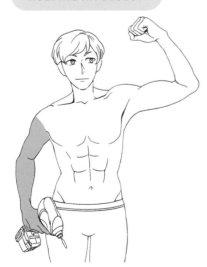

HAND IN POCKET

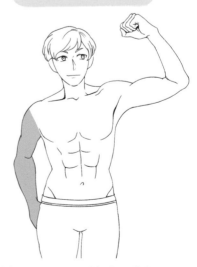

Making the character hold an object to fill in the gap is also a standard technique.

It's easy to use this for slightly pretentious or silly poses.

Slightly Bending the Fingers Makes the Hands Appear More Relaxed

In a pose where the figure is relaxed, if the fingers are straight it will create a robotic effect. If you observe your own fingers, you'll get a sense of how the hands look in their natural state.

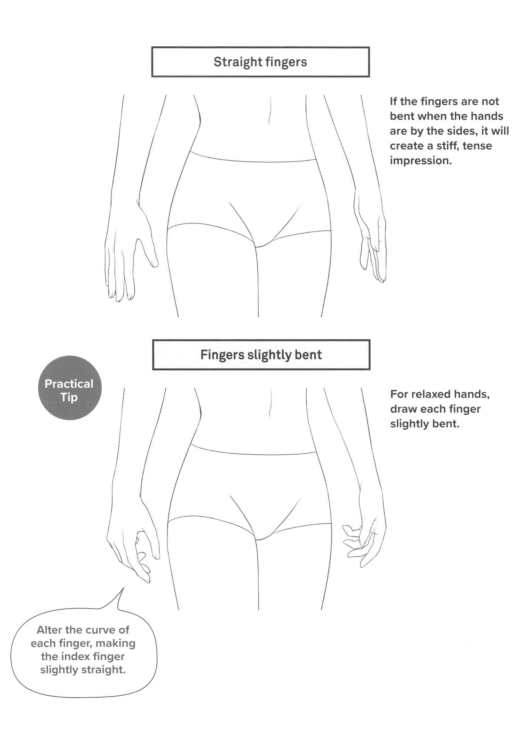

Straight fingers

If the fingers are not bent when the hands are by the sides, it will create a stiff, tense impression.

Practical Tip

Fingers slightly bent

For relaxed hands, draw each finger slightly bent.

Alter the curve of each finger, making the index finger slightly straight.

Create a Light Grip with the Thumb Straight

Hands formed into fists create a dynamic impression that may not suit a more relaxed or playful pose. Altering the nuance of the thumb to create a looser fist makes for a lighter, more appealing pose.

Tight fist	Loose fist

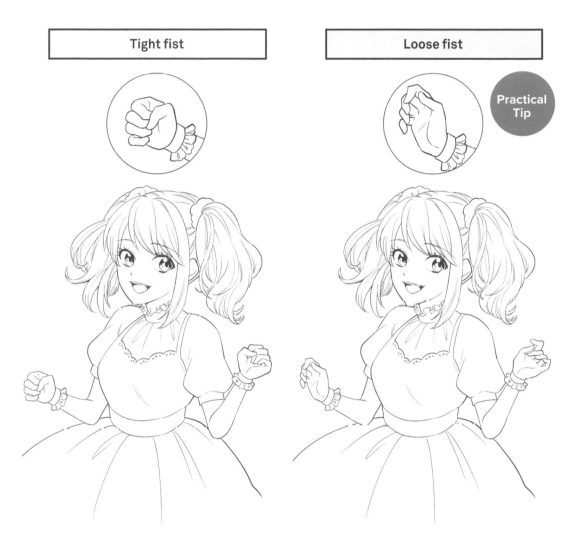

If the hands are in tight fists, the character will appear to be using her strength and the sense of lightness will be lost.

Fists in which the thumbs are not bent yields a more refined pose.

Use the Index Finger to Create Various Poses

There are all kinds of ways that the index finger can be made to stand out in poses. If you're having trouble with a pose, you may want to consider this. Depending on where the finger is pointed, it will create a different impression. So it's important to consider the character's personality.

SCRATCHING THE CHEEK

Create a pose that suits the character's personality.

FOREHEAD

A pose where the character is scratching her cheek or behind her ear suggests embarrassment or awkwardness.

A pose in which the finger points toward the forehead allows you to create an intellectual air.

Tip Variation

MOUTH

CHEEKS

Pointing the finger toward the mouth makes for a perplexed or worried pose.

The fingers pointing at the cheeks add a cutesy, childlike quality.

TIP A pose where the character is holding something up to his or her mouth and nibbling on it creates the impression of innocence or deep distraction.

Create a Floating Sensation by Making the Character Stand on Tiptoes

For a pose where a character is floating in the air or jumping, making it clear that the toes are stretched out so that the feet are not touching the ground heightens the effect. This is because if the toes aren't stretched out, it looks as if there is ground beneath their feet.

Toes not extended	Toes extended

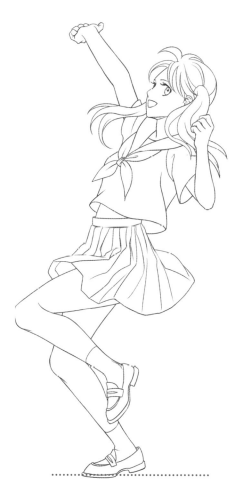

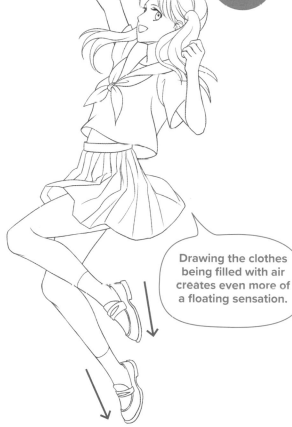

Practical Tip

Drawing the clothes being filled with air creates even more of a floating sensation.

If the toes are not extended, it creates the impression that the character is standing on the ground.

Stretching out the toes and making it clear that the character's feet are not touching the ground creates the sense of floating.

For a One-Legged Pose, Visualize an Inverted Triangle to Make Drawing Easier

When people assume an unstable pose, they use both arms often to get their balance. When drawing this kind of pose, visualize it fitting within an inverted triangle to make drawing it easier.

Equilateral triangle

Inverted triangle

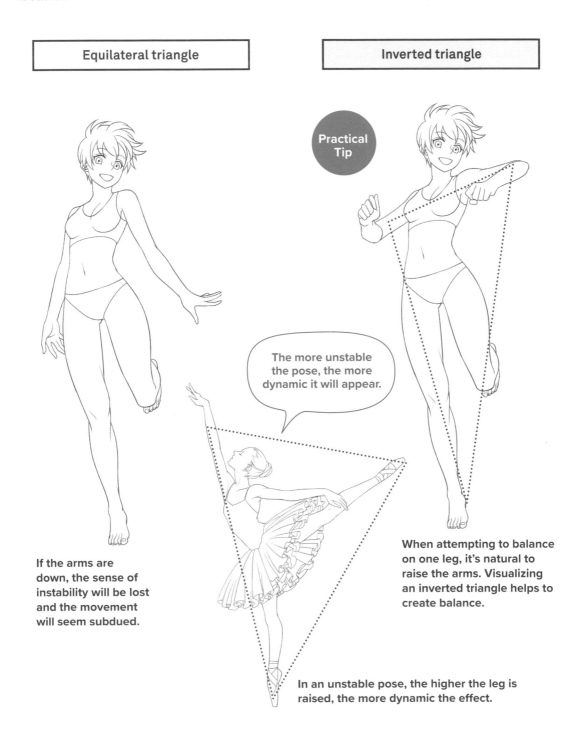

Practical Tip

The more unstable the pose, the more dynamic it will appear.

If the arms are down, the sense of instability will be lost and the movement will seem subdued.

When attempting to balance on one leg, it's natural to raise the arms. Visualizing an inverted triangle helps to create balance.

In an unstable pose, the higher the leg is raised, the more dynamic the effect.

If the Character and Situation Are Clearly Defined, the Pose Will Follow

If a character's back story, if the scene or setting of the illustration is decided, the pose and expression will naturally follow to create an emotionally unified, convincing illustration. If a pose isn't working, then try shifting the setting.

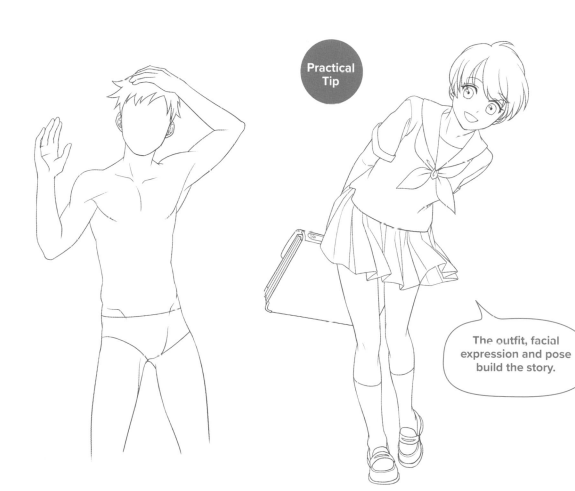

| No setting | With setting |

Practical Tip

The outfit, facial expression and pose build the story.

If you can't visualize the character or situation, it's hard to decide on the facial expression, pose and outfit.

This is the type of scene in which characters have been walking home together after school, and one turns to say, "See you tomorrow"

The Direction of the Face Can Be Used to Express Emotion

It's possible to use the direction of the face to make a character's personality and mood more memorable. If you make a mistake with the direction of the face, it's harder to suggest the character's emotion to the viewer directly.

LOOKING TO THE SIDE

A pensive-looking profile creates a sense of melancholy.

LOOKING DOWN FROM ABOVE

Raising the chin brings out an air of arrogance.

Tip Variation

GLARING UP FROM BELOW

An expression where the character is looking down with a sharp glint in his eye. This conveys strong will or inner turmoil.

LOOKING UP

Looking up creates an air of cheerful positivity.

Using the Horizon Line Creates the Look of Characters Standing on the Same Plane

If characters have the same physique and are in the same pose, the same parts of their body will cross the horizon line regardless of the perspective. If you use the parts that sit on top of the horizon line as a guide, you can make characters that are far away appear to be standing on the same visual plane.

> Place the same parts of the body on the horizon line

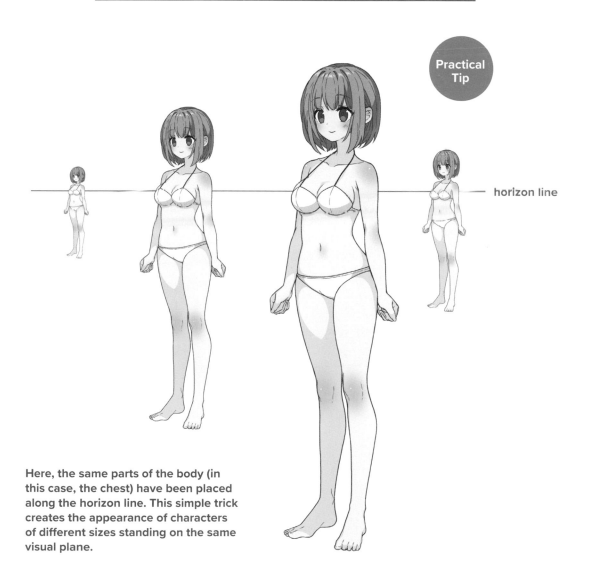

Practical Tip

horizon line

Here, the same parts of the body (in this case, the chest) have been placed along the horizon line. This simple trick creates the appearance of characters of different sizes standing on the same visual plane.

Place the Face Above the Center of the Drawing to Stabilize the Composition

Within a picture, the section that most attracts the gaze is the area slightly above the center. So the face or other parts of the character's body that you want to show should be positioned in this area where things tend to stand out.

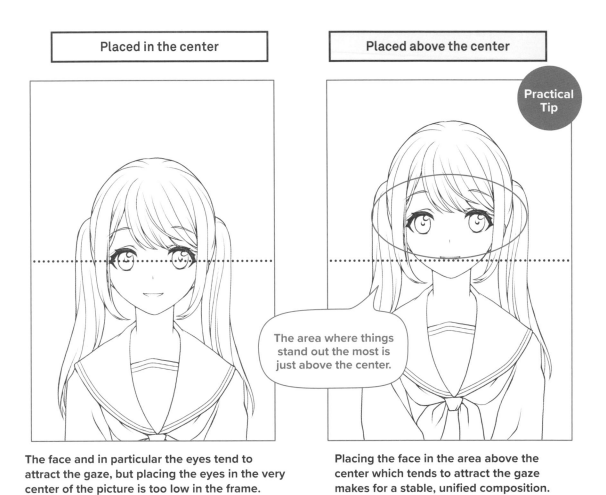

| Placed in the center | Placed above the center |

Practical Tip

The area where things stand out the most is just above the center.

The face and in particular the eyes tend to attract the gaze, but placing the eyes in the very center of the picture is too low in the frame.

Placing the face in the area above the center which tends to attract the gaze makes for a stable, unified composition.

TIP The same goes for horizontal composition, in that the area slightly above the center stands out.

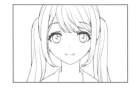

For Close-Ups of the Face, Include the Shoulders to Create a Balanced Look

In a close-up of the face, the key point is where to crop it. Cutting it off at the neck is usually avoided. If possible, include the section down to below the neck. It doesn't matter as much if the section above the forehead is cropped out.

| Cut off at the neck | Shoulders included |

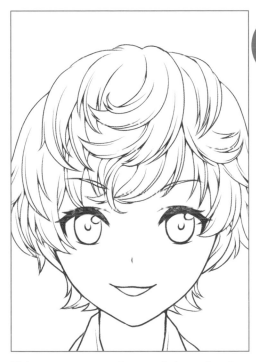

Practical Tip

Unless an extreme close-up is intentional, it's best not to crop the neck out.

When drawing a close-up of the face, you should include the neck and add in a little of the shoulders.

Cutting off the top of the head does not create an unnatural look.

TIP There are also close-ups that look like a camera has zoomed in on the face. In some cases, large parts of the outline such as the forehead and chin are left out, but this does not make for a sinister look as would cutting the face off at the neck.

Clean up the Scenery Around the Face for Easier Viewing

Placing items that stand out in the area around the face distracts or misdirects the viewer's gaze. Be cautious when positioning items in the background. In particular, thin, vertical objects placed behind the character appear to be sticking into the head, so are best avoided.

Around the face is cluttered	Around the face is open

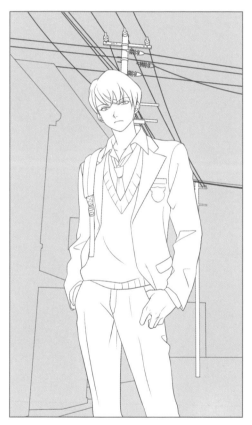

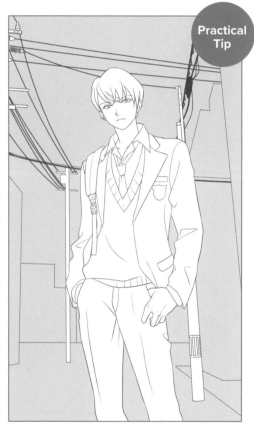

Practical Tip

A composition where telephone poles and other tall vertical objects can be seen behind the head is known as "skewering" and should be avoided.

In the case where there is a detailed background, create the composition so that the area around the face is kept free from clutter or distraction.

Take care when the background includes telegraph poles, trees or other vertical objects.

A Hinomaru Composition Centralizes and Strengthens a Character's Presence

An illustration with its main motif in the center is called a Hinomaru composition, in reference to the design of the Japanese flag. Having a centrally located main image lends strong emphasis to the character's presence.

Image shifted off-center	Centrally located image

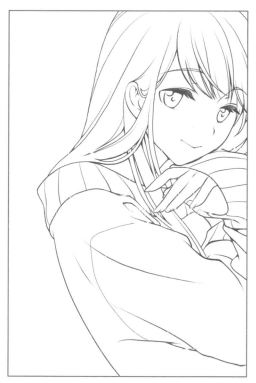

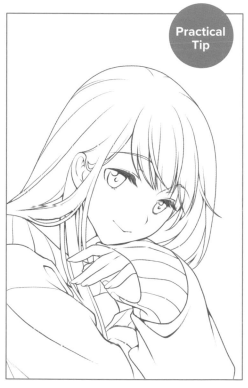

Practical Tip

In this composition, the face is shifted to the edge of the drawing. This allows the background and the line of the body to be shown.

A composition with the face at the center of the drawing. This results in the character's presence being strongly emphasized and highlighted.

TIP This simple approach, centralizing your subject, can lead to uninspired illustrations, so use it selectively.

Use Guide Lines to Divide the Illustration and Create Balanced Positioning

Using guide lines to divide the illustration into three equal parts, vertically and horizontally, makes it easier to create a balanced composition. Using the lines as a reference for the horizon, placing objects where the lines intersect allows a stable composition to be created.

> **Guiding lines to divide the illustration**

Practical Tip

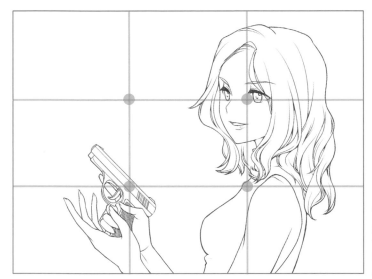

3X3 DIVISION

The face and other items are placed at the points where the three vertical and three horizontal guide lines intersect, creating a sense of balance.

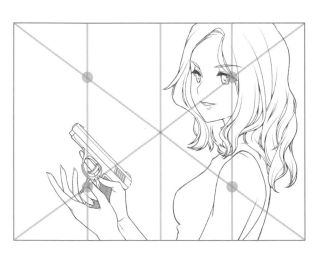

> Along with 3x3 composition, it's handy to learn the Railman composition.

RAILMAN COMPOSITION

Railman composition involves placing points where four vertical lines and diagonal lines intersect. It is characterized by the points being located farther to the outer edges than that of the 3x3 composition.

Tilting the Horizon Line Increases the Momentum of an Action

Normally, the horizon line is horizontal, but putting it on a diagonal creates an impression of instability. It's a technique that can be used in action scenes or to create a sense of unease.

Horizontal composition

Composition with the horizon line tilted

Practical Tip

Unless there's a reason not to, create a horizontal composition.

A diagonal composition creates the sense of the world having been shifted or distorted, making for a dramatic atmosphere while still with a realistic feel.

Don't make the angle too extreme.

A Triangle Provides Hints for Composition

When positioning elements in an illustration, keeping a triangle in mind makes it easier to create the composition. A composition where the triangle has a wide base brings out a sense of stability. A triangle is also a good guide when creating poses for figures.

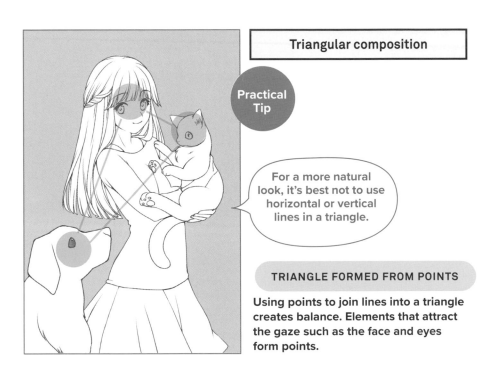

Triangular composition

Practical Tip

For a more natural look, it's best not to use horizontal or vertical lines in a triangle.

TRIANGLE FORMED FROM POINTS

Using points to join lines into a triangle creates balance. Elements that attract the gaze such as the face and eyes form points.

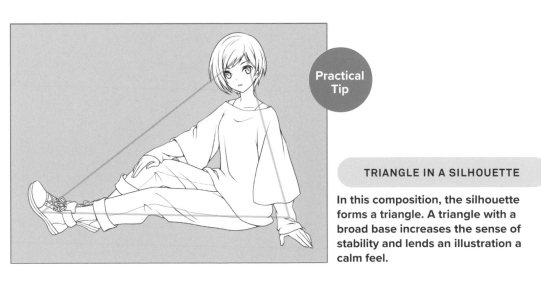

Practical Tip

TRIANGLE IN A SILHOUETTE

In this composition, the silhouette forms a triangle. A triangle with a broad base increases the sense of stability and lends an illustration a calm feel.

A Zigzag Composition Creates Visual Flow

When there are multiple elements in an illustration, simply lining them up creates a scattered impression. A zigzag composition arranges and organizes the elements for easier configuration, lending the illustration a sense of rhythm.

Zigzag composition

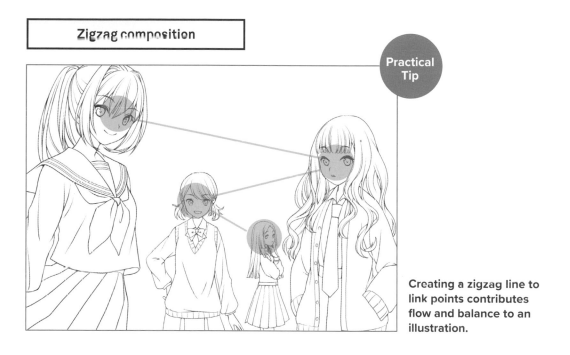

Practical Tip

Creating a zigzag line to link points contributes flow and balance to an illustration.

Random composition

If the main visual elements are randomly positioned, the viewer's gaze will be unfocused and the illustration will seem to lack unity and cohesion.

Leaving Space in Front of a Character Creates a Sense of Stability

When drawing the face in profile, space should be created in the direction that the character is facing. If space is created behind the head, it brings out the sense that something is approaching from behind. Unless bringing out an impression of unease, it's best to create space in front.

Creating space ahead of the character

Practical Tip

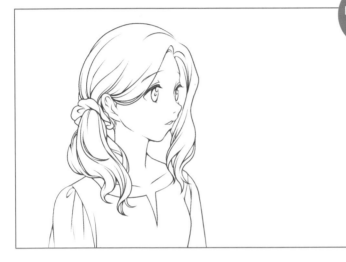

Creating space ahead of the character's line of sight makes for a natural composition.

Creating space behind the character

A composition that sparks unease can be used for horror or suspense scenarios.

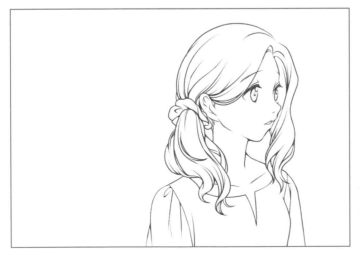

A composition with space behind the character creates the uneasy sense that there is something out of the line of sight.

Diagonal Lines Can Smoothly Guide the Eye

A diagonal line composition, where objects are positioned on the diagonal, is characterized by the way it brings movement to the picture and makes it easier to create impact. It makes it easier to control the movement of the viewer's gaze and allows the illustration to be displayed in a way that seems to flow.

Diagonal line composition

Practical Tip

BODY ON THE DIAGONAL

A figure lying down is easy to crop down into a diagonal line composition.

This allows for a layout where the figure fills the entire screen.

ITEM ON THE DIAGONAL

Stick-shaped items such as swords can be used to create flow in the picture due to the diagonal line created.

Drawing an Object for Comparison Suggests Size and Scale

When drawing giant creatures or robots, including something that makes it easy to visualize their size allows size to be accentuated. Drawing a comparison object makes it easier to isualize their giant scale.

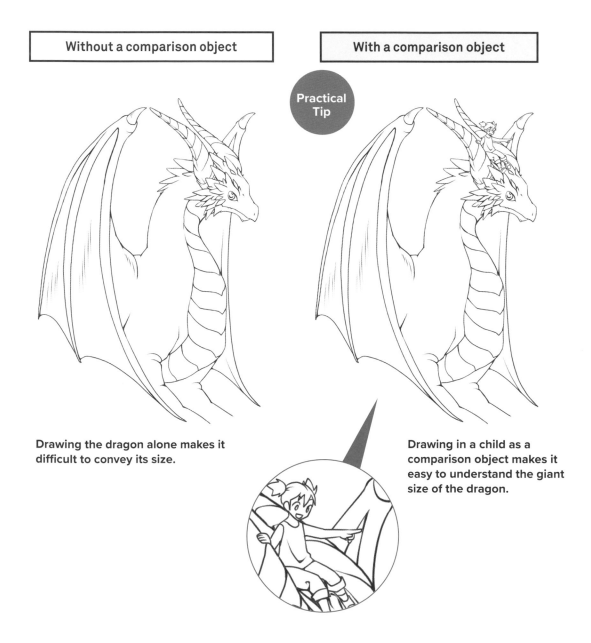

Without a comparison object

With a comparison object

Practical Tip

Drawing the dragon alone makes it difficult to convey its size.

Drawing in a child as a comparison object makes it easy to understand the giant size of the dragon.

TIP In terms of visual comparisons for large objects, drawing a person makes it easy to understand, but for comparison objects for small things, we recommend using everyday objects with characteristic shapes.

A Small Rough Sketch Makes It Easier to Consider the Composition

When planning the composition of an illustration, it's a good idea to draw small thumbnails. This allows you to quickly consider multiple compositions. The fact that it's easier to get the overall impression of compositions if they are small is also key.

Using small, rough sketches

Practical Tip

SMALL ROUGH SKETCHES

Draw simple illustrations at a small size to consider the composition.

ROUGH SKETCH

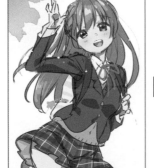

LINE DRAWING

COLORING/FINISHING

Once the composition is basically decided via the rough sketches, draw a detailed rough sketch and use it to proceed with the line drawing, coloring and finishing.

TIP The advantage of small rough sketches is that they are easy to draw. You can dash off a rough sketch in a notebook if you have an idea for a composition while you're away from home.

Depicting a Character Viewed from a Low Angle Increases the Sense of Presence

Viewing an object from a low angle makes it look bigger. A composition with this perspective makes it easier to create a strong impression with the character. It's also an angle that tends to bring out an air of arrogance, so it can be used for overbearing characters or those who want to express their own elevated status.

Eye level	Low angle

Applied Tip

Here, the point of view is level with the horizon to create a basic angle. Visualize the height (at eye level) or set it at around the same height as the face.

Viewing from below creates impact. It works well when you want to bring out an air of arrogance.

Visualize a camera in a low position tilted upwards.

An Overhead Angle Makes It Easier to Fit in the Whole Body

In an illustration where the figure is standing, drawing it from an overhead angle makes it easier to fit the entire body in the composition. Because it's easier to make the face large, this technique can be used when you want to emphasize the expression.

Basic angle	Overhead angle

Practical Tip

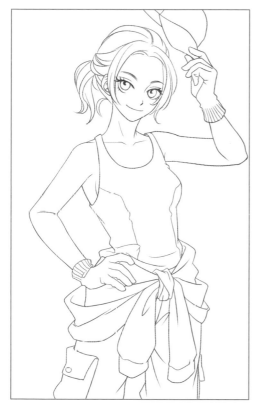

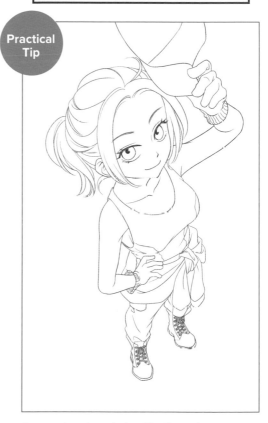

A basic horizontal angle. This is suitable for when you want to show the line of the body.

An overhead angle is effective when you want to fit the entire body into an illustration. As perspective comes into play, make the face large and the feet small.

Visualize a camera in a high position tilted downward.

TIP As it's easy to express the appearance and position of things using an overhead angle, it can be used when you want to convey the setting of a scene.

Applying Perspective Brings out Momentum

Applying extreme perspective to create a composition with impact is a technique used in the chibi-style of manga. A particularly common example is making an outstretched hand large. This gives the viewer the impression that the hand is coming toward them.

| Without perspective | With perspective |

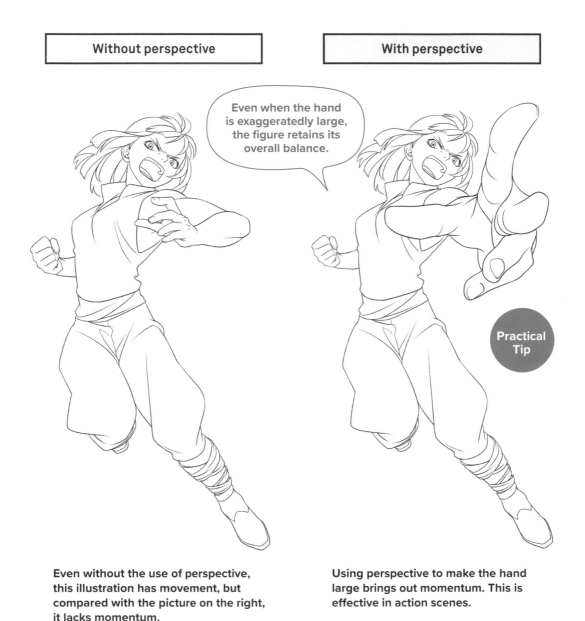

Even when the hand is exaggeratedly large, the figure retains its overall balance.

Practical Tip

Even without the use of perspective, this illustration has movement, but compared with the picture on the right, it lacks momentum.

Using perspective to make the hand large brings out momentum. This is effective in action scenes.

TIP Making close objects exaggeratedly large and emphasizing perspective in other ways is called overperspective. It's also known as manga perspective or false perspective.

A Fish-Eye Lens Perspective Changes the Look of an Illustration

A fish-eye lens composition allows a larger area to be "shrunk" to fit the composition than in a regular view. It creates the sense that the space is distorted, allowing you to create unique effects. The distortion is also effective for suggesting instability or unease.

Basic angle

A regular horizontal angle with horizontal and vertical lines in the background creates a flat impression.

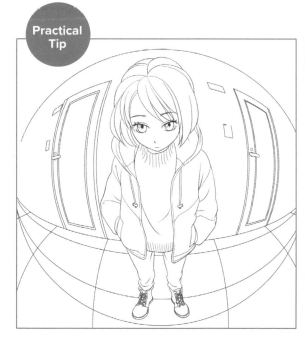

Practical Tip

Fish-eye angle

If buildings and other items that should have straight lines are in the background, the fish-eye effect is accentuated.

Applying fish-eye perspective makes for a picture with a sense of unease and distortion.

In a Two-Person Composition, Use the Gaze to Express Their Relationship

When positioning two characters, it's a good idea to pay attention to their lines of sight. As their gaze can convey their emotions and relationship, it brings a sense of storytelling to the illustration.

UNREQUITED LOVE

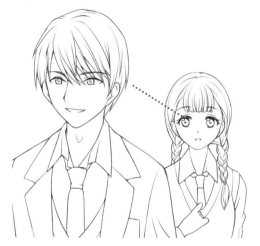

REQUITED LOVE/CONFLICT

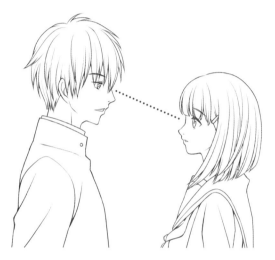

A composition where one character is looking ahead at the other can express unrequited love.

Tip Variation

A composition where characters are looking at each other emphasizes a strong relationship, so can be used for requited love or in scenes of conflict.

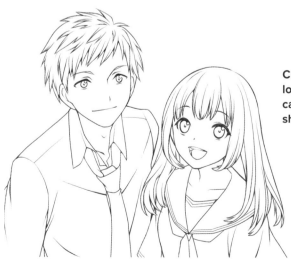

FRIENDS

Characters side by side looking at the same thing can be used to express a shared purpose.

Index

Introducing the Illustrators

Iroriko
Thanks for taking the time to read this.

M-O
I draw illustrations for books, advertisements and games. I'm doing my best.

`URL` https://emuoillust.wixsite.com/emuo　　`Twitter` @emuo_Mo

Sakamoto Rokutaku
I like ghosts and horror and draw those sorts of manga and illustrations.

`Twitter` @S_ROKUTAKU

Nakanishi Ixi
Know-how is important! It's an efficient way to improve your powers of expression!

`URL` http://nakaart.wp.xdomain.jp/　　`Twitter` @nakanishi_ixi

`pixiv` 1153391

hiromyan
Having been involved in producing this book has made me pay more attention to figure composition and rethink character creation!

`URL` https://hirohoma.wixsite.com/tamayura　　`Twitter` @hiromyan5

`pixiv` 10849872

Miyano Akihiro
I'm still learning about drawing. Of all the stages in the drawing process, I particularly like line drawing. It's very calming.

`URL` https://miyanoakihiro.tumblr.com　　`Twitter` @miyanoakihiro00

`pixiv` 3851903

Yamasaki Umi
Congratulations on this publication, I had a blast creating things for it!

`URL` http://site-800544-714-3157.mystrikingly.com/　　`Twitter` @yamasaki_umi

Ech

I was working on the commentary this time, but I want to keep learning more drawing tips!

URL https://ech.fanbox.cc/ Twitter @ech_

pixiv 356998

Kaji Akihiro

I draw character illustrations, mainly young girls and women. I like the Japanese style of drawing.

URL http://akihiro-note.mystrikingly.com/ Twitter @ak_hr

pixiv 31057313

Denki

I often draw illustrations featuring scenery and women.

URL https://fusionfactory.myportfolio.com/ Twitter @denki09

pixiv 10772

Nakahara Miho

I like drawing macho characters.

URL 13613081 Twitter @mh_nkhr

Hoshino Shiho

With the right intention and skills, and lots of practice, you'll vastly improve!

URL https://hosin0work.tumblr.com/ Twitter @hosin0_siho

pixiv 18520718

Mutsuki Nano

It had been a while since I did digital illustration, so it was really fun!

URL https://nanomutsuki.tumblr.com/

pixiv @nano_illustrator

Renta

I'm Renta, an illustrator. I hope you enjoy this great book!

URL http://renta.mystrikingly.com/ Twitter @derenta

pixiv 12136

"Books to Span the East and West"

Tuttle Publishing was founded in 1832 in the small New England town of Rutland, Vermont [USA]. Our core values remain as strong today as they were then—to publish best-in-class books which bring people together one page at a time. In 1948, we established a publishing office in Japan—and Tuttle is now a leader in publishing English-language books about the arts, languages and cultures of Asia. The world has become a much smaller place today and Asia's economic and cultural influence has grown. Yet the need for meaningful dialogue and information about this diverse region has never been greater. Over the past seven decades, Tuttle has published thousands of books on subjects ranging from martial arts and paper crafts to language learning and literature—and our talented authors, illustrators, designers and photographers have won many prestigious awards. We welcome you to explore the wealth of information available on Asia at **www.tuttlepublishing.com**.

Published by Tuttle Publishing, an imprint of Periplus Editions (HK) Ltd.

Copyright © 2023 Periplus Editions

www.tuttlepublishing.com

CHARA ILLUST WO UMAKU KAKU TAME NO KNOW-HOW ZUKAN
Copyright © 2020 Sideranch
Original Japanese edition published in 2020 by SB Creative Corp.
English translation rights arranged with SB Creative Corp., Tokyo through Japan UNI Agency, Inc., Tokyo

ISBN: 978-4-8053-1716-7

25 24 23 22
10 9 8 7 6 5 4 3 2 1

Printed in China 2207EP

DISTRIBUTED BY

North America, Latin America & Europe
Tuttle Publishing
364 Innovation Drive
North Clarendon, VT 05759-9436 U.S.A.
Tel: 1 (802) 773-8930
Fax: 1 (802) 773-6993
info@tuttlepublishing.com
www.tuttlepublishing.com

Japan
Tuttle Publishing
Yaekari Building 3rd Floor
5-4-12 Osaki
Shinagawa-ku
Tokyo 141-0032
Tel: (81) 3 5437-0171
Fax: (81) 3 5437-0755
sales@tuttle.co.jp
www.tuttle.co.jp

Asia Pacific
Berkeley Books Pte. Ltd.
3 Kallang Sector #04-01
Singapore 349278
Tel: (65) 6741 2178
Fax: (65) 6741 2179
inquiries@periplus.com.sg
www.tuttlepublishing.com